THE METROPOLITAN MUSEUM OF ART

The Pacific Islands, Africa, and the Americas

THE METROPOLITAN

INTRODUCTIONS

BY

Douglas Newton
EVELYN A.J. HALL AND JOHN A. FRIEDE CHAIRMAN

Julie Jones
CURATOR

Kate Ezra
ASSISTANT CURATOR

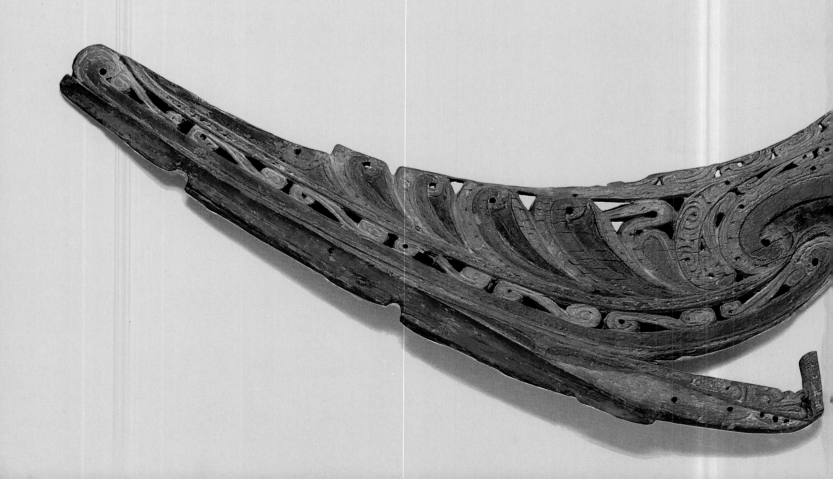

MUSEUM OF ART

The Pacific Islands,
Africa,
and the Americas

THE METROPOLITAN MUSEUM OF ART, NEW YORK

PUBLISHED BY

THE METROPOLITAN MUSEUM OF ART
New York

PUBLISHER
Bradford D. Kelleher

EDITOR IN CHIEF
John P. O'Neill

EXECUTIVE EDITOR
Mark D. Greenberg

EDITORIAL STAFF
Sarah C. McPhee
Josephine Novak
Lucy A. O'Brien
Robert McD. Parker
Michael A. Wolohojian

DESIGNER
Mary Ann Joulwan

Commentaries on objects from the Pacific Islands written by
Douglas Newton, Evelyn A. J. Hall and John A. Friede
Chairman of Primitive Art. Commentaries on objects from
Africa written by Christine Mullen Kreamer. Commentaries on
objects from the Americas written by Julie Jones, curator,
Department of Primitive Art.

Photography commissioned from Schecter Lee, assisted by
Lesley Heathcote: Pages 2–3 and Plates 2, 4–20, 22, 24–28,
31–38, 43, 46–51, 53–58, 62, 64, 66–75, 77, 78, 81–86, 88–91,
93, 94, 96–102, 106, 108–113, 116, 118. Rollout photograph
for Plate 92 © Justin Kerr 1976. All other photographs by
The Photograph Studio, The Metropolitan Museum of Art.

Map and time line designed by Wilhelmina Reyinga-Amrhein.

THIS PAGE

Tunic (detail)
Peru (Wari); 7th–9th c.
Wool, cotton; 21 x 12⅞ in. (53.5 x 32.7 cm.)
The Michael C. Rockefeller Memorial Collection,
Bequest of Nelson A. Rockefeller, 1979 (1979.206.394)

TITLE PAGE

Canoe Prow and Finial
Papua New Guinea, Milne Bay Province; 19th–20th c.
Wood, paint; Prow: H. 42½ in. (16.38 cm.),
Finial: H. 18⅝ in. (7.41 cm.)
The Michael C. Rockefeller Memorial Collection,
Gift of Nelson A. Rockefeller, 1972
(Prow: 1978.412.709; Finial: 1978.412.1492)

Library of Congress Cataloging-in-Publication Data

The Metropolitan Museum of Art (New York, N.Y.)
 The Pacific Islands, Africa, and the Americas.

 1. Art, Primitive—Catalogs. 2. Art—New York
(N.Y.)—Catalogs. 3. Metropolitan Museum of Art
(New York, N.Y.)—Catalogs. I. Title.
N5310.75.N9M48 1987 730'.089011'07401471 87-5814
ISBN 0-87099-460-3 (pbk.)—ISBN 0-300-11941-0 (Yale
University Press)

Printed and bound by Dai Nippon Printing Co., Ltd., Tokyo.

This series was conceived and originated jointly by
The Metropolitan Museum of Art and Fukutake
Publishing Co., Ltd. DNP (America) assisted in coordinating
this project.

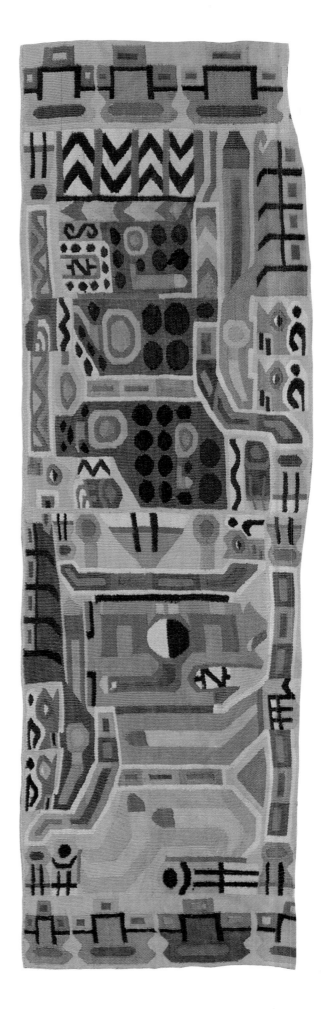

This volume, devoted to the arts of the Pacific Islands, Africa, and the Americas, is the last in a series of twelve volumes that, collectively, represent the scope of the Metropolitan Museum's holdings while selectively presenting the very finest objects from each of its curatorial departments.

This ambitious publication program was conceived as a way of presenting the collections of The Metropolitan Museum of Art to the widest possible audience. More detailed than a museum guide, broader in scope than the Museum's scholarly publications, this series presents paintings, drawings, prints, and photographs; sculpture, furniture, and the decorative arts; costumes, arms, and armor— all integrated in such a way as to offer a unified and coherent view of the periods and cultures represented by the Museum's collections. The objects that have been selected for inclusion in the series constitute a small portion of the Metropolitan's holdings, but they admirably represent the range and excellence of the various curatorial departments. The texts relate each of the objects to the cultural milieu and period from which it derives and incorporates the fruits of recent scholarship. The accompanying photographs, in many instances specially commissioned for this series, offer a splendid and detailed tour of the Museum.

We are particularly grateful to the late Mr. Tetsuhiko Fukutake, who, while president of Fukutake Publishing Company, Ltd., Japan, encouraged and supported this project. His dedication to the publication of this series has contributed greatly to its success.

At the Metropolitan the arts of the Pacific Islands, Africa, and the Americas are on permanent view in the Michael C. Rockefeller Wing. Although the Museum's first acquisitions in this area were made in 1882, a separate department for their care, study, and exhibition was not established until 1969. Permanently installed galleries were opened in 1982 with the inauguration of the Rockefeller Wing. Objects assembled by the once independent Museum of Primitive Art and by Nelson A. Rockefeller form the core of the Wing's collections; they were transferred to the Metropolitan in 1978 and 1979. The Wing is named for Mr. Rockefeller's son, Michael, who collected many of the Asmat objects from Irian Jaya, western New Guinea, that are now in the Museum.

Many other donors have generously contributed to the formation of the collections. Nathan Cummings and Alice K. Bache substantially increased the Precolumbian holdings, while Lester Wunderman added equally to those of West Africa. Evelyn A. J. Hall and John Friede are donors of works from the Pacific Islands, and Mary R. Morgan has given funds for the purchase of numerous works of art. The Buckeye Trust, Charles B. Benenson, and The Denise and Andrew Saul Philanthropic Fund also contributed to the purchase of important pieces. Further acknowledgment must go to Ernst Anspach; Arthur M. Bullowa; Jean and J. Gordon Douglas, III; Jane Costello Goldberg; Bryce Holcombe; Bernard, Brian, and Diane Leyden; Gertrud A. Mellon; Carol R. Meyer; Frieda and Milton Rosenthal; Paul and Ruth Tishman; and Faith-dorian and Martin Wright. Yet other donors are named in the credit lines of the objects reproduced in this book.

We are grateful to Douglas Newton, the Evelyn A. J. Hall and John A. Friede Chairman of the Department of Primitive Art, and to Julie Jones, curator in the Department, for having written the introductions and commentaries for the sections on the arts of the Pacific Islands and the Americas, respectively. Kate Ezra, assistant curator in the Department, wrote the introduction to the Africa section, and Christine Mullen Kreamer prepared the commentaries for that section.

Philippe de Montebello
Director

THE PACIFIC ISLANDS

"We look at these things, and we tremble."
—A young Sepik River man, 1970

Among the arts displayed in this book, to this day the art of Oceania has the uneasy distinction of probably being the non-Western art least accessible to a potential Western audience. It goes without saying that the arts of the great classic cultures, whether Mediterranean or Oriental, present faces to us that are (at least we persuade ourselves) fairly easily recognized. A Chinese or Japanese painting is based on theories of aesthetics that we certainly understand hazily are not ours, but that are, nevertheless, coherent and the outcome of long-established ratiocination. Statehood and imperialism, familiar political concepts, are evident in an Egyptian royal statue or Assyrian relief; Hindu and Buddhist art reflect worldwide ancient religions with recognizable gods and sages. Coming closer to home, Precolumbian art is very largely clearly the product of high cultures, and however unfamiliar, its imagery is often gemlike not only in its materials but also its execution.

Then there is the matter of introduction. Dürer, as is almost too frequently quoted, spoke well of Aztec art, or at least its craftsmanship. At the beginning of this century Picasso and his colleagues placed their stamp of approval on African sculpture, and the rise in their personal prestige has corresponded with an equivalent ascent in popular regard for their African counterparts.

The art of Oceania presents a somewhat different case. It is unlike African art in that most of it cannot appropriately be addressed or described in terms applicable to Western art. That African sculpture can be described in a vocabulary of a corresponding sensibility is not really surprising: it was partly the study of it that formed the vocabulary itself. Where Oceanic art is concerned, the language of form and surface is generally either irrelevant or totally meaningless. This was recognized to a certain extent by the Surrealists, true to their vociferous and would-be subversive agenda. While for the most part they got their ethnography hopelessly wrong, they had a fine understanding of the magical and evocative qualities of Oceanic sculpture. Therefore, they deliberately associated the art of the islands with the world of the dream—a world that could be explained in certain analytic terms, but should nonetheless be wondered at. Some

ethnographers had already proposed that "primitive art" was one with the art of children and the insane—not to the disparagement of any of them, but presuming they all shared an admirable spontaneity and freedom. Moreover, the cultures were thought to be utterly conservative and ahistorical, therefore as eternal as the dream world. Some of the Surrealists, at least, embraced this totally fallacious theory, which has become utterly discredited by art-historical and anthropological research during the last thirty years.

This has produced a vast quantity of data that in itself is often quite one-dimensional and mechanical, but in the first place demolishes the notion of artistic näiveté—as anyone might have expected. It has more recently become the foundation for some very sophisticated systems of interpretation. Raw data are now often worked into models that attempt to reproduce fundamental assumptions and belief patterns that have given rise to symbolic constructs, and from which, in turn, the work of art has drawn its imagery.

We attempt, in fact, to see these works of art with the eyes of their creator. It is an enterprise that cannot be wholly successful, yet without which we cannot understand any work of art. How successful can this transcultural enterprise ever be? The answer may depend on the culture being studied: Some may be fairly easily explained, some may be opaque, and it is, of course, the latter that present the more alluring challenge and with which anthropologists have had remarkable success. These are the cultures in which the visual arts have been defined as nonverbal communication. This does not mean that the artists were solely concerned with aesthetic values, but that they eschewed the narrative possibilities of art—though their cultures certainly had complicated myths with large casts of characters and a wealth of incident. But the essential meanings, some anthropologists have concluded, of the works and the rituals in which they are used, may not only be unexpressed in words, but actually inexpressible. There is an often-quoted statement attributed to various Western artists, "If I could tell you what the music (or the dance) meant, I would not have to play it (or dance it)." This has not, of course, prevented anthropologists from valiant attempts to modulate the nonverbal into the verbal,

even while understanding that what for them is "explanation," to their subjects might be "explaining it away." It has been suggested that understanding can only be attained by those fully socialized in these societies—that is, the elders who have experienced all that the societies and their beliefs have to offer. This brings us back to the possibility that, like the incompletely socialized, we are at liberty to look upon the works of art with incomplete knowledge, certainly, but able to sense them as powerful and magical images: if not exactly in the way the Surrealists did—since we know better than to cling to some of their assumptions—then at least with some of the same awe.

But before enlarging further on the qualities of Oceanic art we should consider its geographic and ethnic bases.

The Setting

If one sails eastward along the 3,000-mile length of the Indonesian archipelago, there are only a few miles at a time where the coastline—beach, headland, or jungle—does not lie to the left or right. From the eastern end of Timor, there supervenes a 600-mile stretch of ocean broken only by scattered groups of smaller islands. Then appears the western end of New Guinea, a vast island 1,500 miles long, and 1,000 miles across at its widest.

If one were to turn to the northeast, one would enter an expanse of the North Pacific Ocean almost 1,000 miles from north to south and over 2,000 miles from west to east. This is dusted with 2,000 islands and islets, volcanic peaks, or atolls. These tiny patches of dry land are collectively known as Micronesia.

An alternative turn with a course along the southern coast of New Guinea leads to a very different environment. The forested alluvial plains, which form the coast of the island, converge toward the coast of Australia. At their closest points, the Torres Strait, south New Guinea, and Australia are no more than seventy miles apart. If one continues along the hilly southeast area of New Guinea, eventually one reaches its farthest capes; rounding them, and turning backward along the northern coast, one encounters the long-drawn-out ranges that form the spines of New Britain and New Ireland, with the small Admiralty Islands beyond. Stretching away to the southeast are, in succession, the Solomon Islands, the New Hebrides, and New Caledonia. The upper ranges of drowned cordilleras are large, mostly mountainous islands that form the Realm of Melanesia—some of which are still volcanically active. To the east lie the Tonga, Samoa, and Fiji islands groups. They form the western edge of Polynesia, the third major division of the Pacific Islands, and the greatest in the expanse of ocean it covers. The "Polynesian Triangle," with apices in New Zealand in the southwest, the Hawaiian Islands in the north, and Easter Island in the southeast, has a base of over 5,000 miles and a breadth of over 4,000 miles. Besides, there are Polynesian cultures in a large number of small islands (the Polynesian "outliers"), mainly in a long belt running parallel to, and east of, the Melanesian archipelagoes. Vast as this area is, the actual square mileage of land involved is relatively small: The twin islands of New Zealand comprise nearly half of it with a little over 100,000 square miles. The other Polynesian islands are small, being generally either high volcanic peaks or atolls—coral formations around the rims of submerged calderas. Their land area is an estimated 110,000 square miles.

New Zealand has a temperate climate, warm in the north, but considerably cooler in the south, where the central ranges are snowcapped for much of the year. The other Pacific Islands nearly all have tropical environments of high temperatures and humidity, and they were once largely blanketed in dense jungle growth except for some very high alpine areas and permanent snowfields of New Guinea.

This imaginary journey reflects, to a certain extent, the actual routes along which human beings may have peopled the Pacific Islands. Australia and New Guinea were inhabited at least 30,000 years ago and perhaps as much as 50,000 years ago. That was the period when, in the frigidity of the Ice Age, the sea levels everywhere sank, and the coasts of the Indonesian and western Pacific Islands became far closer to each other than ever before or since. The earliest people to arrive very probably traveled across the relatively narrow stretches of sea on crude watercraft, perhaps even something as elementary as bamboo rafts. How many of them first reached any one place, or where those places were, we shall never know: With the rising of the water levels, their first settlements along the coastlines were irrecoverably submerged. It can only be presumed that the process of colonization of the area, by people whose ancestors had come from the Asian mainland, continued over a long period, and there is no reason to presume that they arrived in large numbers. But the spread of population through the vast spaces of Australia and New Guinea had penetrated to the far southeast of both places some 30,000 and 26,000 years ago, respectively. Other parts of the great central cordillera of Papua New Guinea were inhabited 20,000 years ago, and all the mountain valleys held settlements 10,000 years ago.

The invasion of the sea that flooded the Torres Strait between New Guinea and Australia cut connections between them, and each continued along differing cultural paths. New Guinea continued to receive visitors from the west who brought with them pigs, food plants, and more than 9,000 years ago, some techniques of agriculture. How far human colonization extended beyond this area, and by what date, is still unclear. The early inhabitants spoke Papuan languages. The later arrivals spoke languages of the great Austronesian group, which extended through much of Southeast Asia.

One particular incursion led to important consequences for the establishment of people throughout the farther Pacific Islands. A group making a distinctive type of pottery and practicing long-range trade spread into the islands of Tonga, Samoa, and Fiji by about 3000 B.C. Over the following centuries there developed in these island groups a distinctive culture and group of related languages. This was the outset of Polynesian society. About the beginning of the first millennium A.D., voyagers began moving eastward—that is to say, remains of their landfalls on various islands have been found dateable to this period. So far as we know, the Marquesas Islands, the Hawaiian Islands, and Easter Island

were inhabited first by A.D. 600. At least five hundred years later, people had spread westward to the islands of Central Polynesia, and from there to New Zealand in the far southwest by A.D. 800. Polynesians also colonized some of the fringe islands of the Solomons group and some island groups of Micronesia, other Micronesia islands apparently having been inhabited by people from the Philippines.

The Artists

While the Pacific Islanders were, in nearly all places, remarkably prolific and inventive artists, their range of materials was limited. As they were generally the heirs of Neolithic cultures, they worked no metals. Weaving, on small backstrap looms, was practiced only in the Caroline Islands (Micronesia), some of the Polynesian outliers, and a few of the small Melanesian islands. A small amount of stone sculpture was made everywhere, but most of the known works are on no great scale, except for some over-life-size figures in the Marquesas Islands and the famous colossi of Easter Island.

In most areas the basic material for sculpture was wood of several species, often worked when it was green. The tool kit included stone blades of different sizes for the initial roughing out and first stages of finishing. (Soon after Western contact began, these were replaced by steel blades.) Fine work was carried out by incising and scraping tools, which were usually honed animal teeth, particularly rodent incisors and boars' tusks, shark teeth, mussel shells, and where geological conditions permitted, flakes of obsidian.

Painting was an Australian, Melanesian, and New Guinea art rather than Polynesian or Micronesian. The usual supports for painting on the flat were slabs of bark or sheets of beaten-out paper-mulberry bark; the colors were ochers in shades of brown, yellow, and red; white from burned lime, and black from charcoal. The medium was usually plain water, though some vegetable oils and tree-sap glazes were occasionally employed. One should also not forget that paint was frequently mixed with magic substances, was sometimes considered a magic substance itself, and was a vivifying agent; its colors, too, had symbolic significance.

Clay was used, mainly in Melanesia (Polynesians abandoned pottery making early in their history) both for vessels, which were often elaborately decorated, and for solid and hollow-bodied sculpture.

Apart from these main mediums, the island artists used practically anything they could lay their hands on. The range was omnivorously wide, from more or less foreseeable materials such as flowers, bird and animal skins, and plant fiber, to such bizarre substances as concoctions of pounded nuts and other vegetable matter and spider webs.

The artist was virtually always a man; the only exceptions were some female makers of (undecorated) pots and weavers. This was due to the powerful identification of works of art with religious beliefs, which they reinforced, and ritual activities in which they were worn or displayed. Religion in many areas was very much man's work, to the point that women were practically excluded from knowledge and ritual (the motivations of male secrecy in this aspect of island life are unfortunately too complex to be discussed here). Preliminaries to actual work included solitude, fasting, and the use of some narcotics to induce visions. This regimen was at least partly followed during the course of the creative effort. Thus, the artist, while on the one hand a normal member of society, was on the other, an expert, the human conduit to supernatural powers.

It is worth noting, however, that the ostensible "creator" was not necessarily responsible for the total result. Communal effort played a considerable part in the accomplishment of some of the huge programs of architectural sculpture and painting, in which a leader, or master, relied on numerous assistants. In other cases a master carver would work commissions for which he was recompensed with food and other valuables.

Trade in whatever might be called works of art was slight even though trade in other goods was very prevalent. Occasionally, experts from a local subgroup, or more rarely from a foreign group, were called upon to provide their services. In some cases, certain objects were made specifically for trade to other groups, perhaps only during short periods in which the objects were thought of as fashionable prestige items. On a more regular basis, some islands produced specific types of small carved objects, such as bowls and spatulas, which they included in much wider ranges of products. Generally speaking, however, the artifacts used in exchanges were ornaments or the raw materials for ornaments and, often in great quantities, such useful goods as pottery. In New Guinea there was a certain amount of trafficking in dances, with the masks made to be worn for them. None of all this necessarily involved trade over long distances, of course; although individual objects sometimes ended up a long way from their sources, the individual links involved were quite short. The effect this trade had on the styles of art of the people who received objects from abroad is hard to assess. In most cases it had none whatever: The imports were looked upon as interesting or attractive exotics. In other cases if the source dried up for one reason or another, people would take to making the same things as nearly as possible in the same style. All groups had distinctive vocabularies of forms and designs, infrequently overlapping with those of other groups, to which their artists adhered. But this was not by any means a matter of following rigid, standardized formulas: The norms were flexible enough so that artists could and did exercise a considerable degree of judgment and innovation. The ancestors set the artists examples but had no final control over what they created.

History

The sketchiness of our knowledge of man's history in the Pacific is matched by equivalent gaps in the history of his art. Only faint indications of it remain. Time and climate have not been kind to wood and barkcloth; only in New Zealand is wood sculpture of well-established antiquity known to have survived. Elsewhere, the extant works from the past are in tough materials—stone, shell, pottery—and these probably do not represent the full wealth of the actual

traditions. The earliest evidence for art in the Pacific world comes from Australia, and so far it is the most copious, even though its dating is often debatable. At Koonalda Cave, in southern Australia, walls are densely covered with long sets of parallel finger markings, perhaps randomly arranged but also possibly placed at ritually important spots. These appear to be from 15,000 to 20,000 years old, and similar patterns have been found in other caves. In northern Australia, engravings in rock shelters have been found that are at least 5,000 to 7,000 years old, and some paintings may be as much as 18,000 years old.

In New Guinea, the first intimations of art are indirect: In the highlands, people were importing and using red ocher, probably as body paint, by 15,000 B.C.; by 7000 B.C. they were using shells imported from the coast. None of the abundant rock art has been dated yet, nor has the large number of stone sculptures found mainly in the highlands. These are mostly carved mortars, pestles with finials in the form of birds, and human or animal figures, again with unknown dates.

The most impressive ancient pottery known was manufactured by the people of the Lapita culture. In its heyday, about 1500–500 B.C., it was notable for fairly simple but graceful forms overlaid with a network of stamped patterns. Most remarkable, one shard found in the Santa Cruz Islands of the Solomons group shows the first dated human face in Pacific art; it was made in perhaps about 1200 B.C. With the move to western Polynesia, Lapita decoration of pottery lapsed. Other pottery traditions, particularly the early Manga'asi of the New Hebrides (700 B.C. onward), were sometimes highly decorated.

Early Polynesian ornaments and weapons simultaneously show connections with Melanesian models and foreshadow more recent types. A major feature of this period was the development of the *marae* or sacred enclosure, which included a platform, usually stone built, and often a stone bounding wall. *Maraes* took many forms: The most spectacular was the work of Easter Islanders. The famous stone colossi—over six hundred exist—were carved about A.D. 1100–1700 and stand on such stone platforms.

In New Zealand the story of archaeological art is somewhat better known. The recovery of many important objects from burials, caves, and swamps has given a fragmentary and not altogether coherent sequence of works from about A.D. 900 to the present. It is at least clear that Maori art went through a number of stylistic changes, with the well-known Classic Period styles beginning about A.D. 1500.

The Subjects

The natural environment of the Pacific Islands is extraordinarily rich in potential imagery. Apart from the overwhelming impact of its landscape (explored by William Hodges, Gauguin, and a host of subsequent painters), the most casual eye can find a superabundance of life, vegetable and animal, in a teeming variety of grotesque and beautiful forms. Almost none of this was used by the islands' artists. Among the few exceptions are bark paintings made by the Kwoma people of the Sepik area of Papua New Guinea, which are named for a number of plants, animals, birds, and even heavenly bodies. All these refer to moments in myth, and all are symbolic rather than representative. Naturalistic depictions of birds, fish, and some animals, even though stylized, are quite common in the arts of Australia, New Guinea, and Melanesia, but much less so in Polynesia or Micronesia. The major subject of art everywhere, both quantitatively and qualitatively, is the human figure. For people who lived in small groups, in environments that overmatched their physical power, and who were frequently under attack from hostile neighbors, this choice was perhaps a way to assert the fragile primacy of humanity.

In accordance with this, the figure sculpture of the Pacific is never purely realistic. It is often sensuous but does not share the Mediterranean tradition of portraying the body's natural beauty and allure. The body is a medium for the expression of concepts. The artist does not glorify the gods by forming them as perfect human beings; he creates images through which the gods express themselves. Supernatural power flows through the sculpture into the unworked wood, and through the finished image to its beholder. While for historical reasons there are many correspondences between the island styles, it is the multiplicity and diversity of Pacific Islands styles that delights and astonishes us. The reasons for such diversity are many. It is clear that in the small islands, isolation gave rise to local styles; in the larger areas of Melanesia and New Guinea, interplay between groups also was a factor influencing styles and effecting changes in them.

The Styles

New Guinea, with its vast size and a population that is relatively large in Pacific terms (about three million people), not unexpectedly has the largest number of distinguishable style-areas. The larger part of the population, living in cordilleras that form the spine of the island, create very little sculpture or painting. The *gerua* boards of the eastern highlands are a rare exception. The people of the central and eastern areas of these highlands are notable, however, for the richness and intensity of their styles of self-decoration. The human body is used as the field for elaborate painting, and the support for shell and boar-tusk ornaments, wigs, and headdresses of flowing bird-of-paradise feathers and iridescent beetle shells. The magnificence of these creations —often with symbolic significance—is an expression of the pride in wealth and accomplishment of their wearers.

Most of New Guinea's prodigious production of permanent art comes from the hill-and-lowland areas to the north and the lowlands south of the mountain ranges. Politically, New Guinea consists of two countries—the western half, Irian Jaya, is part of Indonesia, while the eastern is indepen-dent Papua New Guinea. In the northwest, the great Geelvink Bay and the islands around it are famous for the *korwar*, small standing or squatting figures with grossly exaggerated heads. Various types and sizes of *korwar* were used as personal amulets, shrines for ancestral skulls, and as sha-

mans' property. Most *korwar* hold in front of them a grill of scrolls, a typical motif in the art of this area. Elaborate arrays of scrolls appear in relief in many carvings, especially the large panels used as canoe-prow decoration. The art of the area is, in fact, related to that of eastern Indonesia—an influence that disappears in the east.

The southern part of the island is largely an alluvial plain. Its best-known inhabitants are the large Asmat tribe, formerly headhunters and cannibals. They are also one of the groups most productive of carvings, as befits people who believe that their ancestors were created from wooden logs. Their most ambitious works are enormous symbolic canoes and the great *mbis* poles carved in honor of their dead. East of the Asmat live the Marind-anim who, like the Asmat and the tribes still farther east, were also headhunters and cannibals. Their sculpture and painting were subordinated to costuming for pageantlike reenactments of mythology.

The broad Gulf of Papua, which forms most of the south coast of Papua New Guinea, is inhabited by a number of tribes who produced large numbers of carvings, most of which are in low relief on elliptical boards. These appear to refer to bull-roarers, the sacred musical instruments, as do huge elliptical bark-cloth masks. Masks among the Elema people at the east end of the Gulf are of great variety and often include, besides the human face, effigies of totemic animals, birds, and even plants. A similar amalgam of forms was made by the islanders of the Torres Straits, between Australia and New Guinea, in masks constructed from plates of turtleshell.

The farthest southeastern points of New Guinea and the adjacent islands comprise the Massim area. The importance of the Kula, the extended trading network that encompassed the major islands, led to a development of canoe building, and the decoration of canoes with floridly rich carving. Its refinement of detail was extended to other Massim carving, though this was usually on a small, domestic scale.

On the other hand, along the northeast coast in the Heron Gulf and Astrolabe Bay areas, carving was often on a large scale. Especially significant was architectural sculpture, which included over-life-size caryatid figures, wall panels, and beams. Massive wooden masks were worn at boys' initiations.

The northern part of Papua New Guinea consists of the Sepik Provinces, named after one of New Guinea's longest rivers. An area of plain and swamp bordered by hills, it is famous as the home of the most prolific art-producing societies in Oceania. The nearly two hundred tribal groups compose at least eleven style-areas, each with several substyles. The vital and complex ritual life of these dynamic cultures, based—speaking of the majority—on cults of the ancestors, fertility, and initiation, was deeply integrated with warfare and headhunting. Ceremonial houses in numerous architectural styles, built on the grand scale, were decorated with carved and painted members, and often housed sacred carvings, musical instruments, and flutes. The standard colors of the New Guinea region were black, white, and red, with occasional touches of brown and yellow. In the Melanesian islands, the palette was much brighter and was applied to often startling effect.

The styles of New Britain and New Ireland, the large is-

lands northeast of New Guinea, are less varied. The most southerly area of New Britain had sculpture that was stylistically close to that of the Heron Gulf. Northward were the Sulka, Baining, and Tolai people. They made very little wooden sculpture, but did produce highly polychromed masks in highly ephemeral materials. Sulka masks, for instance, were constructed into human and animal forms from strips of pith painted pink, with brilliant touches of other colors. The Baining worked chiefly in bark cloth over frames, with designs painted on a white ground. Some masks were enormous, and ritual figures in bark cloth up to forty feet high are recorded. Tolai carving is often very delicate, usually in openwork and, again, brilliantly polychromed. As part of their ancestral cult the Tolai also carved small effigies in stone or chalk for presentation to novices.

This practice is paralleled in southern New Ireland in the carving of small chalk ancestral figures. The religious life of New Ireland is indeed characterized by cults of the dead. The chalk figures are, in turn, like the massive wood figures of central New Ireland. In the north, the complex *malanggan* style presents the most virtuoso performances in wood in all Oceania: intricate openwork carvings of mythological scenes painted with black, white, and red patterns, which enhance their hallucinatory juxtapositions.

The sculpture of the Admiralty Islands to the west is different. Most of it consists of utilitarian domestic objects made for trade; the human figure is often represented, always in the same chunky but bland formula in which the only animation is provided by incised bands of small triangles on an overall coat of red paint. Southeast, in the Solomon Islands, we find a similar overall surface treatment, using black instead of red, and pearlshell inlay for incised geometric elements. These contrasting colors impart a far greater energy to an already more vital style, with its solid and frequently aggressive gestures and protuberant forms.

South again are the islands of the New Hebrides. Much of its sculpture uses fernwood, which, cut, resembles a clotted mass of pine needles. Masks are assembled from a heterogeneous repertoire of easily handled materials. In the case of both sculpture and masks, fine fernwood carving —though some exists in other classes of objects—is excluded. As a result, New Hebrides sculpture seems rough, but its extraordinary distortions of reality show a great imaginative power, which is intensified by the lavish use of almost garish color.

The most southerly major island of Melanesia is New Caledonia. A certain ferocity informs the island's sculpture, while a monotone black, touched with red or white, invests its heavy forms with a ponderous sobriety. Masks were carved only in the northern part of the island; otherwise, sculpture is largely limited to house decoration: door jambs, posts, and finials. Figure sculpture is relatively rare.

It is fair to say that our present understanding of traditional Polynesian art has been sadly affected by the abrupt conversions to Christianity that took place in several island groups during the early nineteenth century. Quantities of sculptures were destroyed by zealous converts or missionaries. Consequently, the actual number of works preserved is much less than in Melanesia. Large-scale wood sculpture

hardly exists except in a few examples from Hawaii and, happily, in the still-vital traditions of the New Zealand Maori. Monumental stone sculpture, harder to destroy than wood, has survived in examples from the Marquesas Islands, the Austral Islands, and of course, Easter Island. Polychrome painting, or indeed any painting, was quite rare and simply served to enhance carvings. Two-dimensional art took the forms of painting or printing on tapa; that extraordinary technique, tattooing, which turns the human body into a textile; and the sumptuous feather cloaks, with bold geometric designs, of the Hawaiian nobles.

Western Polynesian art in Samoa, Tonga, and Fiji is mainly represented today by instruments of battle and some appurtenances of religion. The murderous ingenuity, which created many types of clubs, was particularly fruitful in Fiji. Fijians also carved priests' bowls in graceful human, bird, and abstract forms. Throughout those groups figure sculpture was rare and probably always small scale. Most comes from Tonga, including small figures in wood and others in ivory, which were often exported to Fiji. The art of decorating tapa cloth in great quantities for ceremonial presentations was highly developed.

The Cook, Austral, Society, and Gambier Island groups of eastern Polynesia show a wealth of different treatments of the human body: reduced to simple, almost geometric patterns at one extreme, or running through a progressive series of stylizations. Figures are usually squat, with oversized heads. Some of the rare figures from Mangareva (in the more remote Gambier Islands) have a degree of naturalism otherwise unknown in Oceania.

The styles of the more isolated island groups around the perimeter of Polynesia present very differing images. The sculpture of Hawaii, far to the north, is akin to some central Polynesian work in its simplicity of surface, but it is violent in its prismatic stylization of the body and the snarling convention of the face. Bowls, game boards, drums, and other objects have figure supports; individual temple figures of deities, male and female, range up to ten feet high. The stone colossi of Easter Island have already been mentioned; its wooden sculpture is hardly less striking. Owing to a shortage of wood, it was always small. There are four main figure types: lizard- or bird-headed men, flat female figures, naturalistic males, and extraordinary gaunt and almost skeletonic male figures.

In the Marquesas Islands figures were standardized; they had virtually the same heavy proportions as those of central Polynesia but with uniquely stylized, round-eyed faces. They were used as fan handles, stilt steps, and on canoe prows. Some were covered with fine incised patterns relating to the Marquesan passion for total body tattooing.

In the far southwest lie the two islands of New Zealand, the largest of the Polynesian area. The inhabitants, the Maori people, evolved a sculptural style—or rather many styles, though all are recognizably Maori—of astonishing complexity. Wood carving was used on a lavish scale in architecture, for the façades, posts, and interior panels of meeting houses and storage houses; for huge canoes; on weapons, boxes, and many other types of equipment. Highly prized jade was made into pendants and ceremonial blades. The major

theme is ancestral beings, shown as human figures, either simply or in interlocking compositions that sometimes allude to mythological events. Surface decoration is flamboyantly rich, often reflecting the practice of tattooing.

Though sculpture was a major feature of the art of other Pacific island groups, it was rare throughout all parts of Micronesia except the Caroline Islands and Palau. Masks with distinctive white, almost featureless, faces were carved in the Mortlock and Truk Islands; small figures with attached stingray spines were wind charms; and canoe prows represented stylized birds. The most remarkable figure sculptures from the Carolines are a small number of gods and goddesses from the tiny atoll of Nukuoro. Although they are as stylized as other Micronesian sculpture, perhaps testifying to the influence of an errant Polynesian tradition, they are fully three-dimensional. The richest sculptural tradition of the area is that of the Palau Island group, where the large men's clubhouses had carved posts, beams, and plank gables carved in reliefs depicting incidents from mythology and large figures of women.

Micronesian artistry was often expressed in craftwork of exceptional refinement. Among its most striking achievements are vegetable-fiber weavings worked in minute strips on small back-strap looms. These strips were used as loincloths and belts or were pieced together to make women's skirts. Plaited mats are technically coarser than the weavings but are elegantly designed. Personal adornments included many types of headgear, enhanced by flowers, face paint, and tattooing. Even tools and household equipment share the elegant simplicity and sense of balance that is the essence of Micronesian art and links it to similar aspects of Polynesian products.

The kaleidoscope of images that forms the art of the Pacific Islands is a product of their history. In some ways it seems to reflect a distant past rather closely; in others, to be a radical reworking of ancient concepts. Echoes of ancestral styles abound, a form or a design recurring from one group of islands to the next. More important to our understanding of Pacific art is the question of what its makers intended, and here, for answers, we must call upon the religions—the fundamental beliefs of the islanders—and the societies these religions once molded and supported.

A distinction is often drawn between the almost democratic societies of Melanesia and New Guinea, with their "big men" who won their way by individual enterprise, and the hereditary chiefs of Polynesia and Micronesia, whose power was drawn from the accumulation of ancestral prestige. Very different they were, indeed, but the sources of their energy were quite similar: The quest for power was universal, and power could be gained through the intervention of the supernatural. The supernatural world itself was neutral; it was as likely to punish as to bless. It could kill, or it could bestow authority and fertility. And thus these became the grand themes of Pacific Islands art, expressed in images that are not meant to edify, console, or charm us. Rather, they are deadly serious, and from this comes their impressive force.

Douglas Newton

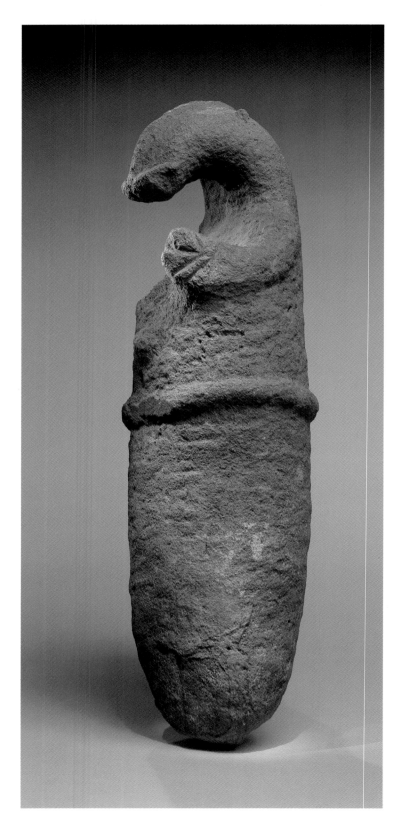

1 Zoomorphic Figure
Papua New Guinea, Southern Highlands
Province, Mendi area
Stone with red paint; H. 13¼ in. (33.7 cm.)
Anonymous Gift, 1984 (1984.123.1)

MENDI ZOOMORPHIC FIGURE

The odd-looking creature represented in this stone carving is probably the echidna (spiny anteater), one of the egg-laying mammals found only in New Guinea and Australia. Its long snout appears as a gracefully carved form rising above the forequarters and raised paws (one is broken away). It is one of three very similar carvings found together.

While numerous stone bowls have been found in Papua New Guinea, representational works are rare. The largest single group consists of approximately fifty pestles beautifully carved with birds or human heads as finials. Independent figures such as this one, are rarer still: So far only about twenty-five have been recorded. The sculptures constitute an archaeological enigma. Historically, stone carvings were not made in the Papua New Guinea Highlands, and there are no traditions accounting for them. The majority of those known have been unearthed accidentally, no one carving having been found in context. However, certain fragments of scientifically excavated stone bowls are approximately thirty-five hundred years old, and their use may have ceased about three to four hundred years ago. To compound the problem, the sculptures bear no relationship to recent Highlands art but have many aspects in common with the rich recent artistic traditions of the lowlands. If they are ever satisfactorily dated, they will be key monuments in tracing the art history of the great island.

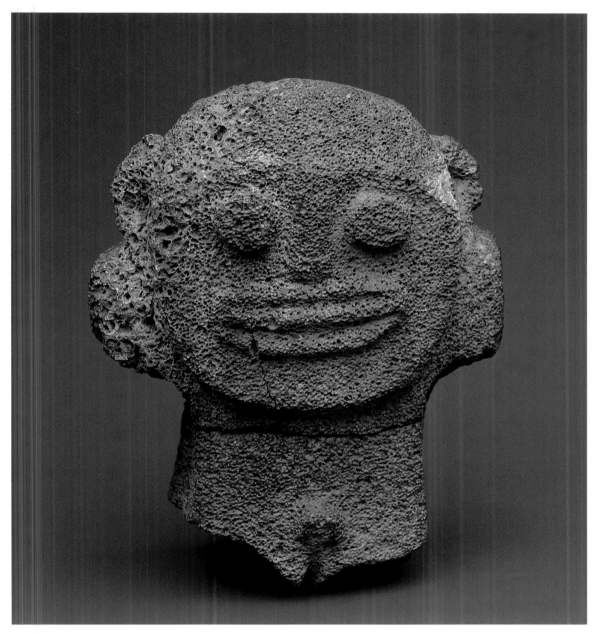

2 Figure
Hawaiian Islands, Necker Island; A.D. 1000(?)
Stone (vesicular basalt); H. 7¾ in. (19.7 cm.)
Rogers Fund, 1976 (1976.194)

FIGURE FROM THE HAWAIIAN ISLANDS

In 1894 an exploring party discovered eleven small stone figures (some merely fragments) on Necker Island, a barren outcrop three hundred miles from the main Hawaiian group. All the figures with the exception of the Metropolitan Museum's example are now in either the Bernice Pauahi Bishop Museum, Honolulu, or the British Museum, London. Like two others, this was apparently lost for many years, until its rediscovery in a New York private collection.

The Necker Island figures occupy a notable position in Polynesian art history, partly owing to their association on the island with a particular type of temple platform. Although there is considerable discussion about the distribu-tion and history of such platforms, the most coherent theory at present is that the type existed about A.D. 650–1300 in the Marquesas Islands, where at least one fragmentary stone figure with a resemblance to Necker Island sculpture and dating from this period has been found. Migration from the Marquesas to Hawaii took place about A.D. 650–800, and Necker Island was being visited from Hawaii, probably as a place of pilgrimage, in about A.D. 1000. The Necker Island figures may therefore belong to a tradition that began in the Marquesas (where it developed into the more recent styles of that island group), was transferred to Hawaii, and was present on Necker Island about A.D. 1000.

ASMAT MEMORIAL POLES

In southern Irian Jaya (west New Guinea) approximately 10,500 square miles of flat, swampy terrain blanketed in jungle is the home of the Asmat, who number about 30,000 people. It was a fundamental Asmat belief that there was no such thing as a natural death; death was always caused by an enemy: either by the indirect methods of sorcery, or by the brutally direct means of warfare, which was endemic among these notoriously fierce, cannibalistic headhunters. Asmat conceptions of society were based on an ideal of balance created by total reciprocity in all aspects of life. Therefore, a death at the hands of the enemy threw society into an imbalance that the living were called upon to correct by im-

posing reciprocal death on the enemy. When a village had suffered a number of deaths, it held the *mbis* ceremony. The carvings made specially for these events were the *mbis* poles, the basic form of which is a canoe with an exaggerated prow that incorporates both ancestral figures—the dead who were being commemorated—and a phallic symbol in the shape of a winglike openwork projection. For each *mbis* ceremony several poles were displayed in front of the men's ceremonial house; they were kept until a successful headhunt had been carried out. The victims' heads were then placed temporarily in the hollow lower ends of the poles, and after a final feast the victors abandoned the carvings in the jungle.

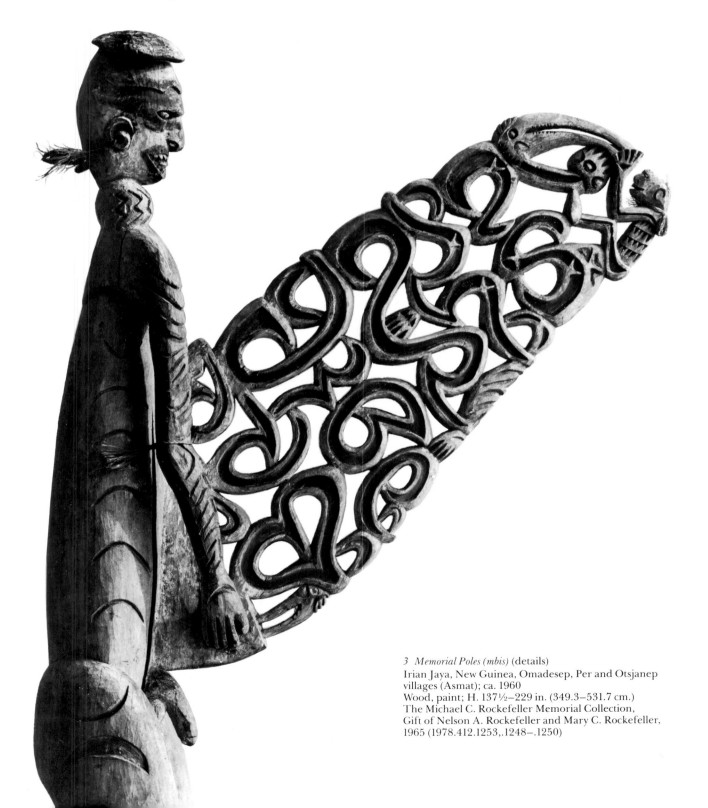

3 Memorial Poles (mbis) (details)
Irian Jaya, New Guinea, Omadesep, Per and Otsjanep villages (Asmat); ca. 1960
Wood, paint; H. 137½–229 in. (349.3–531.7 cm.)
The Michael C. Rockefeller Memorial Collection,
Gift of Nelson A. Rockefeller and Mary C. Rockefeller,
1965 (1978.412.1253,.1248–.1250)

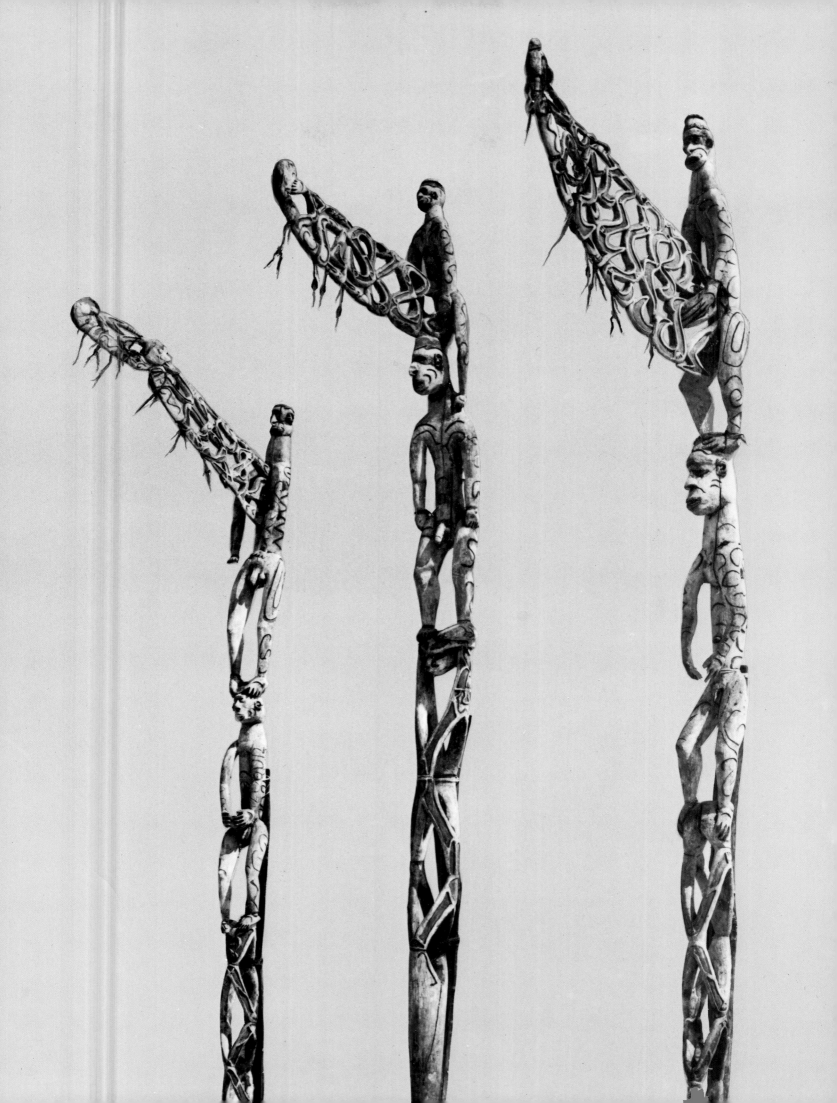

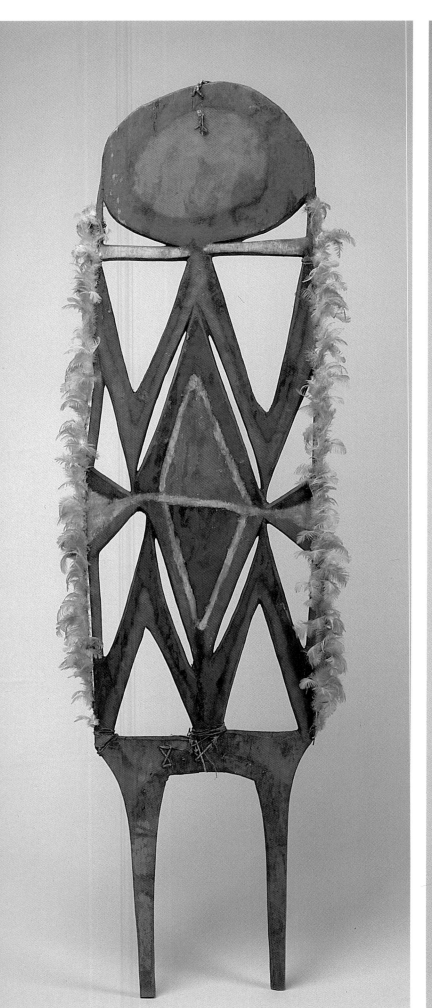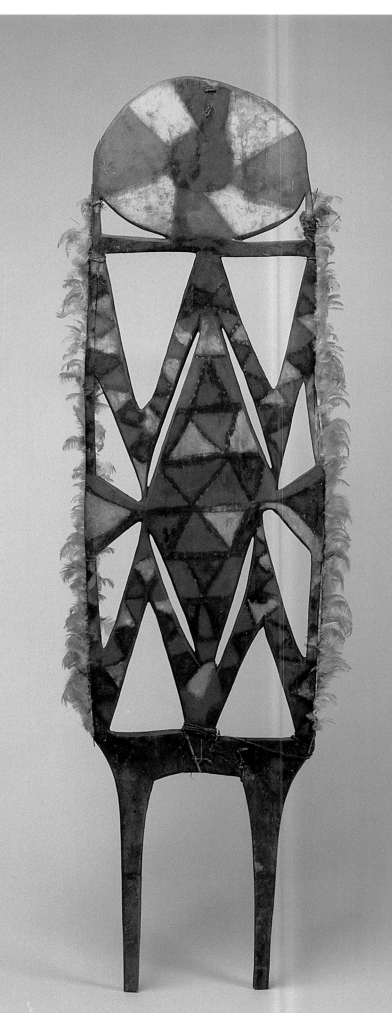

SIANE BOARD

The Highlands tribes of Papua New Guinea largely confine their aesthetic output to the most elaborate personal ornamentation to be found in the whole of that island. Though they have a rich ceremonial life that is often carried out on a large scale—some occasions entail the gathering of thousands of people—their plastic arts are meager. In some areas of the eastern Highlands, however, the people produced thin carved boards of various types, often in openwork and always painted with highly stylized designs. These were displayed in great numbers at large-scale ceremonies during which quantities of pigs were killed to feed ancestral spirits and promote fertility. The anthropomorphic boards embody symbols of the sun (the round head) and moon (the diamond-shaped body). In this example one can trace an ambiguous image, which can be seen both as a figure with hands touching the head and drawn up legs, or as a standing figure. Carved in the early 1950s, this board is partly painted in imported Western pigments.

4 Board (gerua)
Papua New Guinea, Eastern Highlands Province
(Siane); ca. 1950s
Wood, pigment, feathers; H. 55⅛ in. (140 cm.)
The Michael C. Rockefeller Memorial Collection,
Gift of Nelson A. Rockefeller, 1969 (1978.412.741)

Opposite: front and back views

BAHINEMO MASK

The hills south of the upper Sepik River are inhabited by small groups of people who in the past led a seminomadic way of life, often deserting their hamlets for months at a time to wander in the jungles. They reassembled for ceremonies intended to promote success in hunting and for the initiation of girls and boys. Their most sacred objects were masklike carvings including human features and hook projections, which were interpreted in several ways. Sometimes the hooks symbolized birds' beaks, while the whole image was sometimes said to represent a catfish. In both cases they were powerful manifestations of the spirits that haunted the water and the bush.

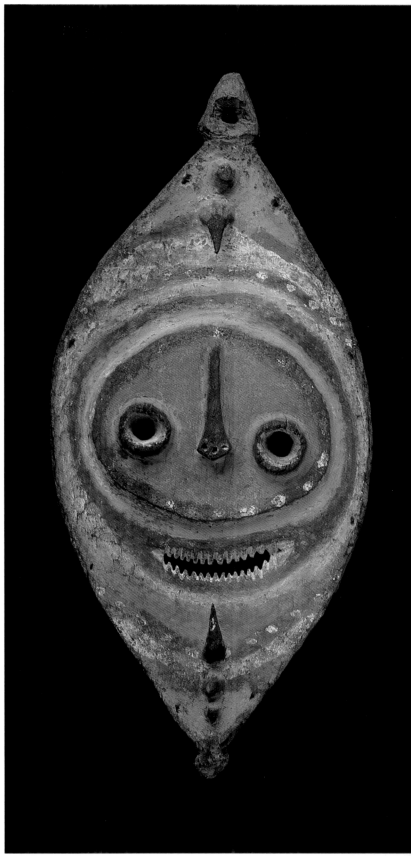

5 Mask
Papua New Guinea, East Sepik Province, Hunstein Range
(Bahinemo); 19th–20th c.
Wood, paint; H. 31¼ in. (79.4 cm.)
The Michael C. Rockefeller Collection, Purchase, Mr. and
Mrs. John J. Klejman Gift and Nelson A. Rockefeller Gift,
1968 (1978.412.1526)

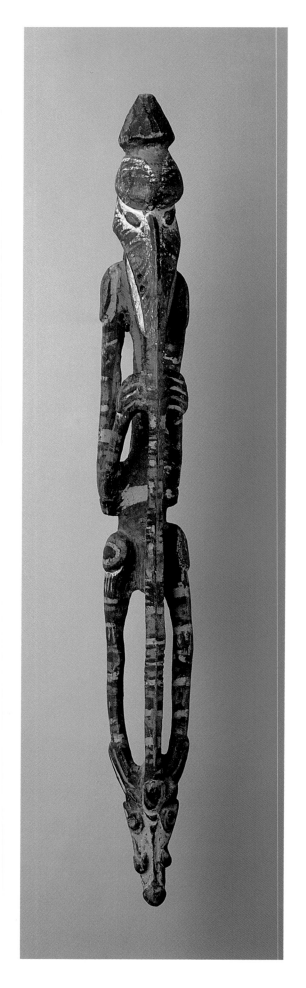

KOPAR FIGURE

Lank and long drawn out, the limbs and torso of this figure exist mainly as a series of wavering rhythms between the figure's head and the boar's head on which the feet rest. The connection between head and pig is an enormously extended nose—it constitutes most of the face—clutched in the figure's hands. A conical topknot was formerly used as the support for a coronet of feathers.

As with masks from other Sepik areas, the combination of images might represent the transformations of a mythical person. Some figures of this type are found tied to lengths of bamboo, raising the possibility that they were originally ornaments for sacred flutes.

6 Figure
Papua New Guinea, East Sepik Province (Kopar);
19th–20th c.
Wood; H. 30½ in. (77.5 cm.)
The Michael C. Rockefeller Memorial Collection,
Gift of Nelson A. Rockefeller, 1969 (1978.412.722)

KOPAR FIGURE

This extraordinary figure is reminiscent of those paintings by Archimboldo in which a human head is constructed from a cornucopia of fruit, or Indian miniatures of elephants made up of other animals, or certain turn-of-the-century postcards. It is a notable example of the creation of an image by accretion.

The body is no more than a tall, narrow, rectangular plank, carved in openwork, but with several lesser elements carved in the round protruding from it. In totality, what we see here is a male figure with a fully carved naturalistic head. Above it—seated, as it were, on the male's shoulders—is a squatting female. Vertically placed on the female's torso is a catfish in the round, perhaps a hint about creation myths in which these creatures figure largely. Below this the torso is pure symbolism: A silhouetted crocodile is shown, its head flanked by two birds, probably hornbills. On the crocodile stands a pig carved in the round. Thus, the whole incorporates creatures of air (birds), bush (pig), and water (crocodile) —the three main elements of the riverine Sepik landscape. Beyond this one cannot go, but all in all the figure implies a being with mastery over the world in which he lives.

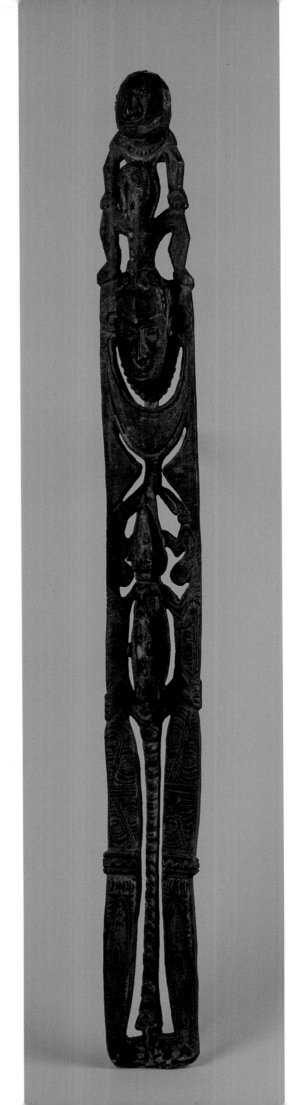

7 Figure
Papua New Guinea, East Sepik Province (Kopar);
early 20th c.
Wood, paint; H. 74 in. (188 cm.)
The Michael C. Rockefeller Memorial Collection,
Gift of Nelson A. Rockefeller, 1969 (1978.412.727)

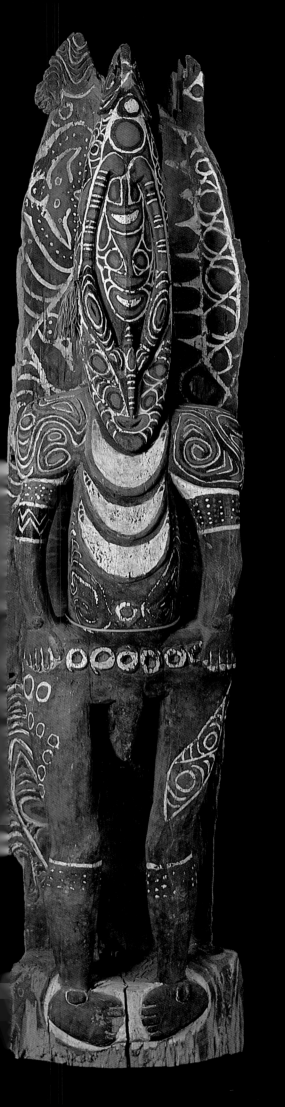

KAMBOT FIGURE

The Kambot people live on the Keram River, a tributary that feeds into the lower Sepik River, and in the swamps around it. They were, on the whole, painters rather than sculptors and produced numbers of paintings of mythological scenes. This figure is probably the largest known work from that area. The head is remarkable as a double image in which the eyes extend into the hands of a figure painted on the forehead. The hands grasp a flute, which is also the nose.

The figure was undoubtedly not an independent sculpture but carved into a huge post in one of Kambot's ceremonial houses. It represents either Mobul or Goyen, two mythical brothers who created plants and animals, and whose spirits lived, from time to time, in the posts. First seen and photographed in the 1950s, it was then already detached from the rotted remainder of the post.

8 Figure
Papua New Guinea, East Sepik Province, Keram
River (Kambot)
Wood, paint; H. 96 in. (243.8 cm.)
The Michael C. Rockefeller Memorial Collection,
Gift of Nelson A. Rockefeller, 1969 (1978.412.823)

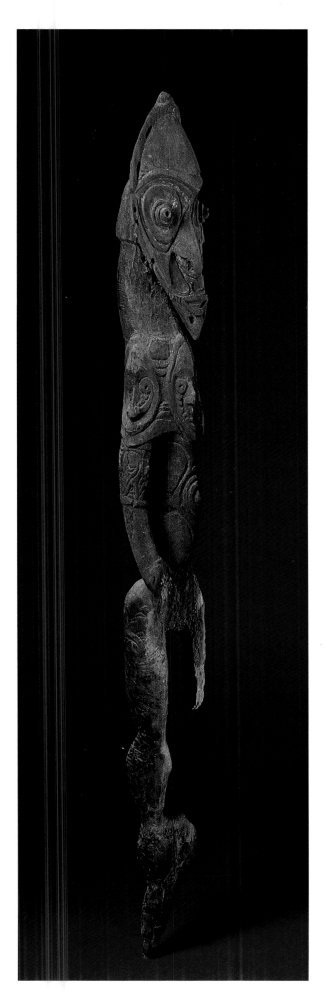

9 *Figure*
Papua New Guinea, East Sepik Province,
Moim (Angoram); late 19th–20th c.
Wood, metal staples, nails, paint; H. 68 in.
(172.7 cm.)
The Michael C. Rockefeller Memorial Collection,
Purchase, Nelson A. Rockefeller Gift, 1964
(1978.412.840)

ANGORAM FIGURE

Large-scale figure sculpture in wood is common in the Sepik River area of Papua New Guinea; as a rule, the carvings represent male ancestral mythical characters. This one was found at Moim, a village of the Angoram people on the lower course of the Sepik, and dates from before World War I, when the whole of northeast New Guinea was a German colony. According to local informants, the authorities conducted a punitive raid on the village during the flood season, and ignited the house in which the figure was kept. The figure saved itself by jumping (or falling) into the water below. Hence its partially burned condition.

Several large figures from this area are named for either of two mythical heroes, Urungenam and Bilishoi. The presence of small masks (originally three of them) on the chest and shoulders of the figure suggests that this is an image of Urungenam or hero of some very similar legend: Urungenam and his three brothers, says the story, wandered away from their home village until they came to a place where there was a stand of bamboos. Urungenam cut some of them to make flutes, which he and his brothers played all night. In the morning a man from a nearby village came to investigate and found the hero lying down in the form of a slit-gong, with his brothers sitting on it. In this way, men learned from Urungenam the secrets of the sacred musical instruments.

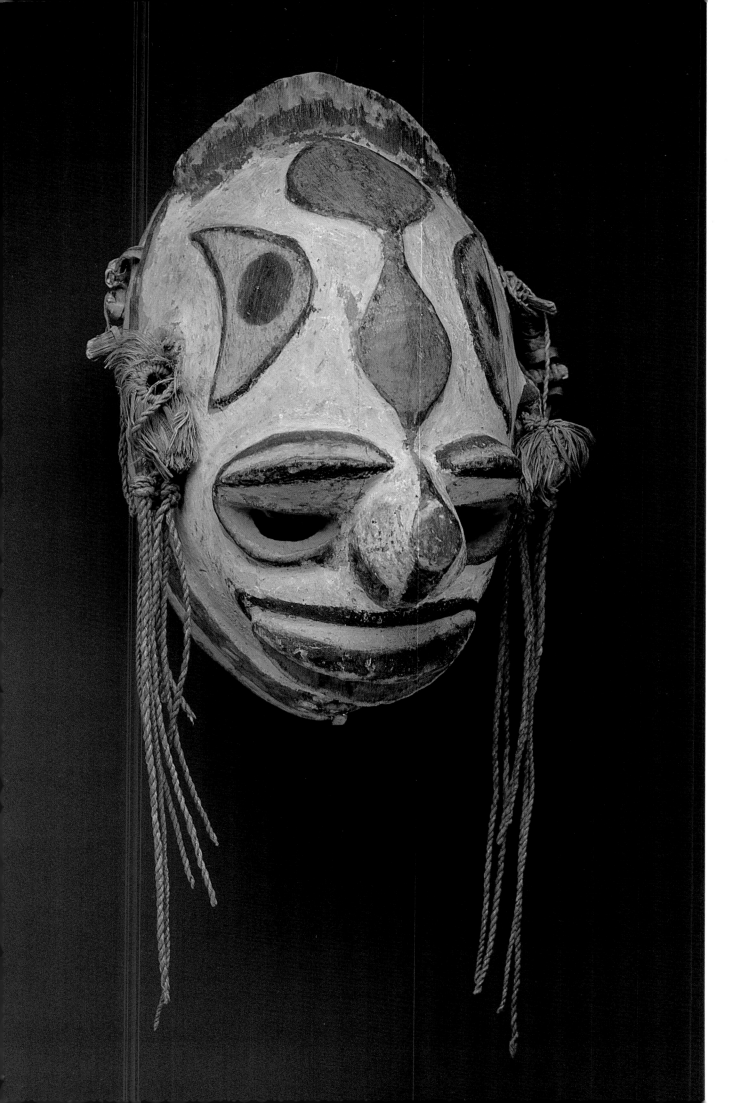

KAMBOT MASK

The Kambot people made a highly distinctive type of mask, with a bulging form that may be based on the general shape of a coconut shell. Actual shells, painted and engraved, were sometimes used as small masks. The protruding lips and rounded nose are also characteristic of this type. Large masks were worn over the face, with crowns of feathers and fiber capes; smaller ones were incorporated into bark paintings as the heads of painted figures.

10 Mask
Papua New Guinea, East Sepik Province, Keram River
(Kambot); late 19th–20th c.
Wood, pigment, cord; H. 12⅛ in. (30.8 cm.)
The Michael C. Rockefeller Memorial Collection,
Bequest of Nelson A. Rockefeller, 1979 (1979.206.1634)

IATMUL MASK

The middle reaches of the Sepik River in northeast Papua New Guinea are inhabited by the Iatmul, a group of about nine thousand people whose culture was once the most elaborate in the island. Their complex religion included ancestor cults and cults of water spirits and other natural phenomena. Almost every occasion was turned into a ceremony, some—including male initiations—lasted for months.

The Iatmul world was largely based on duality: groupings of pairs of phenomena that were in one sense unified and in another opposed: male-female, earth-sky, older-younger, good-bad, life-death, and so forth. Society was divided into pairs of clans grouped again into ever-larger units. Nothing was without its counterpart; hence the masked beings of the Iatmul did not exist as single beings but in pairs, or pairs of pairs, representing ancestral brothers and sisters.

The *mai* masks of the Iatmul are among the best known of New Guinea. They exist in several variations, ours being typical of the Nyaura, or western, group of the tribe. They show human faces with elongated noses, which recall that the long noses of the primal ancestors prevented them from speaking until they became detached. At the tip of the nose there is usually a miniature bird or animal figure that recalls one transformation or another that took place during the ancestor's career. The painting of the faces follows designs appropriate to the ancestors of the clans; this one may show Kavambuangga, who visited the afterworld, and thus, one side of his face is black (death) and the other red (life). The masks were not worn over the face but were attached to large basketry cones, carried on the shoulders, with fiber fringes around the cone that partly concealed the wearer's legs. The cone was embellished with a mass of ornaments: shells, feathers, flowers, and brightly colored leaves.

11 Mask (mai)
Papua New Guinea, East Sepik Province (Iatmul);
late 19th–20th c.
Wood, paint, shell, reed; H. 28⅛ in. (71.4 cm.)
The Michael C. Rockefeller Memorial Collection,
Bequest of Nelson A. Rockefeller, 1979 (1979.206.1480)

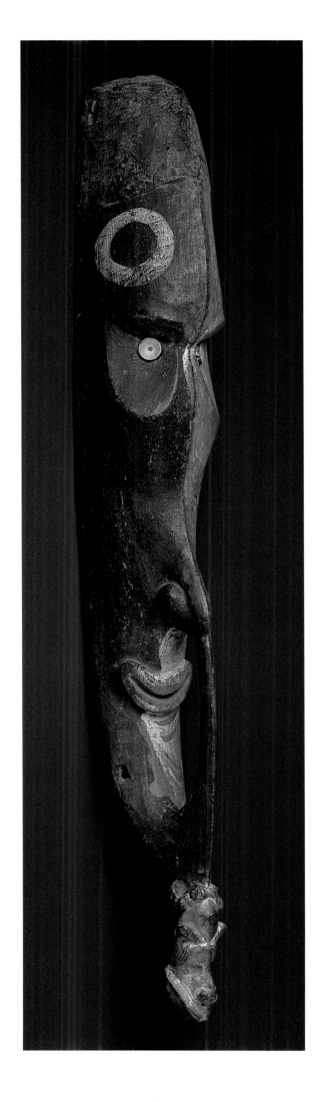

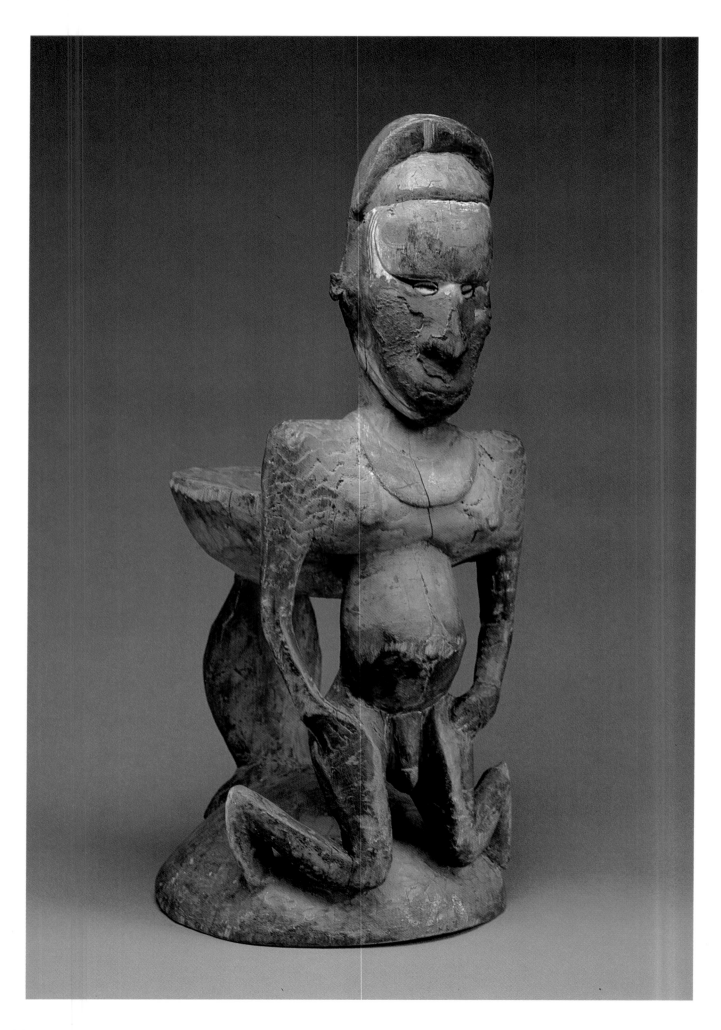

IATMUL DEBATING STOOL

All Iatmul ceremonial houses contained one or more objects like this stool. During the frequent ceremonial debates the speakers struck the tablelike projection behind the figure with bundles of leaves or palm-leaf stalks to mark their points. These debates mainly concerned the rights of the clans to sacred (and often secret) mythological names. Although called "stools" (*teket*), these objects were never used as such; each was, rather, an ancestral image amalgamated with a stool, which, along with weapons and other daily objects, was considered its personal property.

In this figure the deep engraving (representing scarification) on the heavy pectorals and the undercut brows and the cross-ridge (perhaps a feather ornament) on the head are especially characteristic of western Iatmul figure carving.

12 Debating Stool
Papua New Guinea, East Sepik Province (Iatmul);
19th–20th c.
Wood, paint, shell; H. 31 in. (78.7 cm.)
The Michael C. Rockefeller Memorial Collection,
Purchase, Nelson A. Rockefeller Gift, 1963
(1978.412.825)

IATMUL CEREMONIAL FENCE ELEMENT

The Iatmul were vigorous artists and builders. Their most impressive architectural achievements were the ceremonial houses (*nggaigo*), the centers of the men's lives. These were large, gabled structures, splendidly decorated with carvings and paint. Each village had two or three, set in the middle of an extensive dance ground. At either end of the house was an artificial mound (*wak*), planted with totemic trees and shrubs, on which bodies of enemy headhunting victims were laid out. The mounds were sometimes enclosed by fences, which included large carved heads of ancestral spirits.

13 Ceremonial Fence Element
Papua New Guinea, East Sepik Province (Iatmul);
19th–20th c.
Wood, paint, shell; H. 60½ in. (153.7 cm.)
The Michael C. Rockefeller Memorial Collection,
Gift of Nelson A. Rockefeller, 1969 (1978.412.716)

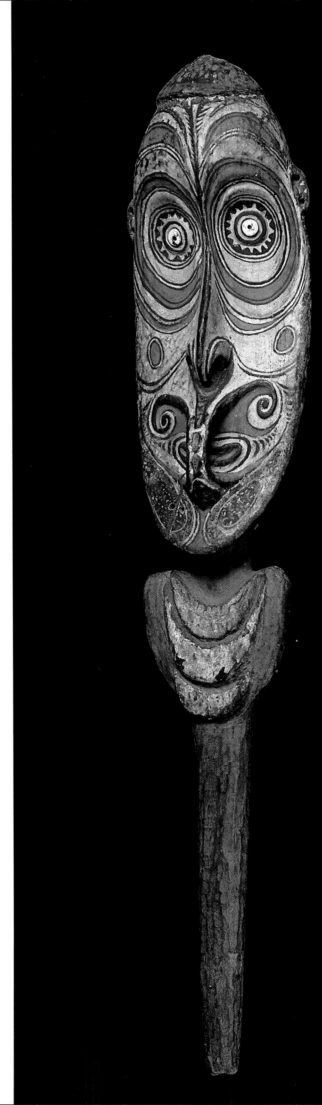

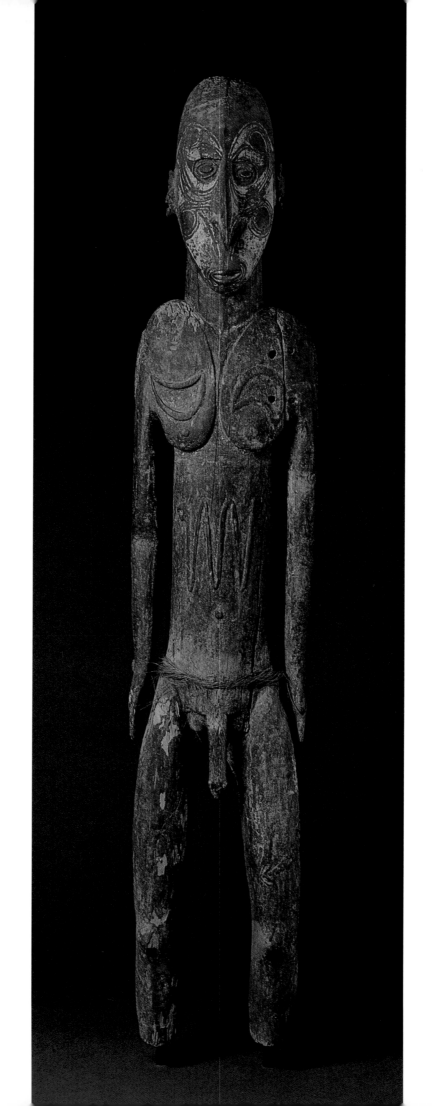

WESTERN SAWOS FIGURE

The Sawos people lived in the bush and swamp areas north of the Sepik River and are generally acknowledged to be the group from which the Iatmul broke away to settle on the river itself. The art styles of the two groups are almost identical.

Among the most impressive Sawos works are a small number of over-life-size figures like the one pictured here. Originally kept in the ceremonial houses, they are images of mythological heroes who were celebrated as great men. The relief designs on the body show the extensive scarification inflicted during initiation. It is likely that the feet, before they deteriorated, stood on a relatively small hook form on which offerings were placed. The figure, or rather the hero, would have been addressed with appeals for aid in war and hunting.

EASTERN SAWOS MASK

In contrast to the rich tradition of sculpture and painting practiced among the western Sawos, the eastern Sawos produced mainly fine engraved and painted pottery bowls that were widely traded through the river area. Their few extant carvings are small, naturalistic masks in black-painted wood, which are said not to have been made for over a century.

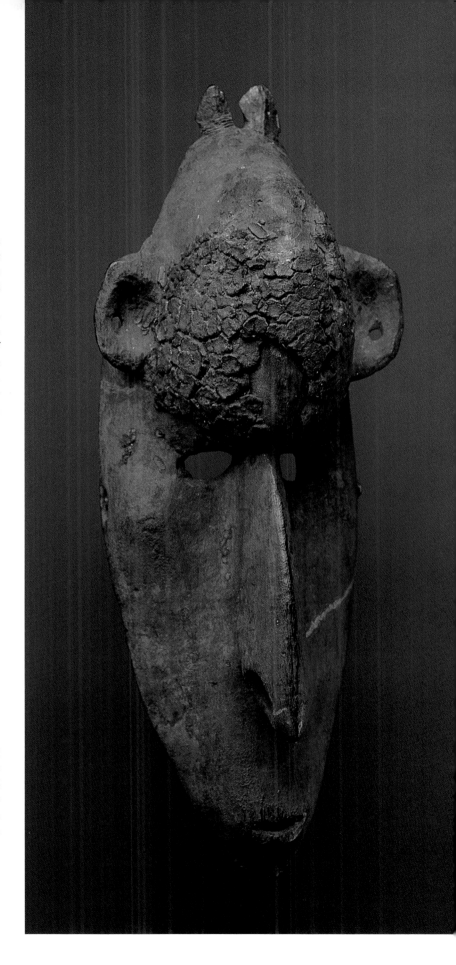

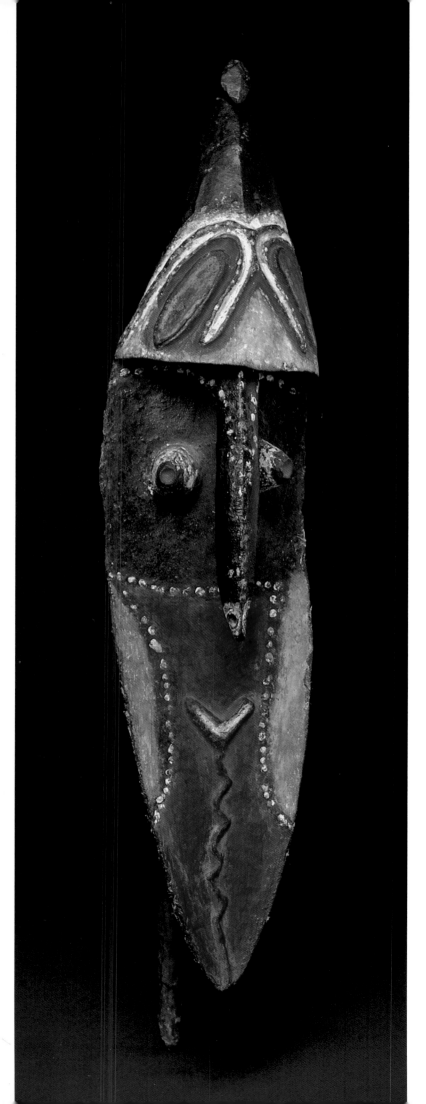

16 Head (yena)
Papua New Guinea, East Sepik Province (Yessan-Mayo);
19th–20th c.
Wood, paint; H. 48 in. (121.9 cm.)
The Michael C. Rockefeller Memorial Collection, Purchase,
Mr. and Mrs. Wallace K. Harrison Gift, 1974 (1978.412.1699)

YESSAN-MAYO HEAD

In the upper Sepik River area three small groups of people
—the Kwoma, Nukuma, and Yessan-Mayo—have developed
a culture with art styles and religion very different from
those of the middle Sepik Iatmul. However, though in a
variant form, they share with the Abelam of the mountains
to the northwest an important religious complex—a cult in-
volved with yam cultivation. Yams are not, as it happens, the
staple food, which, as in much of Papua New Guinea, is
sago. The declivities of the hilly terrain are well suited to
yam cultivation. The significance of the yam lies not in its
alimentary value but in its profound and highly complex
symbolic content.

A long myth, known in many parts of the East Sepik Prov-
ince, but that is particularly prevalent in the upper Sepik
area, links human heads, yams, and ancestors: It concerns the
adventures of a detached human head, which goes through
a number of transformations; in one, it becomes a yam.
Eventually, the head's brain is eaten by a cassowary, which
then gives birth to the first culture hero and, afterwards, to
the whole human race.

Carved heads of this type, known as *yena*, are made in
slightly differing styles by the Kwoma, Nukuma, and Yessan-
Mayo. Wrapped in shaggy cloaks made from the black
feathers of cassowaries, they are displayed at yam-harvest
ceremonies on altars that contain the yams. Although it
seems clear that the combination of the cassowary, the yam,
and the human head refer to the origin myth, there is no
formal interpretation of their arrangement on the altar, only
an awareness that the carvings are of ancient and powerful
spirits.

KWOMA HEAD

Among the Kwoma and Nukuma, pottery making was as
important an art as wood-carving and was equally at the
service of ritual life. Many types of vessels were made for
ceremonial occasions, often beautifully incised with elabo-
rate designs. Large, hollow pottery heads were incorporated
into several of the yam-harvest rituals, either supplement-
ing the wood carvings or as the main sacred objects.

17 Head
Papua New Guinea, East Sepik Province (Kwoma);
19th–20th c.
Clay, paint; H. 15½ in. (39.4 cm.)
The Michael C. Rockefeller Memorial Collection,
Gift of Nelson A. Rockefeller, 1969 (1978.412.859)

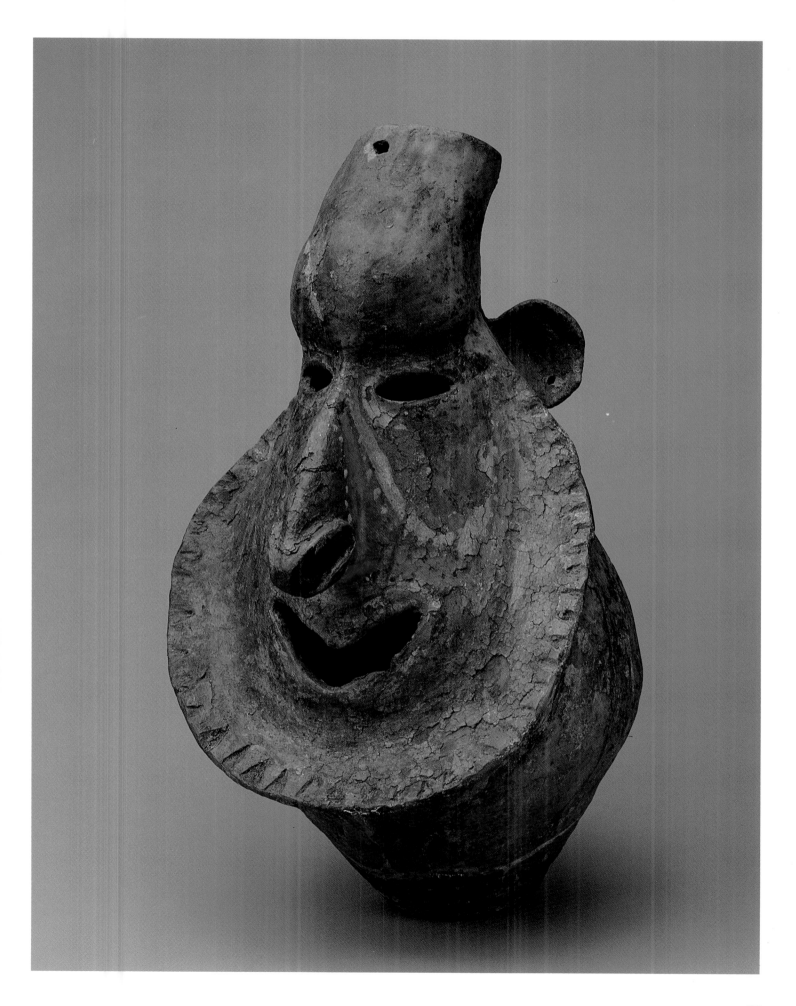

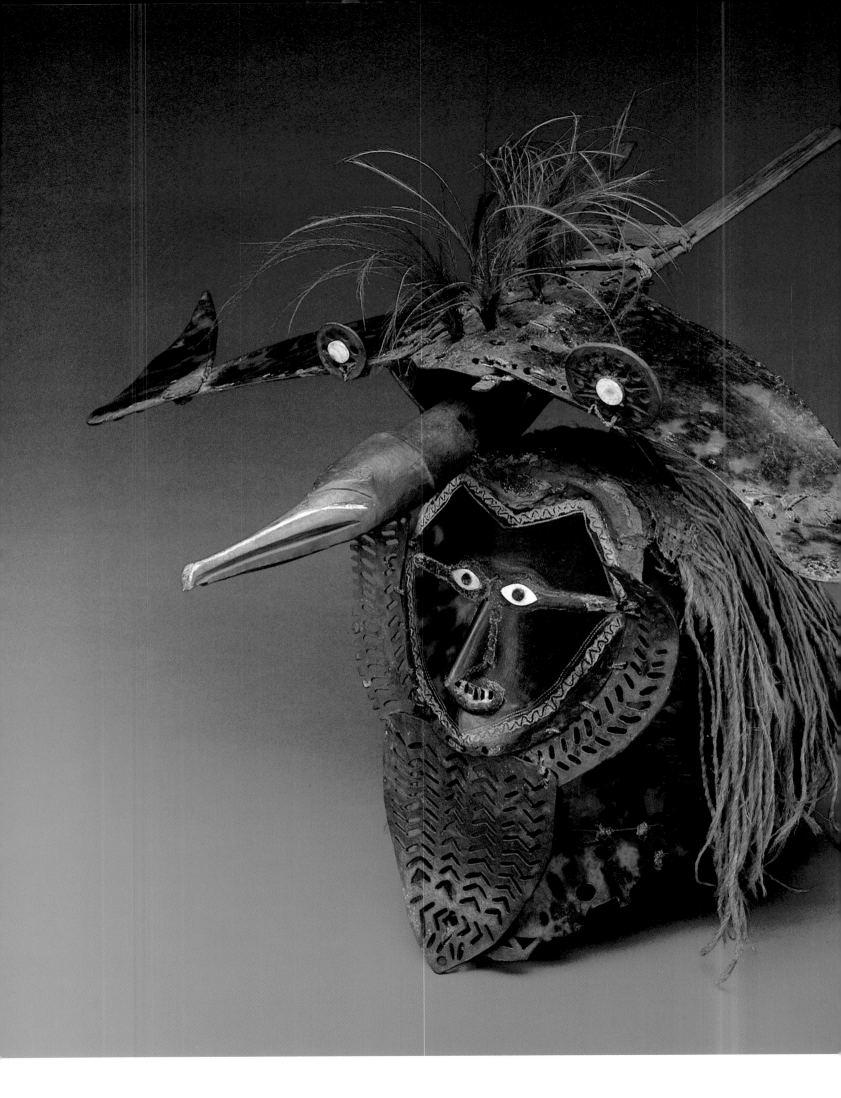

MASK FROM TORRES STRAIT

The islanders of the Torres Strait, between New Guinea and Australia, used plates of turtle shell to construct sculptures, a practice found nowhere else in the Pacific area. Turtle-shell effigies in these islands were first recorded in 1606 by the Spanish explorer Diego de Prado, testimony to the antiquity of the tradition. Some masks are in human form, others represent fish or reptiles, while still others are a combination of attributes from all three. They were often incorporated into ceremonies relating to mythical ancestral heroes or in funerary ceremonies for the dead.

The culture of the islands was profoundly disrupted in the mid-nineteenth century through the presence of pearl-shell traders and missionaries. Consequently, in spite of intensive anthropological work at the end of the century, much traditional knowledge had already been lost. Only two masks of this type are extant.

18 Mask
Torres Strait, Mabuiag Island; 18th c.
Turtle shell, clamshell, wood, feathers, sennit,
resin, paint, fiber; H. 17½ in. (44.5 cm.)
The Michael C. Rockefeller Memorial Collection,
Purchase, Nelson A. Rockefeller Gift, 1967
(1978.412.1510)

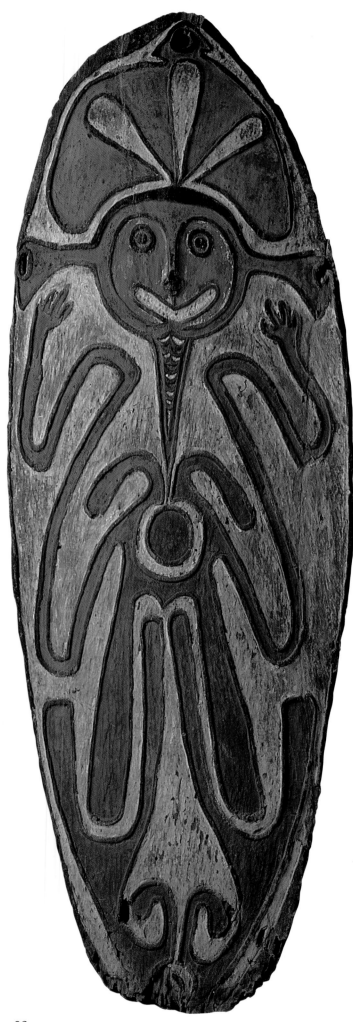

19 Board (gope)
Papua New Guinea, Gulf Province, Wapo Creek
(Gope); 19th–20th c.
Wood, paint; H. 51 in. (130.8 cm.)
The Michael C. Rockefeller Memorial Collection,
Gift of Nelson A. Rockefeller, 1969 (1978.412.794)

GOPE BOARD

Around the western and central shores of the Gulf of Papua, part of Papua New Guinea's south coast, there live a number of tribal groups whose cultures differ in many aspects although they all use certain basic types of objects in their art. One of the most common is a flat, more or less oval board, worked in shallow relief on one surface. With few exceptions, the carvings depict full-length human forms with emphasized faces. All the cultures produced them in considerable numbers; they were kept in the men's ceremonial houses in proximity to ancestral skulls and trophies of war and the hunt. Whether they represented individual ancestors or spirits is uncertain. They were quite definitely regarded as protective of their owners and malevolent toward their owners' enemies: Hence, in this unusually flowing and rhythmic design, the gesture of the arms conventionally expresses both intentions. The small, heart-shaped face is characteristic of the Wapo area style.

IWAINO FIGURE

Most of the figures carved in the Gulf of Papua were, like the more common boards, flat and carved in low relief. The significance of this figure is not known. Like others of the type, it may have been fitted with movable basketry arms.

20 Figure
Papua New Guinea, Gulf Province, Urama Island,
Havasea village (Iwaino); 19th–20th c.
Wood, paint; H. 45⅜ in. (115.3 cm.)
The Michael C. Rockefeller Memorial Collection,
Bequest of Nelson A. Rockefeller, 1979
(1979.206.1663)

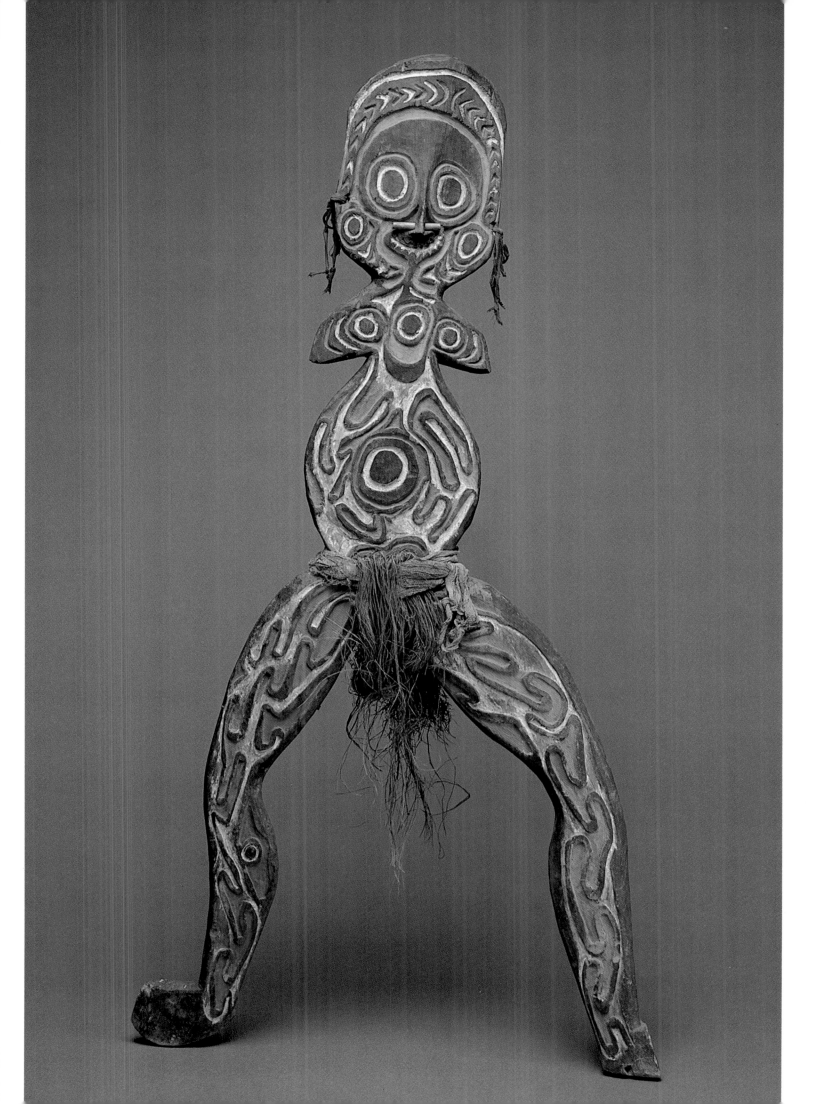

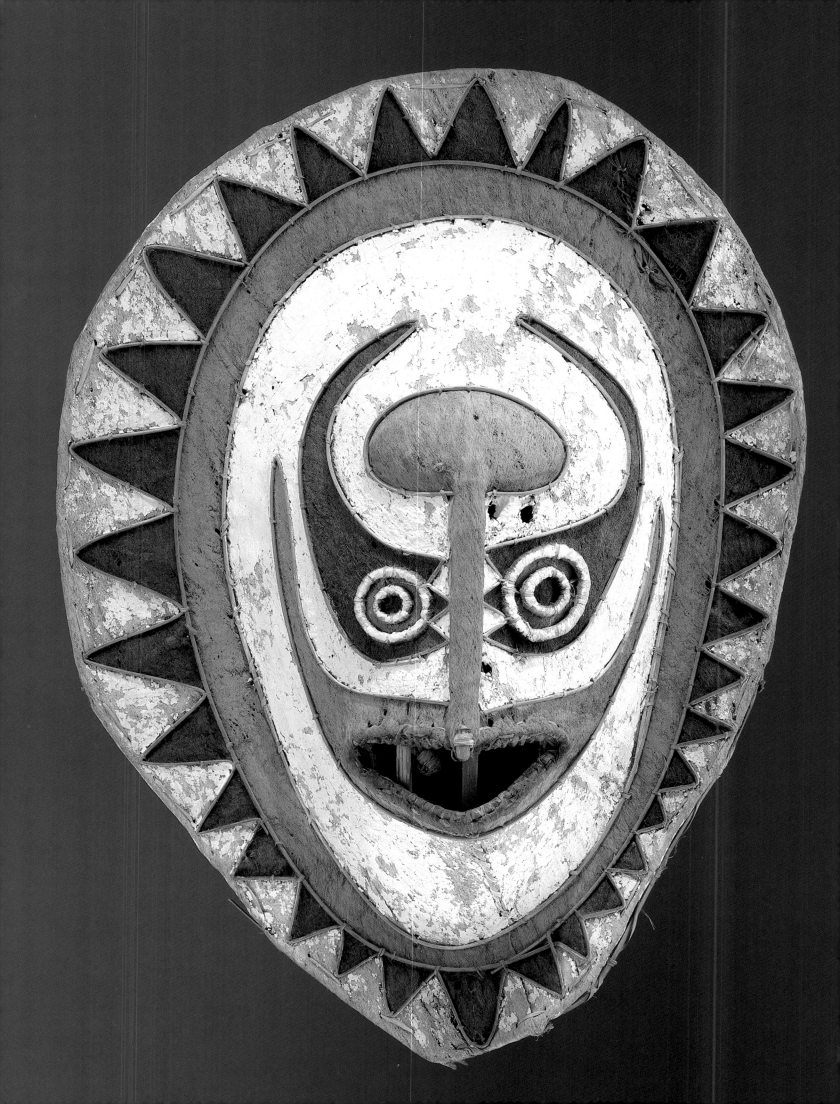

ELEMA MASK

The Elema people live in about twelve separate communities with a common culture, having migrated to their present homes on the eastern shore from the foothills of the central mountains. They are famous for their great cycles of ceremonies, which took many years to complete. The most important was a cult of sea spirits, called Hevehe, for which they made colossal masks of barkcloth over cane frames, some spanned to twenty feet high. The celebration of the Kovave cult (of bush spirits) involved the initiation of young boys, who wore emblematic conical masks. Like the Hevehe masks, the Kovave masks paraded in public for weeks at a time before enthusiastic audiences. A third type of mask was called *eharo*, worn mainly by young men, who visited other villages for a festival preceding the Hevehe. The main masks represent totemic animals, but some, as this one perhaps, performed as clowns.

21 Mask (eharo)
Papua New Guinea, Gulf Province (Elema); 19th–20th c.
Bark cloth, cane, paint; H. 37¾ in. (95.9 cm.)
The Michael C. Rockefeller Memorial Collection,
Gift of Nelson A. Rockefeller, 1972 (1978.412.725)

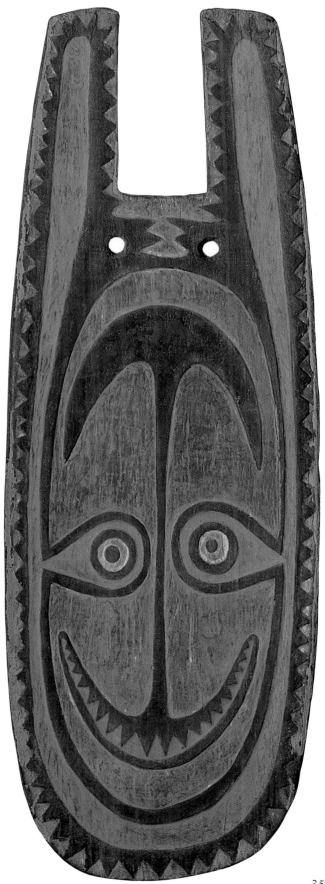

ELEMA SHIELD

The Elema people who live on the eastern shore of the Gulf of Papua are unusual for that area because they use shields in warfare—and the type of shield in itself is unusual. Most New Guinea shields were large planks designed to cover as much of the warrior's body as possible; the Elema shields are so small that they could not protect more than his left side. Moreover, instead of being carried by grips held in the left hand, as was usual, they were slung by a cane loop over the shoulder, leaving the arm exposed and free for the manipulation of bow and arrows.

The front of the shield is always carved in low relief and painted. In this case the symmetry of the design is particularly economical and also ingenious. The viewer sees a face topped with a black crescent of hair and with a crescent open mouth full of teeth. The bearer, looking down, also sees a face, this one with a crescent of feather hair ornament and a dark crescent mouth or nose.

22 Shield
Papua New Guinea, Gulf Province (Elema); 19th–20th c.
Wood, paint; H. 32 in. (81.3 cm.)
The Michael C. Rockefeller Memorial Collection, Purchase,
Nelson A. Rockefeller Gift, 1966 (1978.412.1490)

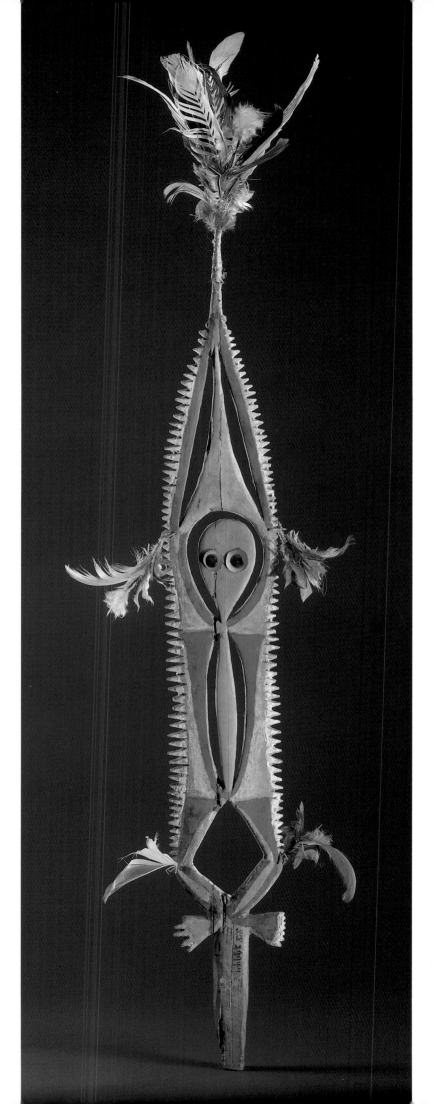

TOLAI DANCE STAFF

Dance staffs in light wood with long vertical openwork panels were carried in identical pairs by the Tolai in dances for the initiation of young men into the Iniet society, which practiced a cult of ancestors. The staffs were used as mock weapons in feigned attacks on the novices.

23 Dance Staff
New Britain (Tolai); 19th–20th c.
Wood, paint, feathers, shell, fiber; H. 37 in. (94 cm.)
Gift of Frieda and Milton F. Rosenthal, 1984 (1984.523)

24 Shield
New Britain (Sulka); 19th–20th c.
Wood, paint, cane; H. 50¼ in. (127.6 cm.)
The Michael C. Rockefeller Memorial Collection,
Bequest of Nelson A. Rockefeller, 1979
(1979.206.1555)

SULKA SHIELD

The large shields of the Sulka are engraved and painted with two extremely stylized faces, one at either end. This symmetrical arrangement is frequently found in other parts of New Britain and New Guinea. In typical Sulka style, the painting is vivid in color and contrast.

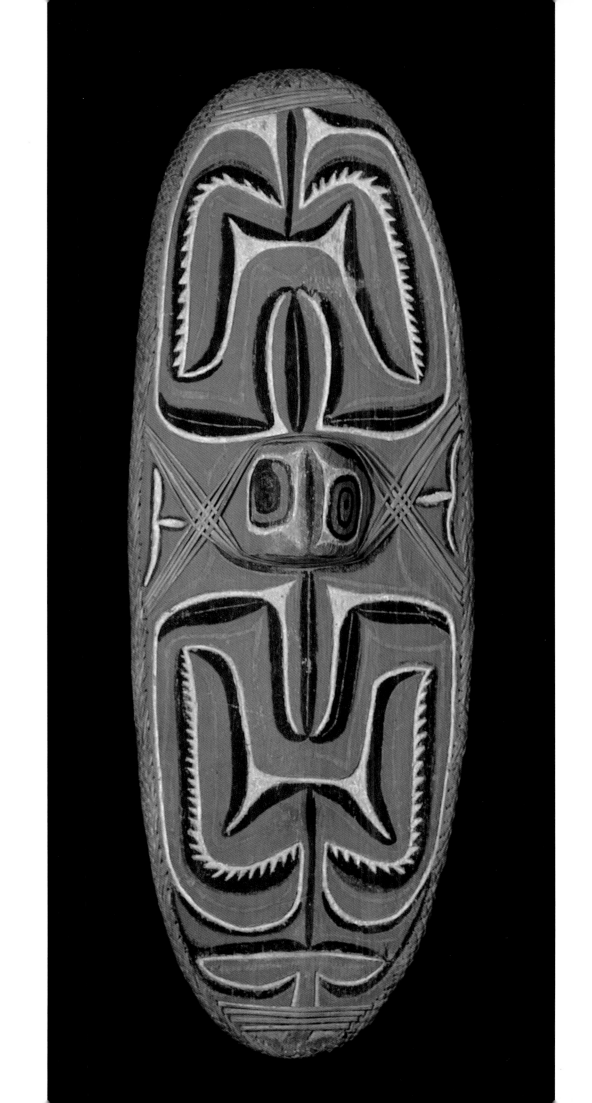

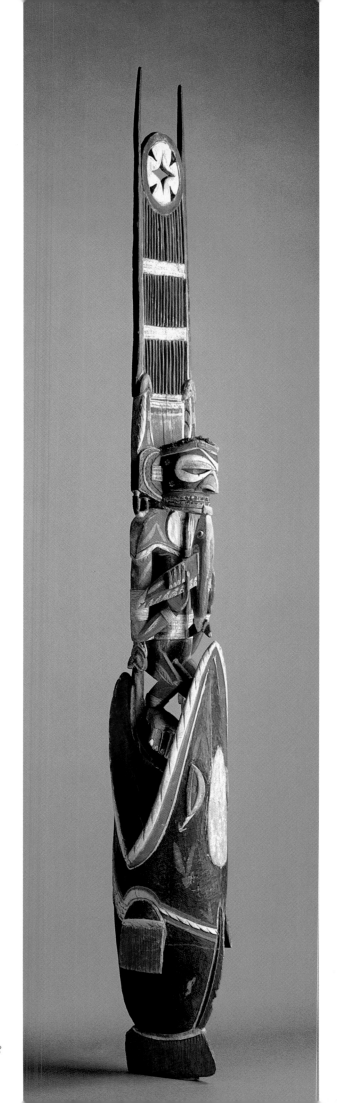

25 *Funerary Carving (malanggan)*
New Ireland, northwest area; 19th–20th c.
Wood, paint, opercula; H. 100½ in. (255.3 cm.)
The Michael C. Rockefeller Memorial Collection,
Gift of Nelson A. Rockefeller, 1972 (1978.412.712)
Opposite: detail

FUNERARY CARVING FROM NEW IRELAND

In northern New Ireland, *malanggan* is the collective name for a series of ceremonies and the masks and carvings associated with them. These rituals, still practiced today, though in modified and curtailed forms, were held primarily in memory of the dead and were combined with initiation ceremonies in which young men symbolically replaced in society those who had died. The carvings, the most complex in the whole range of Oceanic art, were commissioned from recognized experts and embody images from clan mythology. They were displayed in special enclosures, sometimes in considerable numbers, during feasts honoring both the dead and the donors of the carvings. Having served their purpose, they were usually abandoned or destroyed.

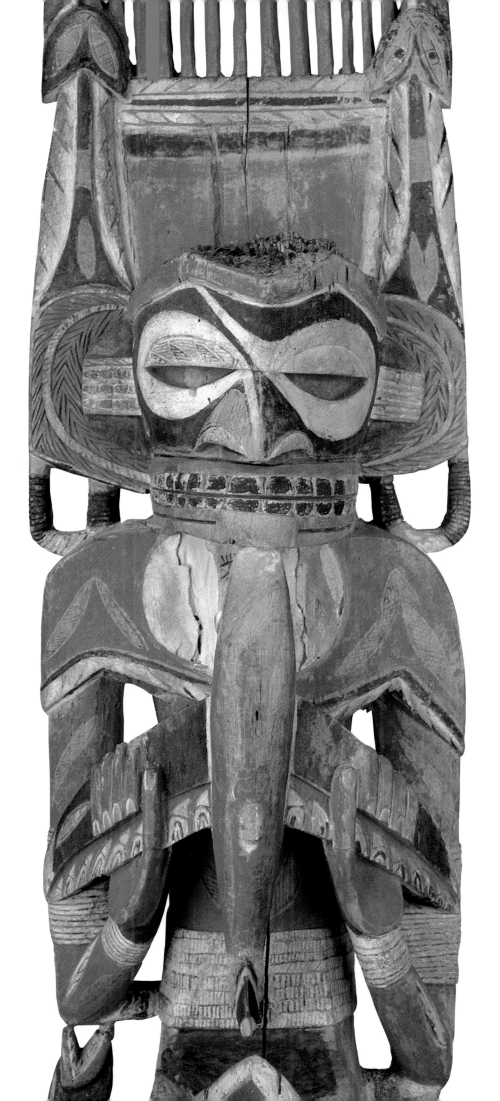

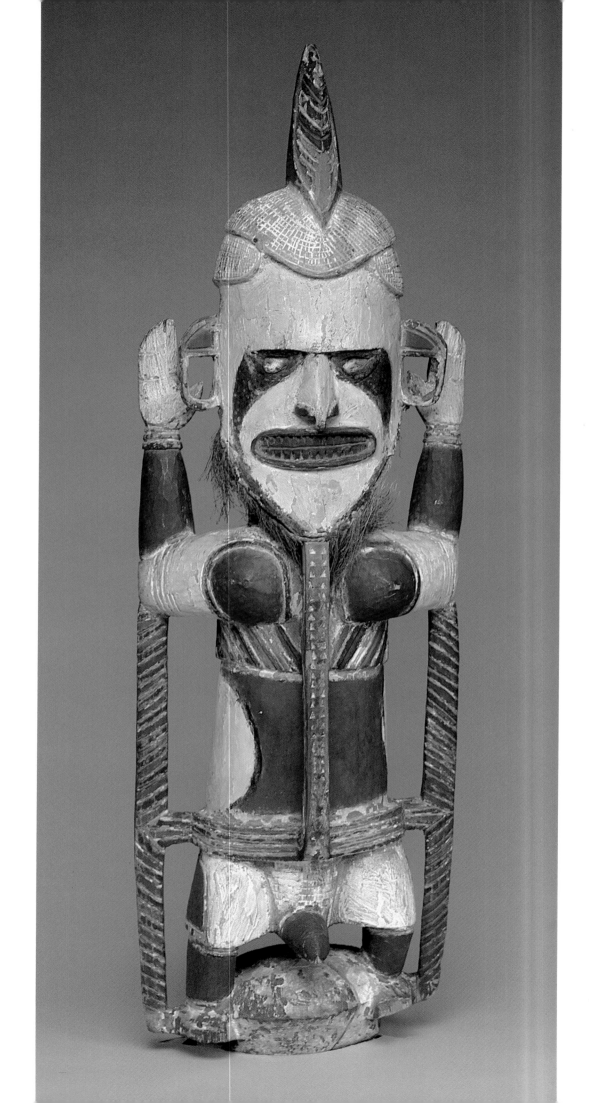

MANDAK-BARAK FIGURE

The central religious cult of the Mandak people, who live in the Lelet Plateau in central New Ireland, was concerned with the deaths of prominent men. In this they resembled the neighboring groups to the north and the south. The stylistic differences between the sculpture of the northern and central areas are, however, very marked. In the central area we find, instead of the rich elaboration of the *malanggan* style, the austere single figures known as *uli* or *euli*. They repeat the raised arms and enclosing bands of the *malanggan* but are massive and ponderous—blocklike rather than an elaborate interplay of interior spaces.

Uli were displayed during long cycles of ceremonies that accompanied the exhumation followed by reburial of great men's skulls. Feasting, including the consumption of dozens of pigs, was an important activity in these occasions. The *uli* are clearly hermaphroditic, a feature that seems to symbolize the powers of a chief to bring success in warfare (and the cannibalism that accompanied it), and the fertility of man, beast, and garden.

26 Figure
New Ireland, Lelet Plateau (Mandak-Barak);
19th–20th c.
Wood, paint, fiber, shell; H. 52 in. (132.1 cm.)
Gift of Sarah d'Harnoncourt, 1977 (1977.455)

27 Figure
New Ireland, southwest area (Kandas);
19th–20th c.
Chalk, paint; H. 26⅜ in. (67 cm.)
Gift of Evelyn A. J. Hall, 1981 (1981.331.5)

KANDAS FIGURE

In the southern part of New Ireland, small chalk figures play much the same role as the *uli* of the island's central area. They resemble *uli* stylistically in their stockiness, though they lack completely the drama and color of the wooden figures. Possibly they represented specific ancestors. Housed in small shrines in the bush, they were the central objects of a cult of the dead.

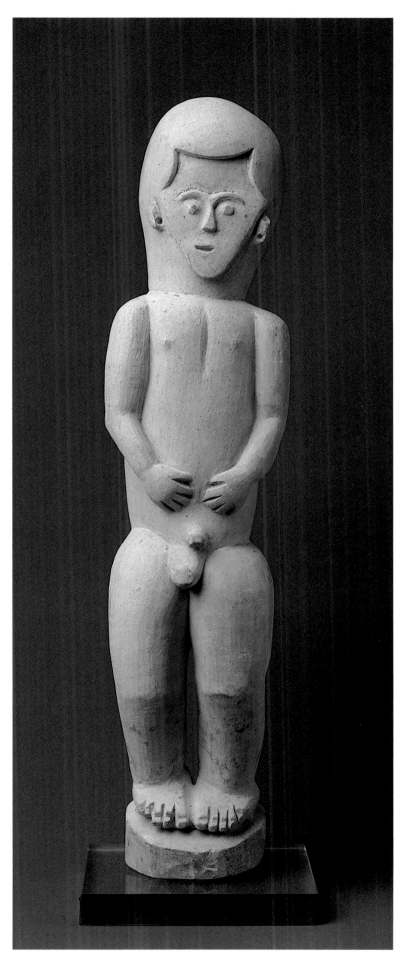

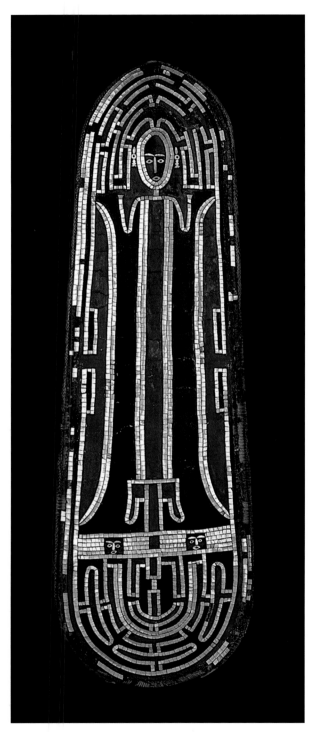

28 Shield
Solomon Islands, prob. Santa Isabel Island; 19th c.
Basketry, mother-of-pearl, paint; H. 33¼ in. (84.5 cm.)
The Michael C. Rockefeller Memorial Collection,
Gift of Nelson A. Rockefeller, 1972 (1978.412.730)

Opposite: detail

Shield from the Solomon Islands

The Solomon Islands form a double chain of seven large
and many small islands. In these islands, carvings were fre-
quently made for canoe decorations and architectural use.
Most carvings were painted black with touches of red; in-
lays of pearl shell were used instead of incised designs. The
standard war shields of the western Solomon Islands were
of wicker woven over cane strips, elliptical in shape. It seems
that they were manufactured on Guadalcanal and exported
to the other islands. The majority were plain or, at most,
had a few designs in black paint. A small number of shields
—perhaps under two dozen—exist that are painted com-
pletely and encrusted with hundreds of tiny squares of lu-
minous nautilus shell, which form designs representing a
figure and several faces. All these decorated shields seem to
have been made in the 1840s–1850s. In view of their fragil-
ity, it seems unlikely that they were used in combat. A func-
tion as status symbols for men of high rank is more probable.

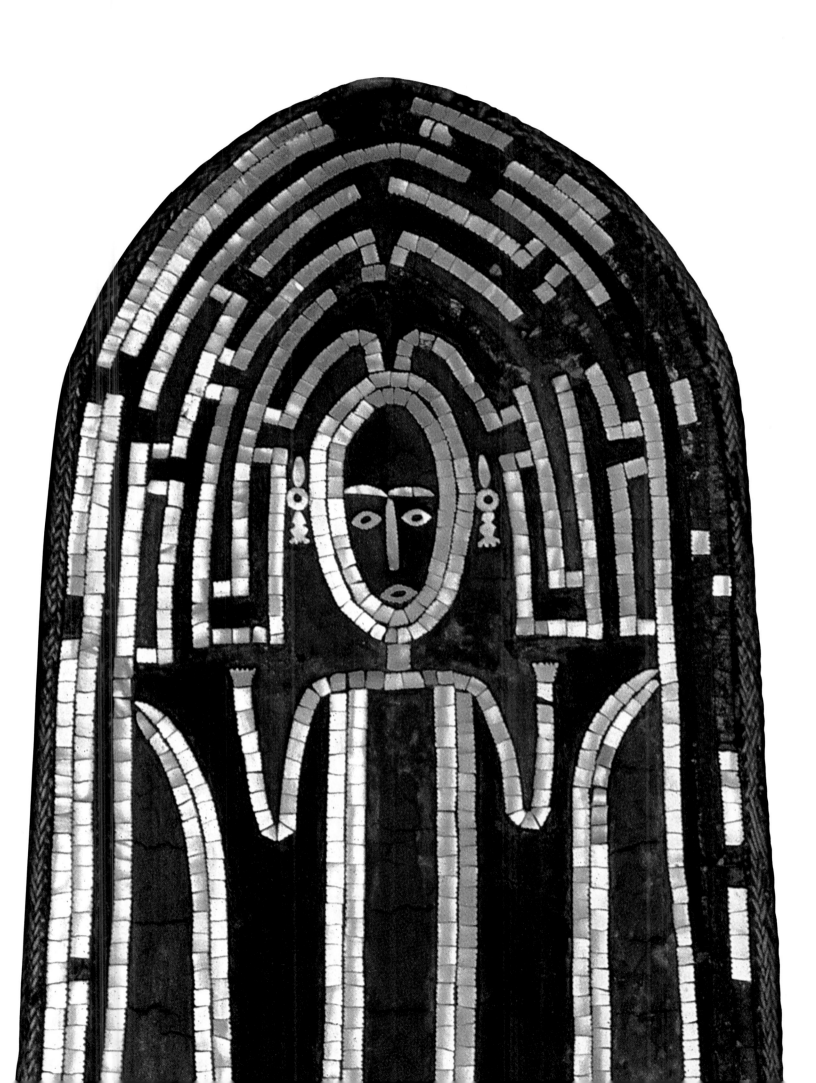

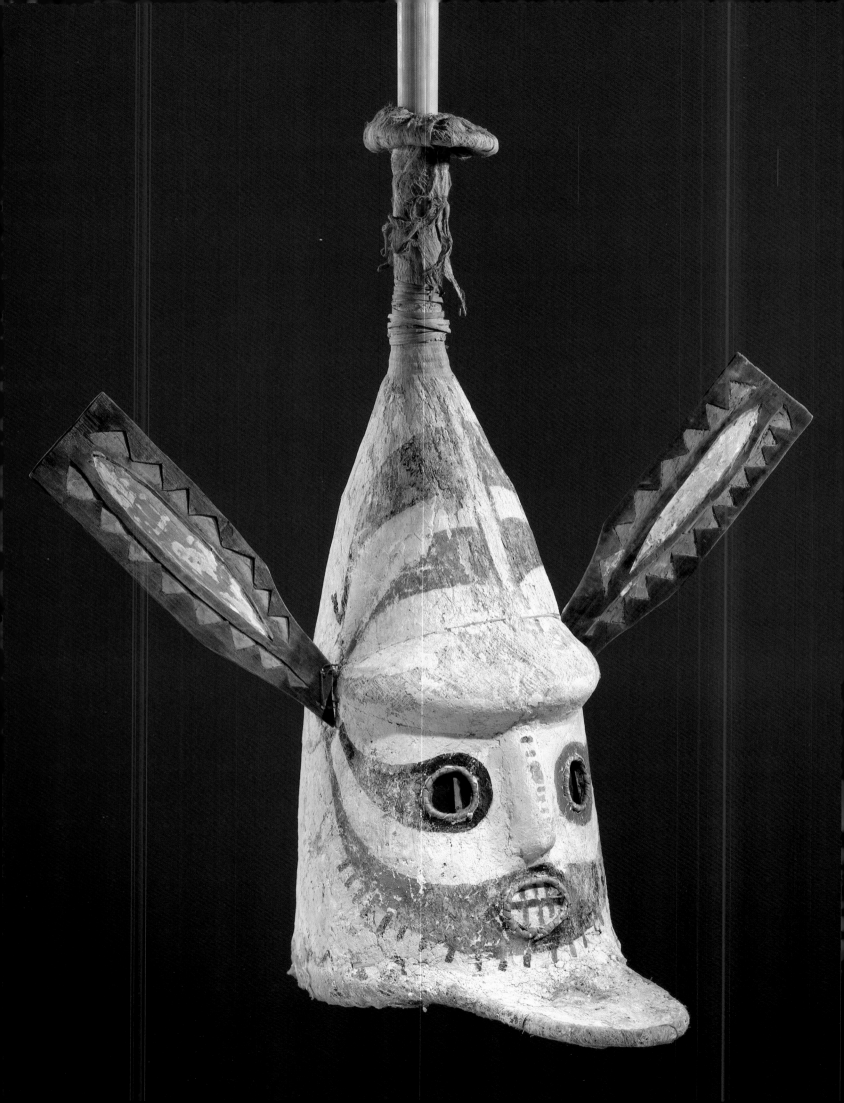

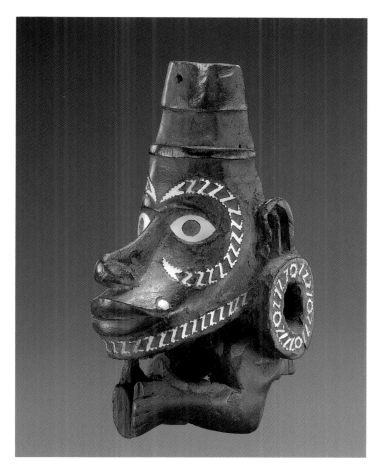

30 Canoe Prow Ornament (musu-musu or nguzu-nguzu)
Solomon Islands, New Georgia Islands; prob. late 19th c.
Wood, black paint, mother-of-pearl; H. 5⅜ in. (13.7 cm.)
Gift of Morris J. Pinto, 1976 (1976.351)

HELMET MASK FROM THE SOLOMON ISLANDS

Masks were rarely used in the Solomon Islands; they were only regularly made in Nissan, Buka, and Bougainville, the northernmost of the group. A few examples are made of wood. A conical type, made of painted barkcloth over a cane frame with wooden tab ears, uses generally the same materials and, to some extent, the same form as masks from northern New Britain.

CANOE PROW ORNAMENT FROM THE SOLOMON ISLANDS

The Solomon Islanders were well known down to the last years of the nineteenth century for their highly warlike propensities. Headhunting and slave-raiding expeditions were frequent; the raiders traveled in the famous *tomako*, huge plank-built war canoes capable of carrying dozens of men. The towering crescentic prows were decorated with mother-of-pearl inlay and strings of large cowrie shells.

Small carvings of human busts were fixed at the waterline, showing heads wearing typical men's ear ornaments and face paint. These *nguzu-nguzu* represented aggressive spirits who ensured smooth seas by warding off dangerous water spirits. Quite often they are shown holding severed heads in their outstretched hands, symbols of the raiders' intentions and hopes.

29 Helmet Mask
Solomon Islands, Bougainville; 19th–20th c.
Barkcloth, paint, wood, bamboo; H. 29¼ in. (74.3 cm.)
The Michael C. Rockefeller Memorial Collection,
Purchase, Nelson A. Rockefeller Gift, 1967 (1978.412.1518)

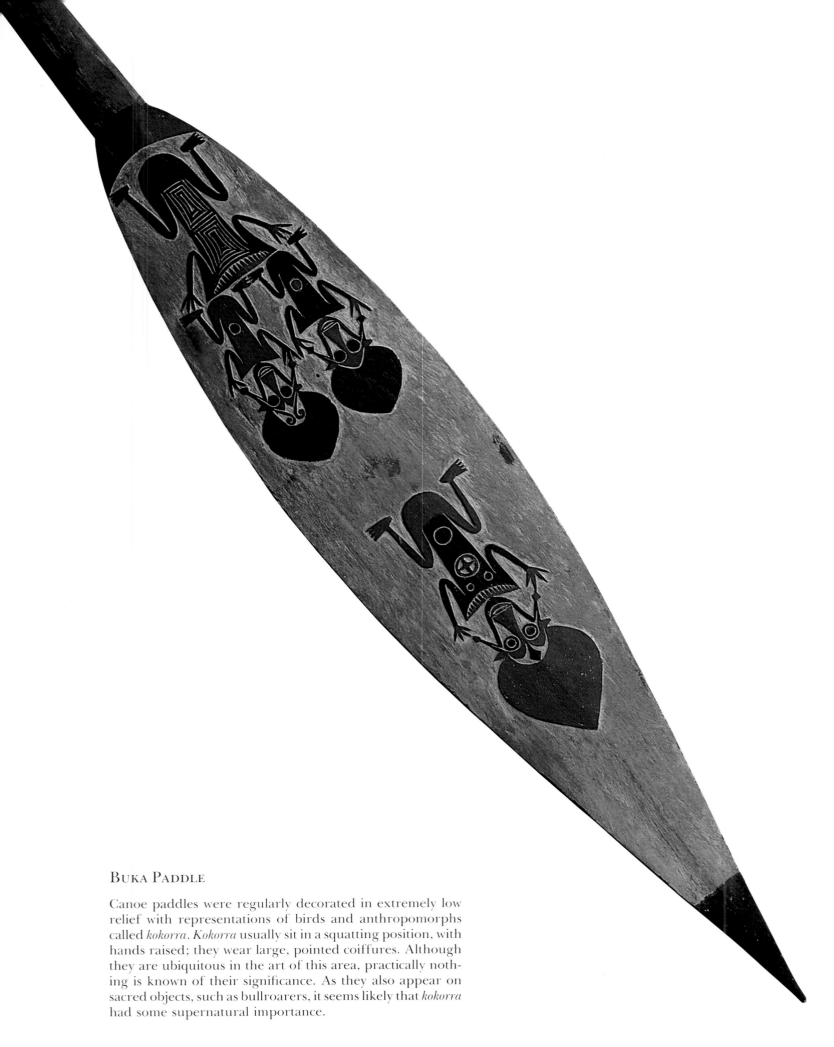

Buka Paddle

Canoe paddles were regularly decorated in extremely low relief with representations of birds and anthropomorphs called *kokorra*. *Kokorra* usually sit in a squatting position, with hands raised; they wear large, pointed coiffures. Although they are ubiquitous in the art of this area, practically nothing is known of their significance. As they also appear on sacred objects, such as bullroarers, it seems likely that *kokorra* had some supernatural importance.

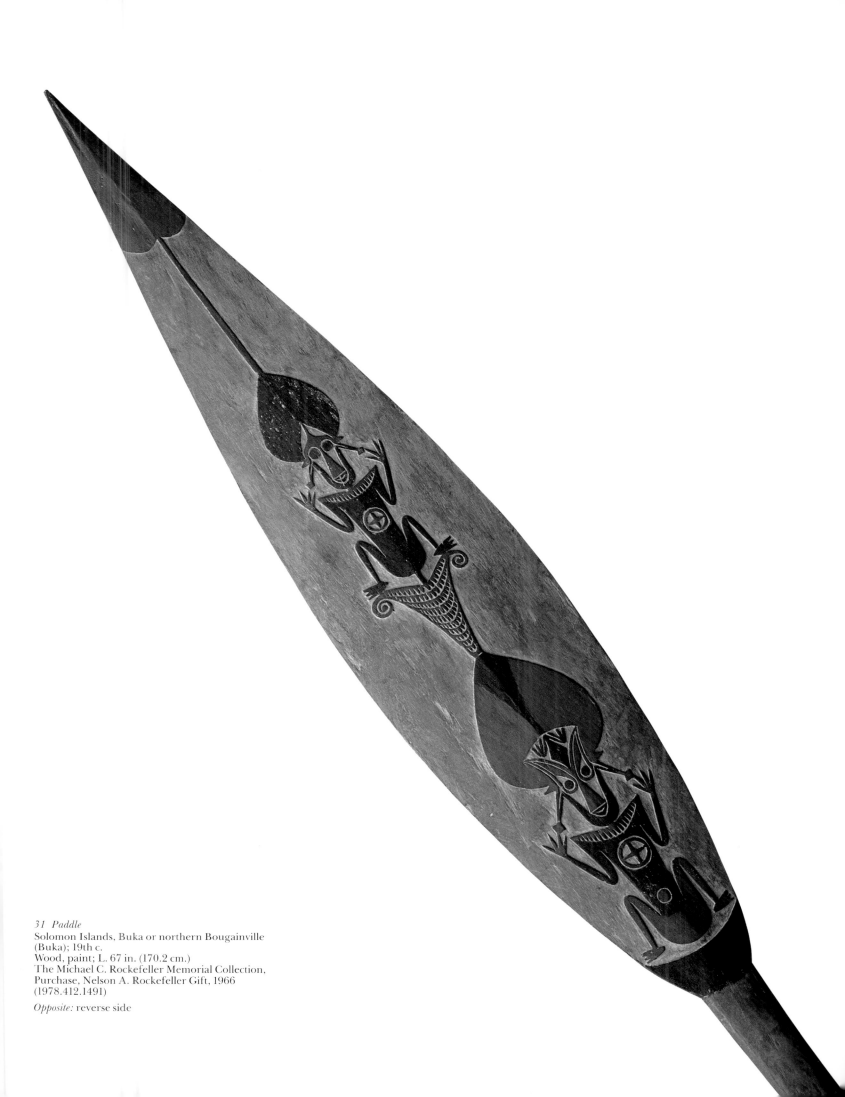

31 Paddle
Solomon Islands, Buka or northern Bougainville
(Buka); 19th c.
Wood, paint; L. 67 in. (170.2 cm.)
The Michael C. Rockefeller Memorial Collection,
Purchase, Nelson A. Rockefeller Gift, 1966
(1978.412.1491)

Opposite: reverse side

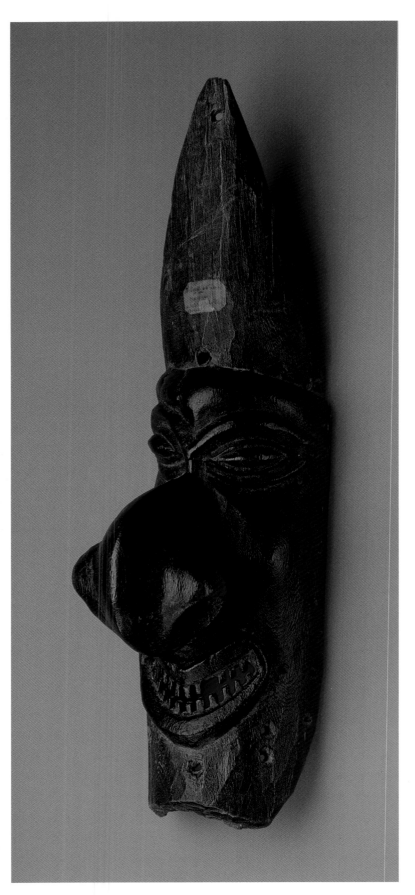

MASK FROM NEW CALEDONIA

The use of masks in New Caledonia was confined to the northern part of the long, narrow island. Several types are known, all representing the human face and mainly distinguished by their noses: either enormous curved proboscises or, as in this case, squat pyramidal forms. The other features are standardized: The eyes are simple beanlike relief shapes under arched eyebrows; the cheekbones protrude; the mouth is a crescent with an open grill of teeth, through which the wearer of the mask would have gazed.

In its complete form, the wooden mask carried a headdress consisting of a cylinder of fine basketry with a globe of human hair inserted into its open top. A beard of human hair was attached to the chin. A loose cloak, made of cords with attached bundles of black-brown pigeon feathers, hung to the wearer's knees. The somber image was completed by the club and spear borne by the wearer.

Early observers saw mask wearers as clownish participants in festivals, who marked time for the dancers with their weapons, or as war leaders or representations of water spirits. It seems likely that their main function was to ratify the legitimacy of living chiefs and reaffirm their powers to promote fertility and prosperity.

MBOTGOTE MASK

Throughout the New Hebrides there flourished a number of men's societies that were known by different names although their structure was essentially the same. These societies were composed of many grades through which members ascended to personal sanctity and greatness by means of initiation rites, festivals, and pig sacrifices. Nimangki and Nalawan were two of the grade societies of south Malekula and, as elsewhere, each involved the making of special figures and masks. This mask represents the mythical cannibal Nevinbumbaan, whose husband or son, Ambat Malondr, sits on her shoulders. Nevinbumbaan created the men's society Nimangki; her mask was worn at the various stages of the Nalawan cycle.

32 Mask
New Caledonia, northern area; mid-19th c.
Wood, paint; H. 20¾ in. (52.7 cm.)
The Michael C. Rockefeller Memorial Collection,
Purchase, Mary R. Morgan Gift, Bequest of
Nelson A. Rockefeller and Nelson A. Rockefeller
Gift, by exchange, 1983 (1983.17)

33 Mask
Vanuatu, New Hebrides, Malekula Island (Mbotgote);
19th–20th c.
Vegetable compost on armature of tree fern, straw,
paint, tusks, shells, glass beads; H. 26 in. (66 cm.)
The Michael C. Rockefeller Memorial Collection,
Bequest of Nelson A. Rockefeller, 1979 (1979.206.1697)

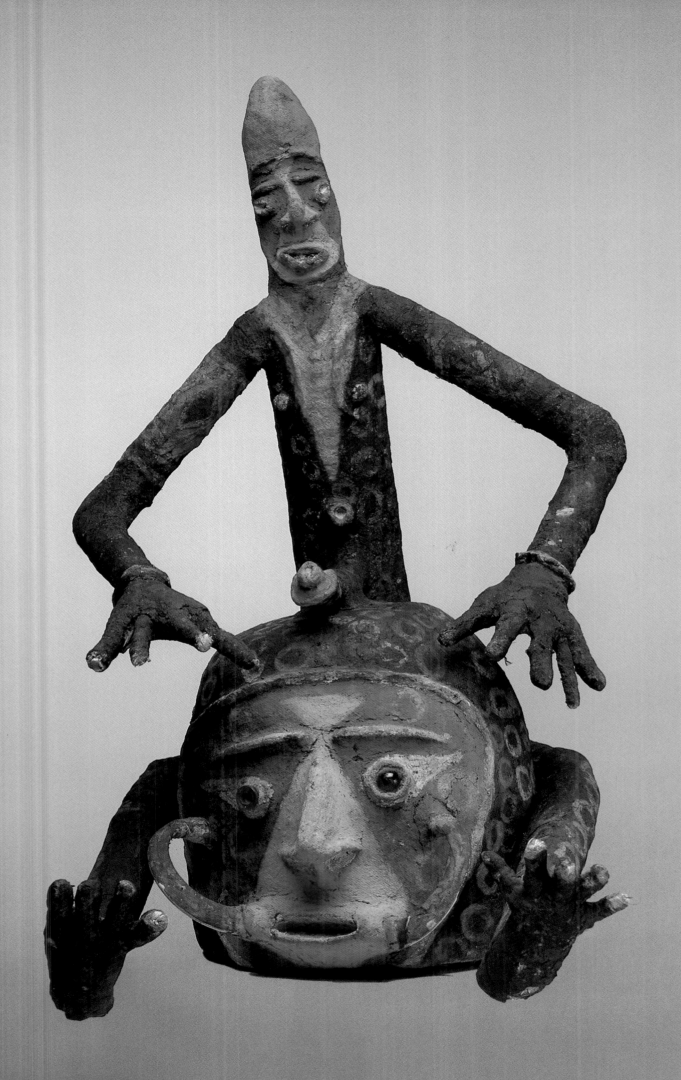

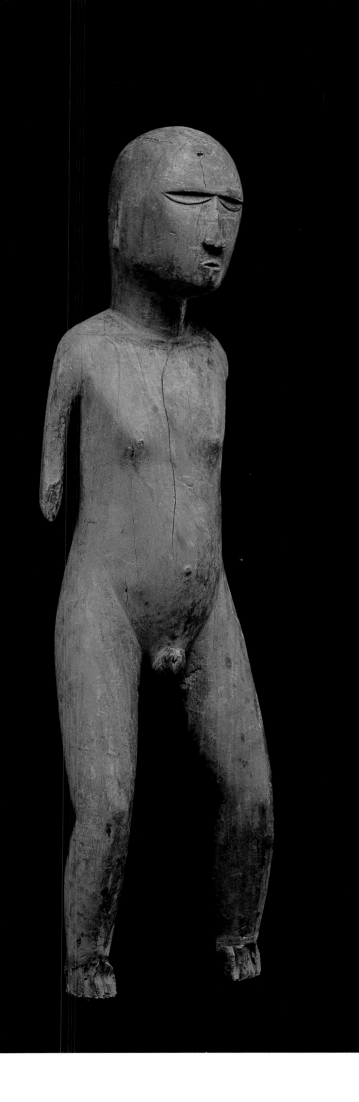

MALE FIGURE FROM THE GAMBIER ISLANDS

It is not known which of the numerous deities worshiped in the Gambier Islands is represented by this figure, but the god most often the subject of wood figures was Rogo, sixth son of Tagaroa and Huamea, the mythological first inhabitants of Mangareva, a small island where this figure was carved. Rogo was the god of peace, agriculture, and hospitality in all of Polynesia, and he revealed himself in the form of a rainbow and as fog. On Mangareva Island he was involved especially in rites connected with the cultivation of turmeric tubers. Most of the sculpture of Mangareva was burned in April 1836 at the instigation of missionaries. Only eight figures have survived, six of them naturalistic and two of them highly stylized.

34 Male Figure
Gambier Islands, Mangareva Island; 19th c.
Wood; H. 38¾ in. (98.4 cm.)
The Michael C. Rockefeller Memorial Collection,
Bequest of Nelson A. Rockefeller, 1979 (1979.206.1466)

MALE FIGURE FROM EASTER ISLAND

The loneliness of Easter Island in the eastern Pacific Ocean, with its astonishing array of huge stone figures, is one of the legends of the South Seas. The small wood sculptures from the island are as eccentric, in the context of Polynesian art, as the colossi. Some are extremely grotesque. Other sculptures include the well-known *moai kavakava*, skeletonic figures of male ancestors, and the flat female figures known as *moai pa'apa'a*. A third class of figures, *moai tangata*, is more naturalistic. Within this category is a group of outstandingly elegant figures that are among the rarest types of Easter Island works; fewer than ten exist in museum collections. These *moai tangata* represent stocky, paunchy males with somewhat oversized heads. They may represent human progenitors rather than supernatural ancestors—hence their smooth contours and rather juvenile proportions. At the same time, they have the small goatee beards worn by other *moai*, male and female. Their scalps, like those of *moai kavakava*, are decorated with shallow reliefs of marine creatures with bearded human faces. Some of the figures are pierced through the back of the neck and must have been worn ritually as pendants. These *moai tangata* are so close to each other in style as to suggest that they might be the work of a single carver. If so, when did he live? The information that might provide an answer is completely lacking; one can only presume that our figure was carved before Peruvian slave raids in 1862 and missionary activity in 1864 together destroyed the Easter Island culture.

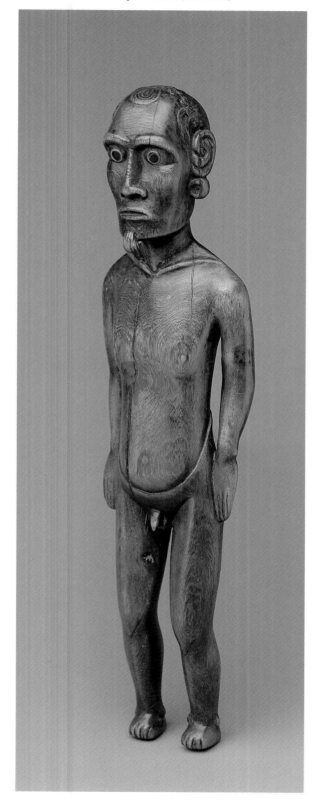

35 Male Figure (moai tangata)
Easter Island; early 19th c. (?)
Wood; H. 16 in. (40.6 cm.)
Gift of Faith-dorian and Martin Wright,
in honor of Livio Scamperle, 1984 (1984.526)

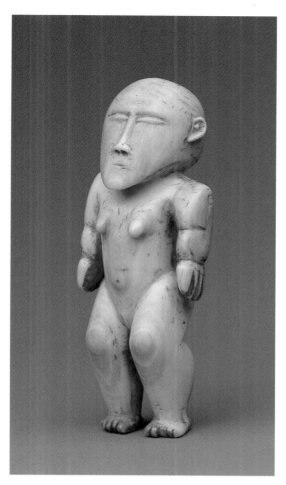

36 Figure
Tonga Islands, Ha'apai Group; 18th–19th c.
Walrus ivory; H. 5¼ in. (13.3 cm.)
The Michael C. Rockefeller Memorial Collection,
Bequest of Nelson A. Rockefeller, 1979 (1979.206.1470)

Tonga Figure

The majority of surviving Polynesian carving consists of elaborate utilitarian objects; figure sculpture—destroyed, in most areas, under early Western influence—is relatively rare. Small female figures were carved in ivory in the Tongan archipelago at least as early as the late eighteenth century, when a few were collected on one of Captain Cook's voyages. These are only an inch or two high. The relatively large size of this one would indicate that it was made at a somewhat later date when, owing to the visits of whalers, ivory became more available. A few were exported to the Fiji Islands where this example was found on Viti Levu by the Reverend Cyril G. Hawdon in 1868. The figures are usually bored so that they could be suspended, probably on necklaces. Sometimes called "goddesses," they are thought to represent female ancestors.

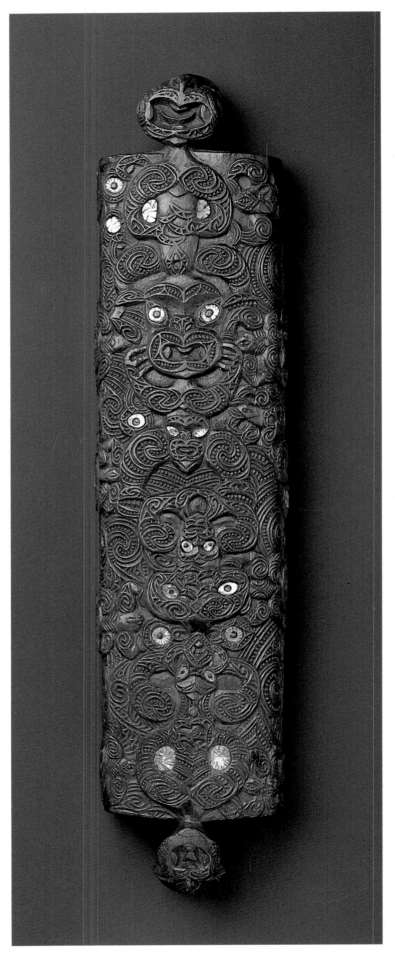
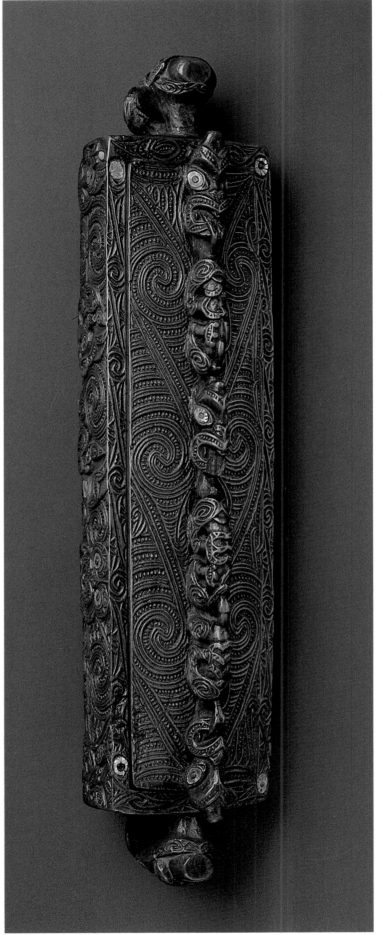

Maori Feather Box

The wooden boxes with fitted lids made by the Maori of New Zealand were always carved with elaborate designs —scrolls and figures of ancestors—covering the entire surface in splendid profusion. The ultimate reason for the decoration and detail of such boxes was the belief, which the Maori shared with many other Polynesians, that the head of a chief was sacred, holding a concentration of his *tapu* (power and sanctity). By extension, anything that touched a chief's head became imbued by this potentially dangerous force: particularly his hair, which had to be ritually buried when it was cut, and the feathers he wore in his hair. The most prized feathers were those of the now extinct *huia* bird; hence the name of this type of container (*waka*), in which the chief kept his feather ornaments. As much to keep their sacredness from endangering others as to keep the feathers, jade ear pendants, and so forth out of danger, the boxes were hung high in the rafters of the house. Since they were usually seen from below, the undersides of the boxes were carved as fully as were their lids and sides.

37 Feather Box (waka huia-papahou)
New Zealand, North Auckland area style (Maori);
prob. 18th c.
Wood; 17⅝ x 4⅛ x 3½ in. (44.8 x 10.5 x 8.9 cm.)
The Michael C. Rockefeller Memorial Collection,
Purchase, Nelson A. Rockefeller Gift, 1960
(1978.412.755 a,b)

Opposite: bottom and top views

Maori Weaver's Peg

Pre-European Maori clothing was simple, consisting of woven wraparound kilts for women and cloaks for both sexes. However, cloaks were made in a remarkable variety of types from the plainest to the treasured cloaks covered in feathers. The entire process of weaving was carried out by women. They extracted fiber from the leaves of flax plants by skillful cutting, scraping with a mussel shell, and washing. The fiber was then bundled into rolls and pounded with a stone beater to soften it. The process of weaving, or more properly, twining, began with the weaver's driving two pegs into the ground and stretching between them a string from which the strands of flax were hung. The left-hand peg was plain, the right-hand one was carved and dedicated to the moon goddess, Hine-te-iwaiwa. Weaving had some religious aspects: A woman could not practice the art before she had been ritually introduced to the goddess by a religious expert who received her first cloak in recompense.

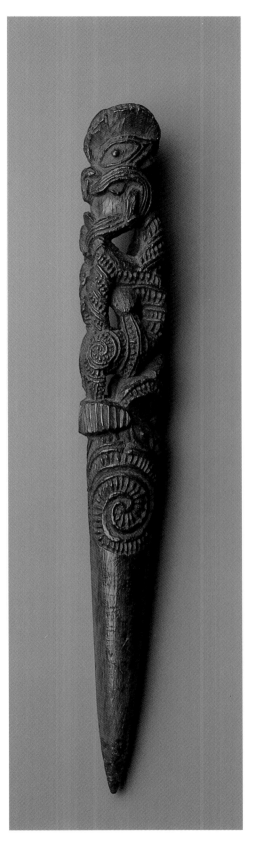

38 Weaver's Peg (turuturu whatu)
New Zealand, South Taranaki area style (Maori);
prob. 18th c.
Wood; 14⅝ x 1⅜ in. (37.1 x 4.1 cm.)
The Michael C. Rockefeller Memorial Collection,
Bequest of Nelson A. Rockefeller, 1979
(1979.206.1600)

Figure from the Caroline Islands

In the Palau archipelago of the Caroline Islands men were grouped according to age and status. Each group had a clubhouse in which the men spent much of their time, and the power and wealth of a village were reflected in the number of such structures. The clubhouses were impressive buildings, with high, pitched roofs and large gables. The interior beams and the horizontal planks screening the gables were incised and painted with a multitude of scenes that, in a manner unique in the Pacific Islands, formed illustrative series of successive legendary incidents, not unlike comic strips. Large figures of women, often attached to the gables above the entrances, also illustrated legends. This figure was inspired by a tale about a promiscuous girl called Dilukai, whose angry father tied her in the position shown here as a lesson in chastity to the women of the village. Ironically enough, the clubhouses were frequently the temporary homes of prostitutes who had been sent from other villages to gain wealth for their families.

39 *Figure*
Caroline Islands, Palau Islands; 19th–20th c.
Wood, paint; W. 38 in. (96.5 cm.)
The Michael C. Rockefeller Memorial Collection,
Gift of Nelson A. Rockefeller and Purchase,
Nelson A. Rockefeller Gift, 1970 (1978.412.1558a-d)

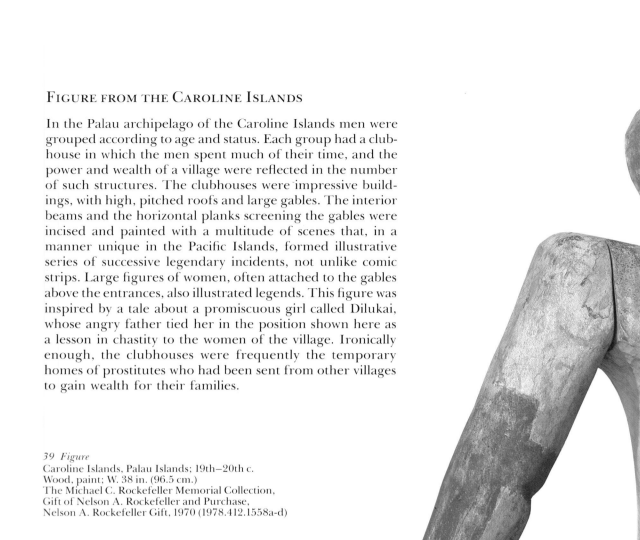

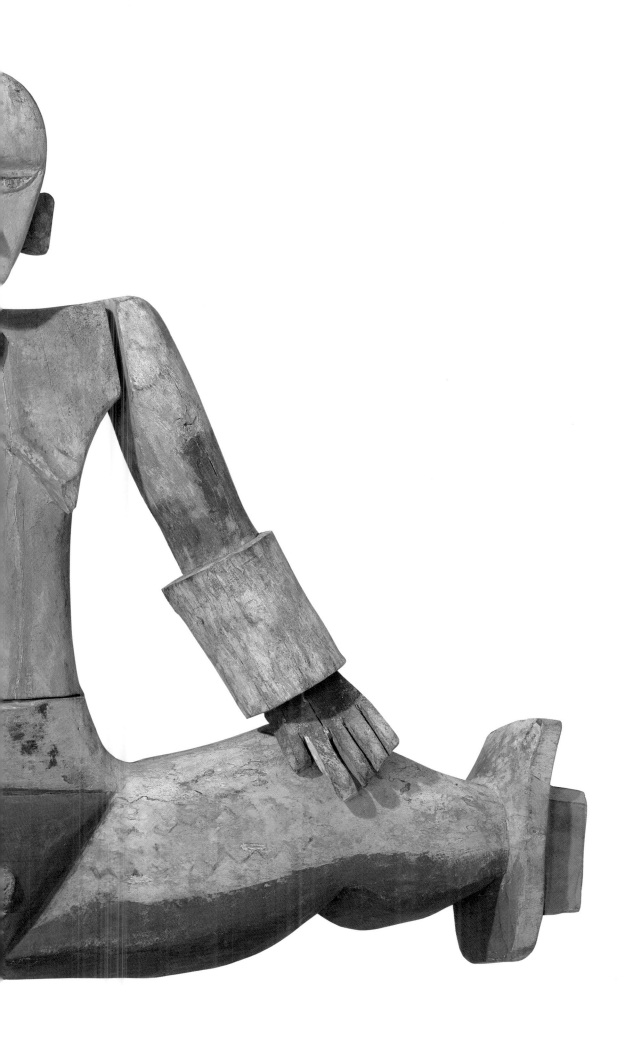

AFRICA

The art of Africa is as old and as complex as any in the world. More than a million and a half years ago, the first human beings to walk erect did so in eastern Africa, and in the half-million years that followed, the population spread to most parts of the continent. Modern humans began to appear about one hundred thousand years ago, and the crude stone tools of their predecessors were gradually replaced by the more refined and efficient examples of the New Stone Age. It is during this period that the first African art appears—rock paintings of people and animals made in Namibia twenty-eight thousand years ago. When about four thousand years ago the climate of Africa became drier, people south of the Sahara began to domesticate animals, cultivate food crops, and adopt a more settled lifestyle. Finally, by the middle of the first millennium B.C., sculptors in northern Nigeria modeled the terra-cotta figures that are the earliest preserved examples of sub-Saharan African sculpture known today.

Although the record of African sculpture begins with works of durable terra-cotta, most African sculpture is made of wood or other organic materials that rarely survive long in a tropical climate. For this reason, most extant African wood sculpture is believed to date only from the past century or two. Objects fashioned from more resistant mediums, such as metal, stone, and terra-cotta, are therefore especially valuable as records of earlier periods. Fortunately, recent archaeological work has revealed a great deal about African art, and modern scholars have also learned much from the writings of the traders, explorers, and missionaries who for the past two thousand years have come to Africa from other parts of the world—Greece and Rome, the Middle East, and since the fifteenth century, western Europe and America. With the help of these sources, and the study of African oral traditions, it is becoming increasingly possible to view African art in a historical perspective.

It may never be possible, however, to write a single, unified history of African art, since the continent is so vast and the cultural contexts, which give art its reason for being, are so varied. Modern Africa comprises fifty-three nations that are home to some 480 million people who form a greater number of distinct ethnic groups than are found on any other continent. Each has a language, religion, history, and way of life all its own, and in each of these societies, art plays an important, but subtly different role. Most African sculpture comes from the forest and savanna areas south of the Sahara Desert, which can be divided on the basis of their similar history, culture, and art into four broad regions: the Western Sudan and Guinea Coast areas of West Africa, and the Equatorial Forest and Southern Savanna areas of Central Africa. Eastern and southern Africa, lacking a strong sculptural tradition, are rich in such other art forms as poetry, music, dance, body decoration, and architecture; they are not represented in this volume. The art of North Africa and Egypt, which reflects a separate tradition, is also not discussed here.

One of the most salient features of African art is the way in which it is integrated into the most important events in the lives of individuals and the community. Sculptures are present, for example, when young people in Africa are initiated into the privileges and responsibilities of adulthood, and when the dead are ritually transformed into ancestors who can continue to aid and protect their descendants. If the intercession of the spirit world is needed to ensure an abundant harvest or numerous progeny, artists are called upon to create appropriate objects for the rituals. When African rulers appear before their subjects, splendid art forms are employed to proclaim their majesty, wealth, wisdom, and the sacred sources of their power. African artists rarely create art for its own sake, but they do apply rigorous aesthetic standards to their work, and they value the prestige that their artistic abilities provide them. Knowledge of the contexts for which African art is made and of the conditions of its making are essential to an appreciation of its forms and to an understanding of its meaning.

It is also important to remember that in their original context, these objects would not be seen as they are here —isolated, static, silent. Rather, they would be surrounded by other sculptures and ritual objects in a shrine, or incorporated into the many other costume elements worn by a masked dancer. They would be set in motion, by the rhythm of the dance, by the gestures of the ritual specialist, or by the throng of spectators around them. Their meaning would be articulated and amplified through prayers or proverbs, songs, and music. By highlighting the sculptures as we have here, we are seeing but one aspect—albeit an important one—of a rich world of creativity and meaning.

The Western Sudan

Arab geographers, the first to write about the interior of Africa, called the area south of the Sahara Desert *bilad al-Sudan*, "the land of the blacks." The term Sudan is still used today to refer to the broad swathe of grassy, tree-covered savanna that stretches across Africa from the Atlantic Ocean to the Red Sea, separating desert from rain forest. Since the second millennium B.C., the people of the Western Sudan have been farmers, cultivating cereal plants that were domesticated as the once-lush lands gradually became drier.

The earliest surviving sculptures from the Western Sudan are the terra-cotta heads and figures from sites of the Nok culture, spread throughout northern Nigeria. The iron-using Nok culture lasted from 500 B.C. to A.D. 200. Despite their antiquity, the Nok sculptures already embody many features found in African art made in the ensuing centuries, such as the stylization of the human form, the disproportionately large size of the head, and the depiction of elaborate hairstyles, garments, and body ornaments.

The Western Sudan, which includes the modern nations of Mali, Burkina Faso, Niger, and the northern parts of Guinea, the Ivory Coast, Ghana, Togo, Benin, and Nigeria, has witnessed the development of great empires as well as of peoples among whom political power was limited to the village and lineage. By the time of the first Arabic descriptions of Western Sudan in the eighth century, the Ghana empire was thriving by trading gold north across the Sahara in exchange for salt. The Mali empire arose in the thirteenth century, its wealth similarly based on the trans-Saharan trade. Mali's rulers enjoyed the services of many artists, including architects, masons, wood and ivory carvers, gold- and silversmiths, blacksmiths, musicians, and poets, all of whose work was visible at the lavish royal court visited and described by Ibn Battuta in 1352. The trans-Saharan trade on which these empires depended had enormous impact on the arts of Africa, as imported materials such as textiles, beads, and manufactured objects were incorporated into local traditions. Copper mines in the Sahara Desert, exploited since about 2000 B.C., as well as mines in North Africa and Europe provided the raw material for bronzes made not only in the Western Sudan but also in the forest regions far to the south.

One of the most important stops along the trans-Saharan trade routes was Jenne, located in the Inland Delta region of the Niger River. By the eighth century, Jenne was a flourishing city whose fertile agricultural base and position near the juncture of desert and savanna provided wealth and access to a wide range of materials, goods, and craftsmen. Terra-cotta sculptures found in Jenne and the surrounding region are invaluable documents for the history of art in the Western Sudan. Found primarily in contexts dated from about A.D. 1000 to 1200, the Inland Delta terra-cottas often exhibit a freedom of movement that is rare in later African art. Some of these terra-cottas depict elegantly dressed and ornamented individuals, such as elaborately appointed equestrian warriors, while others depict subjects more difficult to explain, such as figures with diseased or deformed bodies, or figures whose bodies are covered with writhing snakes. The function and meaning of the Inland Delta figures is still poorly understood.

Although the most extensive archaeological investigations so far have taken place at Jenne, hundreds of similar mound sites have been found throughout the Western Sudan, many containing sculpture and other material remains that are changing long-held views of the history of Africa and its art. Significant groups of terra-cotta figures have been uncovered near the bend of the Niger River, in southern Mali, and in northern Ghana. As a result of this growing corpus of ancient art from the Western Sudan, the early Nok terra-cottas no longer appear as isolated achievements, but rather must be seen in the context of a variety of highly developed aesthetic traditions occurring across a wide area.

The legacy of these early art traditions can be seen among ethnic groups still producing art in the Western Sudan today. Some Dogon and Bamana figures, for example, wear garments and carry accoutrements identical to those on the Inland Niger Delta terra-cottas. Some also exhibit a similar rounded, full-volumed, and descriptive style, although sculpture in the Western Sudan is generally characterized as stylized, austere, and cubistic. Indeed, a preference for polelike figures, whose limbs and features surround the cylindrical torso in an angular composition of geometric solids and voids, is found throughout the Western Sudan from the Bamana in Mali to the Mumuye in eastern Nigeria, and even beyond, into eastern Africa. Despite the prevalence of this style, with its many local variations throughout the Western Sudan, our view of art in this part of Africa has been broadened to include the less geometric, more carefully observed style seen in the Inland Delta terra-cottas and in some Dogon, Bamana, and Senufo works.

Despite the importance of empires and states in the history of the Western Sudan, the arts most often focus on the individual, the village, and the spiritual forces that animate the universe. Figurative sculptures generally represent either real or mythical ancestors or idealized individuals. They are generally left unpainted or are blackened with a hot knife, and are covered with incised geometric designs. Masks are associated with funerary or commemorative rituals, with the celebration of the planting and harvest seasons, and with initiation into the many associations that in traditional Sudanic culture affected all aspects of village life: religion, politics, and family relations. Masks most often represent stylized animals or combinations of animal forms; they are either unpainted and incised, or are painted red, black, and white in bold geometric patterns.

As in most of sub-Saharan Africa, wood is the most common medium of sculpture in the Western Sudan, although iron is also worked into figures and staffs, brass is cast into pendants, bracelets, and other ornaments, and fiber and cloth are frequently used for masks. Wood carving is done exclusively by men, who are generally members of hereditary artisan groups; women who belong to these artisan groups make pottery and baskets.

The Guinea Coast

South of the savanna grasslands of the Western Sudan, an area of tropical rain forest known as the Guinea Coast hugs the shore of West Africa from Senegal to Cameroon. In this landscape, closely spaced trees tower over the thick under-

growth. Because of the restrictions on movement and communication imposed by the dense vegetation, the tropical rain forest of the Guinea Coast was once considered less conducive to trade and the growth of cities and states than the savanna of the Western Sudan. Archaeologists probing the soil in this area have found ample evidence to dispel this view. In the forests of southeastern Nigeria, the site of Igbo Ukwu was a political and religious center in the ninth and tenth centuries, relying on trade across the Sahara for copper to make complex cast-bronze regalia and ritual objects. Ife in the twelfth century and Benin slightly later also developed far-reaching trade networks, as well as specialized urban centers, vast provincial territories, and hierarchical political and religious systems. When the first Europeans arrived on the western part of the Guinea Coast in the mid-fifteenth century, they found numerous small chiefdoms, and remarked on the orderliness of their rule and the skill of the artists they employed.

The peoples of the Guinea Coast can be viewed as forming two major cultural areas, roughly divided by the Bandama River, which flows through the Ivory Coast. On the western Guinea Coast, most people speak languages of the Mel and Mande families, and are organized in small chiefdoms or village groups that are often coupled with powerful religious associations. In contrast, the peoples living in the eastern part of the Guinea Coast speak languages of the Kwa family and have formed more extensive, centralized, and hierarchically organized states, often with similarly organized religious pantheons. Art tends to reflect the differences in these major cultural areas, being associated with men's and women's societies and the affairs of village government in the west and with royal power in the east.

The western Guinea Coast has close ties to the Western Sudan, as changes in the Ghana and Mali empires caused people to move southward toward the forest. Sudanic peoples have both conquered and been assimilated by the forest's earlier inhabitants, resulting in the complex mosaic of relationships between ethnic groups visible there today. One of the most dramatic of these population movements occurred around 1550 when the Mande-speaking "Mane" from the north (the ancestors of the present-day Mende, Kono, and Vai peoples) confronted the indigenous "Sape" peoples (the ancestors of today's Temne, Bullom, Baga, Nalu, and Landuman) and caused vast changes in the culture of this area, including its art. Prior to the Mane invasions, some of the peoples of the western Guinea Coast made delicately carved ivory horns and containers, both for their own use and for sale to the newly arrived Europeans. They also made stone heads and figures that depict the costumes and regalia of the rulers of the area's many small chiefdoms. Despite the differences in their mediums, the delicate ivories and the more robust stone carvings exhibit many similarities in style and iconography, and are important documents of life and art on the Guinea Coast before 1550.

Although the ivory and stone carvings probably ceased to be made after the Mane invasions, many other art forms have continued. Masks are the most common sculptural form throughout the western Guinea Coast. In the extreme west, particularly among the Baga, Nalu, Landuman, Temne, Mende, Gola, and Vai peoples, masks are the concern of men's associations such as Poro, Simo, and Ragbenle, and

with the women's association known as Sande. These societies oversee the initiation and education of young people, and enforce laws and moral values among adults. Some of these associations were described in early European accounts of life on the Guinea Coast, although exactly how the art forms of today resemble those used by these societies in centuries past is still not clear. The forms most commonly seen today are helmet masks, or large masks that cover the wearer's head and shoulders. These masks contrast dark, lustrous surfaces with areas of richly textured or sometimes painted decoration. Some groups, such as the Mende, Gola, and Vai, share similar art forms, a result of their common adherence to the same men's and women's societies.

As one moves eastward along the Guinea Coast, such secret associations decrease in importance. Among the Dan and We, for example, Poro and Sande do not exist. Here masks are manifestations of nature spirits that are associated with village-wide functions such as circumcision, dispute settlement, social control, and entertainment. Wooden masks cover only the face, although they are worn with a variety of cloth or fiber headdresses and costumes that conceal the rest of the wearer's head and body. Within a single ethnic group, mask forms may vary from idealized naturalism to extreme abstraction, and identical masks may be worn by a number of different ethnic groups. Masks are just one manifestation of the many forms of contact and interaction between the ethnic groups of the western Guinea Coast.

The art of the eastern Guinea Coast is predominately royal. The arts of the Akan-speaking peoples of southern Ghana and the Ivory Coast appear primarily at royal funerals and state festivals that are multimedia pageants combining sculpture, costume and body arts, music, poetry, and dance. These festivals are associated with significant moments in the agricultural year, underscoring the important agricultural basis of Akan society. Trade with areas beyond the forests of the Guinea Coast also influenced the history and art of this area. Before A.D. 1500, Mande-speaking traders from the Western Sudan reached the northern Akan. They came in search of gold, which they traded across the Sahara, and brought with them copper alloys and the lost-wax technique of casting, cotton weaving, new forms of pottery, weapons, regalia, and a new religion, Islam. These new materials and ideas spread rapidly among the Akan-speaking peoples and resulted in the formation of many Akan kingdoms from the fifteenth through the eighteenth centuries. After 1471, the growing presence of Europeans on the "Gold Coast," as this part of Africa was known, also encouraged the expansion of these kingdoms. Asante, the most powerful of them, was formed in 1701.

Gold, both cast by the lost-wax method and in the form of gold leaf over wood, is ever present in Akan royal arts. It appears as gold-hilted state swords with attached cast-gold ornaments, as linguists' staffs with gilded finials, and as ornaments worn over the entire body. Cast-brass weights are used for measuring gold dust, and ornate brass containers hold gold and other royal treasures. Akan state arts also include wood stools to support the ruler, umbrellas and palanquins to shade and carry him, and opulent cotton and silk textiles. These royal arts are profuse and, in a sense, redundant, in that a multitude of small and diverse objects repeats the identical message—the authority of the ruler.

Since the mid-seventeenth century, Akan royal arts have also included terra-cotta heads and figures that depict deceased rulers and their attendants, often arranged in tableaux. These generalized "portraits" vary in style from one kingdom to another, but usually feature a smooth, round, flattened face, with stylized features and elements such as hairstyles and scarification marks applied in relief. Similar disklike faces are found on Asante wood sculptures, including the schematic *akuaba* that women carry to aid in the conception and birth of beautiful and healthy children, and on shrine figures that likewise emphasize the theme of motherhood. Wood masks are not commonly found except in the far western part of the Akan area, as among the Baule.

Copper and beads—not gold—predominate in the royal arts of southern Nigeria. At Igbo Ukwu in southeastern Nigeria, archaeologists have found numerous bronze staff tops, flywhisk handles, vessels, pendants, and other ritual objects and regalia that were deposited in the ninth or tenth centuries in the burial chamber, shrine, and storage house of a powerful priest-king. The copper from which these objects were cast, as well as the glass beads with which many of them were decorated, are evidence that Igbo Ukwu was linked to a vast trade network that stretched to the Western Sudan, across the Sahara, and on to Europe and the Middle East. These objects are profusely covered with delicate geometric and curvilinear patterns and with images of birds, animals, insects, and surprisingly, few humans. While the art of the Igbo people living in this area today is made of different materials and has a different focus, it often exhibits a similar love of dense surface pattern and texture.

West of the Niger River at the city of Ife, there arose another great kingdom with its own distinctive court arts. Archaeological evidence tells us that people have lived at Ife since the sixth century A.D., although the society that created brilliant works of art to glorify its rulers did not develop until about five hundred years later. The rulers of Ife were wealthy and able to attract the trans-Saharan trade that brought them copper, brass, and other luxury and utilitarian materials in return for ivory, kola, and slaves. Like Igbo Ukwu, the arts of Ife seem to have been used in contexts related to the burial and commemoration of its rulers and the worship of its deities. Unlike Igbo Ukwu, however, the art of Ife is essentially humanistic in focus. Among the most naturalistic and sensitive of all African arts, the brass and terra-cotta heads and figures from Ife depict rulers and their companions in the prime of life, with careful attention to bone structure and the soft layers of flesh covering it. Ife works portray individuals whose innate personal qualities—composure, control, serenity—are enhanced by the detailed observation of the trappings of leadership—elaborately beaded crowns, collars, and ornaments, carefully wrapped garments, and other insignia of office.

Ife sculptures were made between the twelfth and fifteenth century, after which sculpture of the same style and technical virtuosity ceased to be made there. The primacy of Ife was replaced by the kingdom of Benin, whose oral traditions point to Ife as the origin both of the present ruling dynasty and the knowledge of brass casting. Benin was already flourishing when Portuguese navigators arrived there in 1485, and it continued until the capital at Benin City was overrun by British forces in 1897. The British Punitive Expedition removed thousands of works of art from Benin, providing a more complete record of the history of Benin art than exists for any other early African kingdom.

The earliest Benin cast-brass royal commemorative heads, made from the late fourteenth to the mid-sixteenth centuries, are already different in style from those made in Ife, but show the same command of the material and a youthful idealized naturalism similar to that seen in the work of the earlier kingdom. Benin court objects show a preoccupation with hierarchy that is reflected in their careful attention to the details of royal dress and regalia, and in the relative size of figures. This concern for status and hierarchy, and emphasis on rich surface patterns and textures can also be seen in the ivory saltcellars and horns that Benin artists carved for Portuguese visitors to the court.

In the late sixteenth and seventeenth centuries, rectangular cast-brass plaques covered the pillars of the palace. These plaques documented the attributes and activities of the many officials, both local and European, present at the Benin court. The brass commemorative heads gradually became larger, and more stylized, reaching a climax of royal aggrandizement and ostentatious use of expensive imported metal in examples made in the eighteenth and nineteenth centuries. Throughout the kingdom's long history, the brass casters and ivory carvers of Benin used a consistent vocabulary of symbolic motifs often taken from their natural environment—mudfish, crocodiles, leopards, birds, leaves—to express concepts pertaining to the power of Benin kingship and the relationship of the king to the gods.

These ancient artistic and cultural centers of southern Nigeria—Igbo Ukwu, Ife, and Benin—have successors in the present-day Igbo, Yoruba, and Edo peoples, whose arts, though different from the royal arts of the past, have many points in common with them. Among the Yoruba, the importance of glass beads, like those depicted on many Ife works, can still be seen in the bead-embroidered crowns and regalia of their rulers. Most Yoruba art is made of wood, and unfortunately, no works in this fragile material have survived from the excavated sites of Ife to compare with more recent examples. Yoruba wood-carvers, among the most prolific in Africa, work in a lively, full-volumed style that permits many individual and regional variations. Carved and painted wood figures, masks, and shrine furnishings are dedicated to a complex pantheon of gods who bring fertility, health, and prosperity to their followers.

In southeastern Nigeria, home of the Igbo, Ibibio, Ijo, and other peoples, political power usually extends only to small groups of villages rather than to centralized states as among the Yoruba and Edo west of the Niger River. Rather than glorifying the state or ruler, the arts of southeastern Nigeria are much more concerned with community-wide associations, and with the power, wealth, and accomplishments achieved by individuals. Art objects and the institutions that use them often cross ethnic borders in this region, and the style and context of objects often move independently of one another, making the artistic map of southeastern Nigeria all the more complex.

Sculpture from this region depicts ancestors who made important contributions to the history of the community. Carved wood altars combining human and animal forms pay homage to an individual's personal skills—usually re-

ferred to as the power of his own right hand—that allow him to achieve success and prominence. Masks and headdresses are made in a variety of styles, ranging from delicate, brightly painted, and richly textured face masks to severely abstracted and often grotesque helmet masks.

In the extreme eastern part of the Guinea Coast along the Cross River in Nigeria and Cameroon, highly stylized stone figures have been found, some believed to date from the second century A.D. In this area, men's associations use headdresses and masks covered with a sheath of antelope skin. The features of these masks may be startling in their naturalism or their fierce expression; the skin covering further heightens the tension between reality and abstraction.

The Equatorial Forest

A continuation of the tropical rain forest of the Guinea Coast, the Equatorial Forest stretches across Africa, north and south of the equator, from Cameroon to the great lakes. This dense, junglelike landscape has seen many large- and small-scale population movements, beginning twenty-five hundred to three thousand years ago when the first Bantu-speaking farmers left the plateaus of northeastern Nigeria and adjacent Cameroon to settle the forest, eventually coming to occupy most of central and southern Africa. Because of the often tangled relationships among the many small ethnic groups here, the Equatorial Forest is an area of great complexity but also one of considerable cultural homogeneity. With only a few notable exceptions, the Equatorial Forest did not foster the formation of large political groupings. Spread thinly through the forest, people formed autonomous villages and lineages led by "big men," who were powerful and charismatic individuals. Art in the Equatorial Forest region is often related to the quest for power in village politics. Voluntary associations, which also require masks, figures, and other objects for their initiations and rituals, are a means of balancing these competitive tendencies.

On the western edge of the Equatorial Forest region are the grassy highlands of northwestern Cameroon. Over the past three hundred years, many independent kingdoms have formed there and are ruled by kings whose authority is enforced and balanced by palace regulatory societies. Grasslands art focuses on the palace, the royal family, and the men's societies. Palaces are magnificent, high-roofed buildings with carved and painted support posts, windows, and door frames. Luxurious objects surround the king at court —carved thrones and stools, flywhisks with sculpted handles, cast-brass or terra-cotta pipes, containers for food and palm wine. Carved figures representing royal ancestors are often shown with these emblems of royal status, many of which are embellished with symbols of royal wisdom and power. Some objects are embroidered all over with brightly colored, imported glass beads as a proclamation of the king's wealth. Face masks and headdresses, made both of carved wood and bead-embroidered cloth, are owned by the regulatory societies and by particular lineages. They appear publicly at funerary celebrations, at installations of new rulers, and at annual displays of the king's wealth and generosity. Grasslands sculptures are characterized by exuberant, expansive forms, seen in swelling cheeks and bulging eyes; by

open, space-embracing compositions; and by dynamic, often asymmetrical postures. There has been much contact between the various Grasslands kingdoms, and it is often difficult to identify the specific origin of Grasslands objects.

South of the Grasslands, in the lush forests of southern Cameroon, Gabon, and Republic of Congo, a widespread belief in the spiritual power of ancestral relics underlies the creation of remarkable works of art. Skulls and other relics, preserved in boxes and baskets, embody forces that can be ritually mobilized to benefit the community. Carved figures and heads surmount these reliquaries and guard them from the uninitiated and from those who would use the relics' power for evil purposes. Kota reliquary guardians are flat, schematic wooden figures covered with gleaming strips and sheets of copper and brass, which became increasingly available in the nineteenth century as a result of European trade. Among the Fang peoples, whose nineteenth-century migrations also reflected the growing European presence, the guardians are heads or figures carved in wood, their blackened surfaces shining with repeated purifications of palm oil. Fang figures are stiffly symmetrical in pose, yet their tensed muscles, alternating bulging and constricting outlines, and the sweeping curves of their concave faces, create a sense of vitality and strength. Concave, heart-shaped faces are seen also on masks throughout this area.

In the thinly populated forest area of northern Zaire live many small ethnic groups that have complex cultural, historical, and linguistic relationships, including the sharing of voluntary associations that are the principal patrons of the arts. These initiation societies play a crucial role in running village affairs, governing the relationships between people, and guiding an individual's moral development. Among the Lega, for example, the teachings of the Bwami association are made known through a variety of wood and ivory masks, heads, and small figures. Masks and figures throughout this region are characterized by severe geometric abstraction, which usually includes a concave, heart-shaped face, clearly demarked planes and angles often enhanced by the contrast of colors, and a spare sense of surface decoration. Although simple in form, the sculptures of the northern Zairean forest embody complex and multiple meanings that are often elaborated through proverbs, skits, and dances.

The Southern Savanna

South of the Equatorial Forest region, a vast expanse of savanna stretches across Central Africa from the Atlantic Ocean to the great lakes of East Africa. The many tributaries of the Zaire River, such as the Kwango, Kwilu, Kasai, Lomami, and Lualaba rivers, have served as focuses for the region's population who find the river valleys well suited to agriculture. Bantu-speaking farming people began to populate this region in the last centuries before Christ, acquiring the knowledge of ironworking soon afterward. Archaeologists have found evidence, as early as the twelfth century, for the use of copper, iron, and ivory for prestige purposes, implying the existence of craft specialization, long-distance trade, and hierarchical political structures. Indeed, when Portuguese ships exploring the coast of Africa reached the mouth of the Zaire River in 1482, they encountered the al-

ready vast and thriving Kongo kingdom. The Southern Savanna is characterized by many kingdoms that arose between the fourteenth and seventeenth centuries. In a few areas, such as the Kuba kingdom, the splendor of the Central African royal courts is still visible today.

The art of the Southern Savanna is made to enhance the prestige and power of kings and chiefs. Carved wood staffs and flywhisks, often with ivory tops or handles, luxurious woven, embroidered, and appliquéd textiles, elaborate caps, ornate containers, caryatid stools —all serve to distinguish the king or chief and to represent his authority among his subjects. Sculptures created to house and manipulate supernatural forces are also an important aspect of Southern Savanna art. These carved wood figures are empowered by a ritual specialist who adds diverse ingredients—special earths, leaves, nuts, seeds, animal and bird parts, mirrors, metal blades and nails, cloth and fiber bindings—that attract forces and direct them to a desired goal, such as healing an illness, afflicting an enemy, or swearing an oath. The third major component of Southern Savanna art are the ensembles of brilliantly painted masks worn at initiation rituals that mark the transition from childhood to adult life.

The kingdom of Kongo, founded between 1350 and 1400, was a model of centralized government, with a divine king and a network of provincial governors, advisors, and village chiefs, until its decline in the eighteenth and nineteenth centuries. The dignity and authority of Kongo kings and chiefs are embodied in their ivory and wood staffs and flywhisks, ivory horns, intricately patterned caps, and woven raffia cloths. Examples of these court arts were acquired by Portuguese traders and missionaries who frequented the Kongo kingdom, and they testify to the technical virtuosity and rich design vocabulary of the early Kongo artists. Kongo sculptures—stone figures placed on tombs and wooden ones kept in ancestor shrines—are also carved with the trappings of rank and leadership that include such personal arts as ornamental scarification patterns, filed teeth, and elaborate hairstyles. Other Kongo sculptures are "power figures" (minkisi), whose bodies and heads are swollen with the power-laden materials packed in and around them, or bristling with the blades and nails that are inserted when calling upon their potent forces. Kongo sculpture is characterized by a full-volumed naturalism, sensual and expressive features, and a freedom of movement and posture—often violent, aggressive, and asymmetrical—that are rare in African art.

East of the Kongo live the Yaka, Suku, Pende, and other peoples, among whom political power is vested in local chiefs who owe allegiance to rulers imposed in the eighteenth century by their Lunda conquerors. Among these peoples, masks worn to celebrate boys' circumcision and initiation are the primary form of sculpture. These masks, which appear in ensembles depicting a variety of characters, are characterized by upturned noses and by the addition of brightly painted raffia fiber coiffures and superstructures.

Farther east in central Zaire, lies the Kuba kingdom, whose present dynasty was founded in the early seventeenth century by an immigrant from the west. This foreigner is credited with introducing many new ideas, techniques, and materials—including many art forms—to the Kuba. The Kuba kingdom unites several ethnic groups into an efficient bureaucracy whose officials are ambitious and status-conscious, and who require sumptuous articles as visible signs of their wealth and rank. Specialized professional artists —carvers, smiths, weavers, embroiderers—supply their needs. Except for a series of royal portraits, figurative sculpture is rare among the Kuba. Instead, Kuba art consists of utilitarian objects—cups for drinking palm wine, boxes for storing cosmetics and valuables, pipes, spoons—all of which are elaborated beyond mere function by their sophisticated, imaginative, and often playful forms and lavish surface decoration. The intricate incised geometric patterns that cover the surfaces of Kuba objects are borrowed from the motifs embroidered on their luxurious raffia pile cloths. This decorative approach to surfaces extends also to the masks worn at initiations and at court ceremonies; in addition to painted designs, Kuba masks are copiously ornamented with glass beads, cowrie shells, leather, fur, and metal sheets to produce dazzling contrasts of color, pattern, and texture.

On the eastern edge of the Southern Savanna live the Luba and peoples with related art traditions—the Hemba, Tabwa, Boyo, Songye, and others. Early in Central African history, this area, endowed with copper and salt deposits, and a system of rivers for both trade and fishing, saw the development of a hierarchical society whose leaders made use of prestige materials and objects to proclaim their status. Burials excavated at Sanga and dated between the eleventh and fourteenth centuries, contain ivory pendants, copper-wrapped staffs, and bead ornaments—the very same types of objects later used to distinguish Luba kings.

The Luba empire arose in the seventeenth century and collapsed—like so many other Central African kingdoms— in the late nineteenth century, its population exhausted and its resources depleted by the slave and ivory trades. Luba kings employed magnificently carved regalia—caryatid stools, paddlelike staffs and three-pronged bowstands, cups, neckrests, and ceremonial weapons—that were distributed to chiefs as a means of extending royal power to outlying areas. Luba leadership arts often depict women, images of the king's sisters and daughters given as wives to provincial leaders as a means of solidifying their relationship to the Luba capital. On Luba court objects, the figures themselves display signs of rank such as beautifully scarified torsos and intricately coiffed hair. Luba sculpture emphasizes rounded forms and carefully finished surfaces, with smooth, polished sections that contrast with other areas of finely textured patterns.

In looking at the art of these four regions, it is clear that African art has undergone many changes since the first sculptures were made twenty-five hundred years ago. Art has reflected the flourishing and decline of states and chiefdoms, has responded to the availability of materials and models, and has evolved according to the changing religious, intellectual, political, and social values of the people who use it. Even today, African artists continue to create traditional works that perform vital functions for their communities and that reflect new developments in African society. One aspect of African art remains constant, however, and that is its essential role in expressing the ideas and values that are critical to the lives of its makers and users.

Kate Ezra

40 Seated Figure
Mali (Jenne); early 13th c.
Terra-cotta; H. 10 in. (25.4 cm.)
Purchase, Buckeye Trust and Mr. and Mrs. Milton F.
Rosenthal Gifts, Joseph Pulitzer Bequest, and Harris
Brisbane Dick and Rogers Funds, 1981 (1981.218)

JENNE SEATED FIGURE

Terra-cotta figures from the Inland Delta of the Niger River of Mali are frequently attributed to the ancient city of Jenne. Founded about 250 B.C., Jenne was a flourishing center for agriculture, trade, and craft production by the middle of the first millennium A.D. The region formed part of the Mali empire, which reigned from the thirteenth to the fifteenth century, and its successor, the Songhai empire, which lasted until the beginning of the seventeenth century. The stylistic diversity of these complex terra-cotta images suggests the rich history of art traditions in this area.

This figure sits with its arms clasping its bent legs, its head resting on one upraised knee. It is unadorned except for a series of raised and punched marks on its back, which may depict body scarification patterns. The bulging eyes, broad nose, large ears, and projecting open mouth are seen on other Jenne works. The figure's asymmetrical posture is also characteristic of terra-cottas from the Inland Niger Delta, which show a greater freedom of movement than most African sculpture. The rounded, fluid contours of the entwined limbs reflect the amorphous, malleable properties of clay and differ from the stiff, angular forms often seen in wood sculpture from this area.

The figure's seemingly pensive posture may reflect an attitude of mourning, an impression strengthened by visual cues such as the shaved head, absence of dress, and the suggestion that the figure sits on the ground. Such mourning practices are common in traditional African societies throughout the Western Sudan. The function of Jenne terra-cottas is uncertain. The few figures that come from properly documented sites were originally set into the walls or floors of houses, suggesting that they may have had ancestral or protective meanings.

DOGON OR BOZO STAFF: SEATED MALE FIGURE

This elaborate bronze-and-iron staff may have been the in-
signia of an important title holder or political leader. A large
male figure in full regalia is shown seated on a spool-shaped
stool. Details of dress and body ornamentation—including
the elaborate headdress and stylized beard, complex body
scarification patterns, heavy pendant, armlets, bracelets, and
anklets, and the decorated wrappers around the chest and
waist—reveal an individual of high status. The impression
of a successful warrior is conveyed by the dagger in a deco-
rated sheath strapped to the figure's left arm, and the spear
held in his right hand.

The bronze figure surmounts an unadorned columnar
iron staff that is inserted into the underside of the stool.
The figure was cast in one piece, without a clay core, using
the lost-wax method of casting, in which the image is first
modeled in wax, permitting abundant detail and decora-
tive motifs. Clay is formed around the wax model, which is
then fired, melting the wax but leaving a hollow clay mold.
Molten metal is then poured into the clay mold and allowed
to cool. The clay exterior is broken, destroying the mold,
but revealing the cast image, which duplicates the exquisite
detail of the wax model. Because the mold has been de-
stroyed, the image is unique. Decorative features such as
the scalloped edges of the beard, the textured surfaces of
the chest band and waistcloth, and the zigzag patterns on
the jewelry and knife sheath reveal the high degree of skill
that the craftsman devoted to producing this flawless object.

The figure's rigid posture, prominent facial features, and
attenuated, tubular torso and limbs are stylistic features that
place it within Western Sudanic art traditions, although there
are few comparable bronze figures from this area to help in
refining the attribution or the date. A similar staff was found
in a Dogon village, and another was documented among
the nearby Bozo people. Artisans in Jenne, a city in the In-
land Delta region of the Niger River, made cast bronze or-
naments as early as the middle of the first millennium A.D.,
and details of this figure's dress and body ornament are
similar to some Inland Niger Delta terra-cottas.

41 Staff: Seated Male Figure
Mali (Dogon or Bozo)
Bronze, iron; H. 30 in. (76.2 cm.),
Edith Perry Chapman Fund, 1975
(1975.306)

DOGON SEATED COUPLE

Dogon couples such as this one are usually identified as primordial ancestors, although specific field documentation is lacking. In this example, a man and woman sit together on a single round stool, which is supported by four figures. The man has his arm around the woman, with his right hand resting on her breast, his left hand on his own genitals. He carries a quiver on his back, while she carries an infant on hers. These iconographic elements allude to the man's role in Dogon society as progenitor and protector, warrior and hunter, and to the woman's role as mother and nurturer. These themes are found in the sculpture of many sub-Saharan African peoples and serve to reinforce cultural stereotypes that enhance the group's social organization.

These elongated, angular figures, with their attenuated limbs and torsos, and balanced, frontal orientation, reflect stylistic features common in the art traditions of many peoples of the Western Sudan. The bold, arrow-shaped nose is a distinctly Dogon characteristic. Body ornamentation in the form of metal earrings and anklets, elaborate coiffures, a cylindrical lip plug for the female figure and a rectangular jutting beard for the male, reflect ideas of personal beauty as well as the status of the person represented.

42 Seated Couple
Mali (Dogon)
Wood, metal; H. 29 in. (73.7 cm.)
Gift of Lester Wunderman, 1977
(1977.394.15)

43 *Standing Male Figure*
Mali (Dogon)
Wood; H. 82⅞ in. (210.5 cm.)
The Michael C. Rockefeller Memorial Collection,
Gift of Nelson A. Rockefeller, 1969 (1978.412.322)

Dogon Standing Male Figure

Along an arid stretch of Sahel to the east of the Inland Delta
of the Niger River a spectacular landscape of cliffs known
as the Bandiagara Escarpment is home to the Dogon peo-
ple. Caves in the cliffs contain the remains of the Tellem,
predecessors of the Dogon. The Dogon ascribe many of their
sculptures to the Tellem, and it is difficult to distinguish
between the two art traditions on the basis of style. The dry
climate on the cliffs, as well as the practice of keeping sculp-
tures in caves that provide shelter from the elements, have
preserved Dogon and Tellem works far longer than is usual
for African wood objects. Dogon sculpture is primarily con-
cerned with the spirits responsible for the fertility of both
land and people. These include a family's real and mythical
ancestors, the souls of women who died in childbirth, and
water spirits.

This monumental figure of a man with upraised arms
has a well-modeled body, naturalistic stance, and a careful
rendering of musculature, anatomical detail, and body or-
nament. The figure wears wristlets, armlets, and anklets that
indicate his status in Dogon society, as well as a belt and
neck pendants that closely resemble leather talismans worn
throughout West Africa, thus implying his importance in
spiritual terms as well. The stylized jutting beard identifies
him as an elder, a person whose age, experience, and close-
ness to the ancestors entitle him to participate in the most
important religious, political, and social affairs in Dogon
society. The position of his upraised arms has been variously
interpreted as a position of prayer, a gesture of communion
between earth and sky, and an invocation of rain.

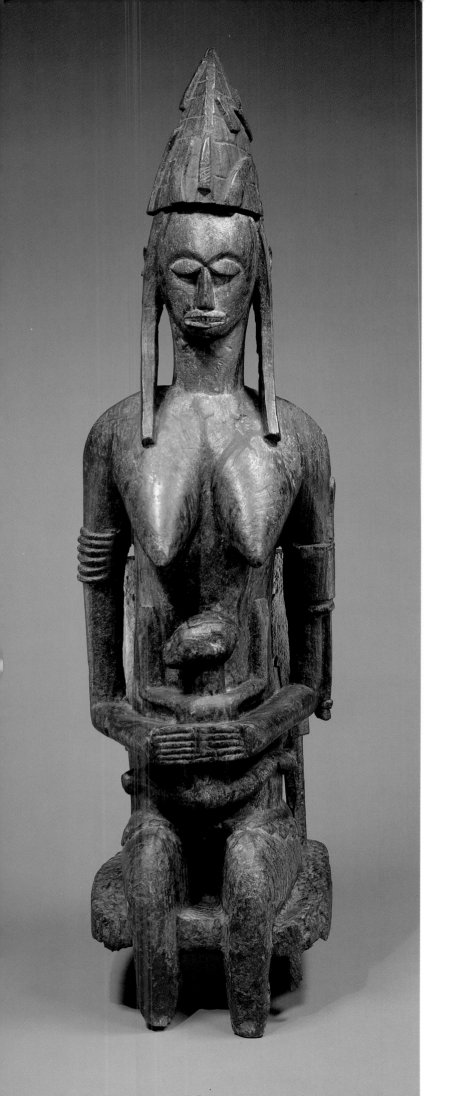

BAMANA MOTHER AND CHILD

Bamana notions of ideal beauty and character are evoked in this figure of a mother and child. The figure is a part of a corpus of large, relatively naturalistic sculptures whose rounded volumes and variety of gestures depart from the angular forms and stiff postures characteristic of many other types of Bamana sculpture. These figures are displayed at the annual ceremonies of Jo, an association of initiated Bamana men and women, and at the rituals of Gwan, a related society whose purpose is to help women conceive and bear children. In each village, a group of figures is displayed, depicting a mother and child, a seated male, and their companions, including warriors, musicians, water-carriers, and figures bearing ritual objects. This figure depicts a woman of extraordinary abilities, as shown by the amulet-laden hat she wears and the knife strapped to her left arm. Within the layers of meaning embodied in the sculpture can be seen the importance of motherhood in maintaining social cohesion and continuity within Bamana society, and the mothers' role in passing on their skills, powers, and values to future generations.

44 Mother and Child
Mali (Bamana); 15th–20th c.
Wood; H. 48⅝ in. (123.5 cm.)
The Michael C. Rockefeller Memorial Collection,
Bequest of Nelson A. Rockefeller, 1979 (1979.206.121)

BAMANA ANTELOPE HEADDRESSES

The importance of agriculture to the Bamana people is seen in annual performances that honor the mythic ancestor Chi Wara—half man, half antelope—who introduced agriculture to the Bamana. The Chi Wara society teaches traditional farming techniques and knowledge of the seasons, the soil, and plant life. Its celebrations encourage farmers in their efforts and ensure a successful harvest. The wooden antelope headdresses are carved in male and female pairs and are attached to basketry caps and fiber costumes. They are worn by strong, young male dancers who are accompanied in song by Bamana women praising farmers who work as hard as the mythical Chi Wara. Male antelope headdresses often have elaborate openwork manes that curve out from the neck, linking the vertical axis of the head and horns with the horizontal axis of the body. Female antelope headdresses are identified by the baby antelope carried on its mother's back, the way African women carry their infants. Delicate chip-carved patterns, incised linear designs, and metal strips ornament the face and horns of the antelope headdresses.

45 Pair of Antelope Headdresses
Mali (Bamana); 19th–20th c.
Wood, metal bands; H. 28 in., 35¾ in. (71.1 cm., 90.8 cm.)
The Michael C. Rockefeller Memorial Collection,
Gift of Nelson A. Rockefeller, 1964 (1978.412.435, 436)

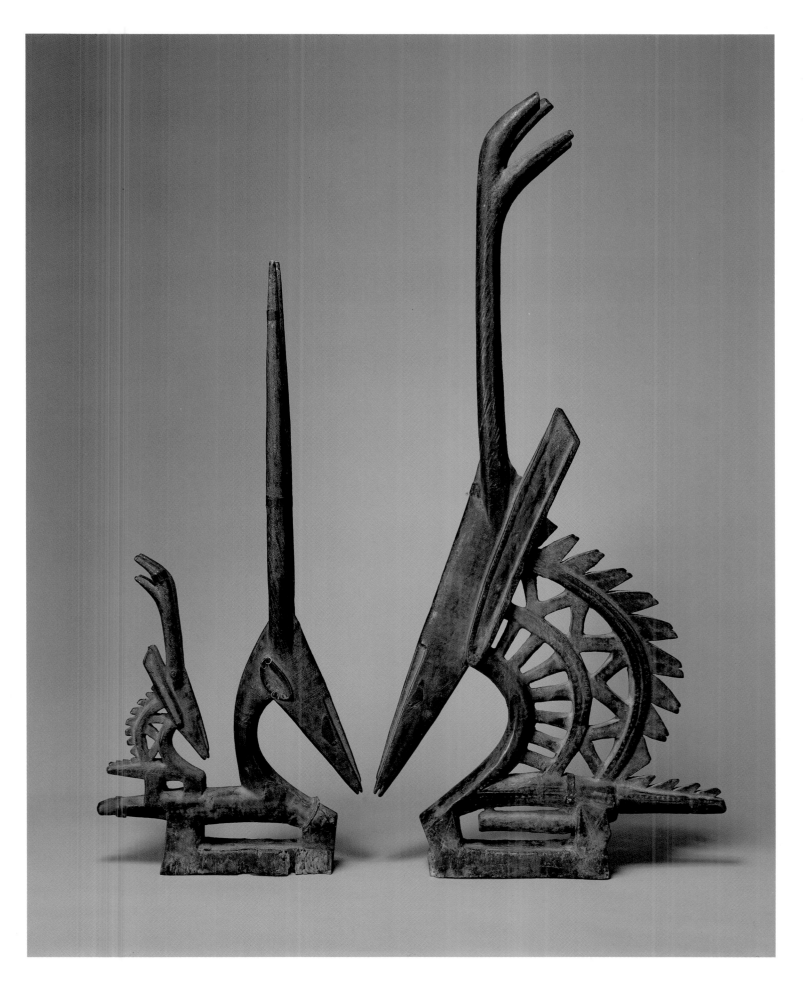

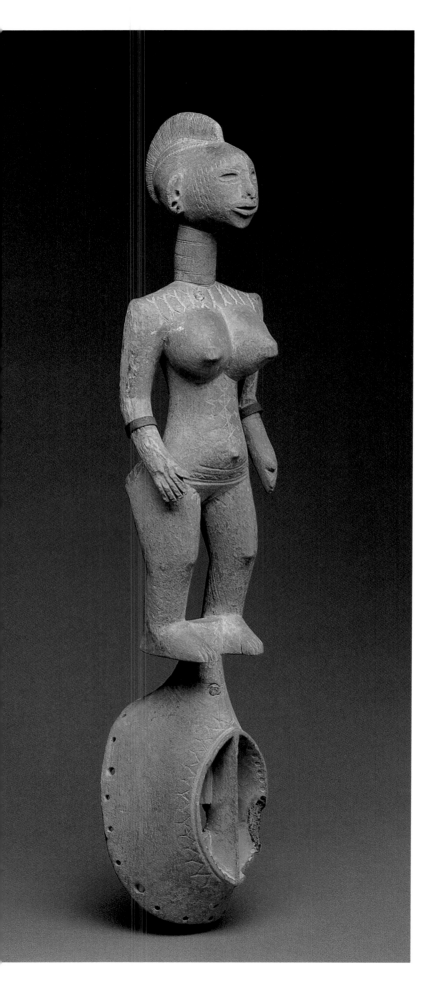

46 *Mask with Female Figure*
Burkina Faso (Mossi); 19th–20th c.
Wood, metal; H. 29½ in. (74.9 cm.)
The Michael C. Rockefeller Memorial Collection,
Bequest of Nelson A. Rockefeller, 1979 (1979.206.84)

MOSSI MASK WITH FEMALE FIGURE

Throughout the savanna region of West Africa, commemorative funerals pay tribute to the memory of deceased elders with performances of music, dance, and masks. Among the Mossi of Burkina Faso, a wooden face mask surmounted by a female figure appears at the funerals of old women. The mask honors a woman whose great age, wisdom, and experience had elevated her to the rank of a living ancestress, an ideal intermediary between the living and the spirits of the family's ancestors. Rather than showing the effects of old age, the artist has depicted the woman at the height of her physical beauty, her youthful body adorned with the scarification patterns traditionally applied after the birth of her first child. These incised linear patterns complement the figure's strong back, rounded thighs, broad hips, and full, projecting breasts. Additional curvilinear and geometric incisions encircle her buttocks and may represent waistbeads, a traditional mode of body decoration. The crest-shaped coiffure, metal armlets and pierced ears (which probably held metal or beaded earrings) further enhance the beauty of the figure and reflect Mossi styles of personal embellishment.

The stylized oval face mask, with its central vertical ridge and elongated, recessed eye sockets, indicates an origin in the Yatenga region. Mossi masks from this area resemble Dogon masking styles and reflect their shared history. Five centuries ago, when the Mossi states were founded, some Dogon living in this area were assimilated into Mossi society, while others fled to the present home of the Dogon on the Bandiagara cliffs.

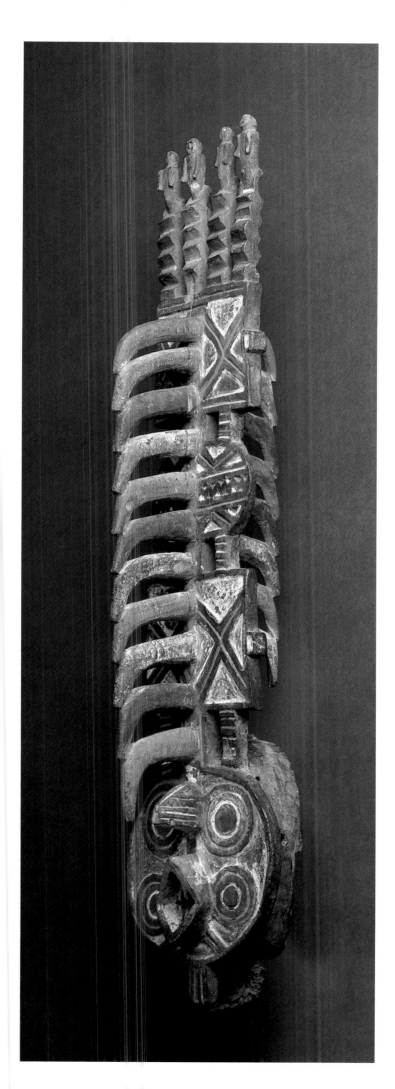

Bwa Plank Mask

The Bwa live in west-central Burkina Faso, and are neighbors of the Mossi to the west and the Bobo to the south. Their art reflects considerable interaction with other Gur-speaking peoples, evident in shared stylistic conventions such as geometric surface designs painted red, black, and white. Plank masks such as this one are used in southern Bwa country and appear at initiation and funeral ceremonies, agricultural rites, and village cleansing rituals. The masks vary in size and design, but generally they include a disclike face surmounted by a large flat superstructure. A diamond-shaped mouth, open and often revealing teeth, projects from the facial plane. Concentric circles, which repeat the shape of the face, suggest multiple eyes and stand in marked contrast to the checkerboard, zigzag, and diamond patterns that ornament the plank. These patterns, once thought to be merely decorative, may actually symbolize oppositions, such as good and evil, male and female, wise and stupid.

A hooked element resembling a bird's beak, possibly that of the hornbill, projects from the lower segment of the plank and overhangs the round face. This mask is unusual in having a row of multiple projecting hooks that fill the plank—both front and back—and depart from the two-dimensional quality characteristic of Bwa plank masks. The inclusion of four carved figures at the top is also uncommon.

47 Plank Mask
Burkina Faso (Bwa); 19th–20th c.
Wood, paint; H. 36¼ in. (92.1 cm.)
The Michael C. Rockefeller Memorial Collection,
Gift of Nelson A. Rockefeller, 1969 (1978.412.329)

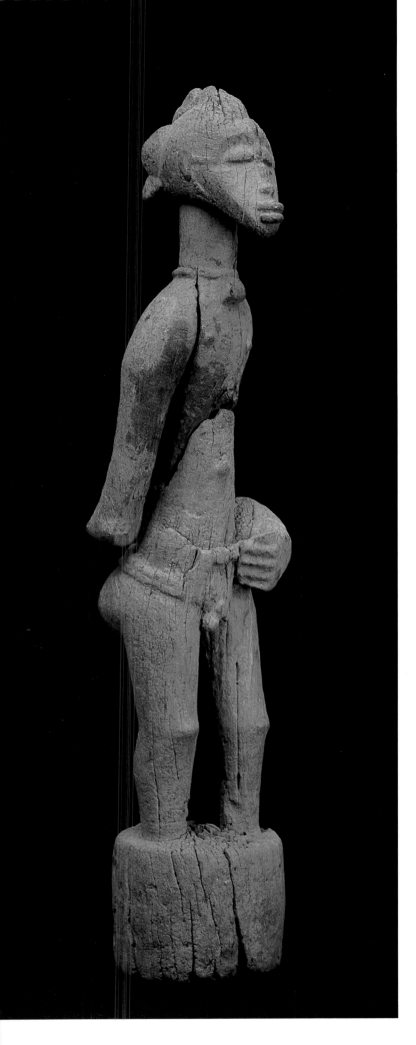

SENUFO MALE FIGURE

The Senufo carve large wooden figures called *pombibele*, "children of Poro," the traditional religious association responsible for the education and spiritual development of Senufo men. These figures appear at funerals of Poro members, either in stationary displays or carried by masked dancers who swing the sculptures side to side, rhythmically striking the earth.

Senufo sculptures generally conform to the Western Sudanic style of figure carving. This figure, however, departs from the abstract, angular conception of the human form found in many Sudanic sculptures; the carver has endowed it with rounded contours, heavy thighs, broad hips, and massive arms. The heavy-lidded eyes and full lips are particularly expressive. The figure is embellished with a tripartite coiffure, an elaborate waistband, and a pendant resembling a protective leather amulet.

Pombibele figures are made in pairs and allude to the primordial man and woman as the ideal social unit. This male figure is the pair to a female figure in the collection of the Museum Rietberg, Zurich. Both were collected in the early 1950s in Lataha, a Fodonon Senufo village.

48 Male Figure
Ivory Coast (Senufo); 19th–20th c.
Wood; H. 42½ in. (108 cm.)
The Michael C. Rockefeller Memorial Collection,
Gift of Nelson A. Rockefeller, 1965 (1978.412.315)

49 Face Mask
Ivory Coast (Senufo); 19th–20th c.
Wood, horn, fiber, cloth, feathers, metal,
sacrificial materials; H. of mask 14⅛ in. (35.9 cm.)
The Michael C. Rockefeller Memorial Collection,
Purchase, Nelson A. Rockefeller Gift, 1964
(1978.412.489)

SENUFO FACE MASK

Among the Senufo, wooden masks and figures play a crucial role in men's and women's secret societies, known respectively as Poro and Sandogo. Small feminine-looking face masks are worn by Poro initiates at funeral celebrations for men and women. They are distinguished by the delicate oval face, smooth curved forehead, and geometric projections on either side of the face; the leglike forms at the base of the face reflect a traditional hairstyle for Senufo women.

This particular mask is unusual in the accumulation of attached materials, which may serve to identify the context within which the mask was used. Feathers project from the top of the mask, and numerous small antelope horns are suspended from it; although decorative in appearance, these added elements may have enhanced the mask's power to combat negative forces in the community. In their association with nature and the bush, they stand in marked contrast to the mask's carefully polished visage, embellished with raised scarification patterns whose textures are repeated on the projections framing the face. This combination of aggressive and refined qualities may refer to the interdependence of Senufo men and women in ensuring spiritual and social equanimity.

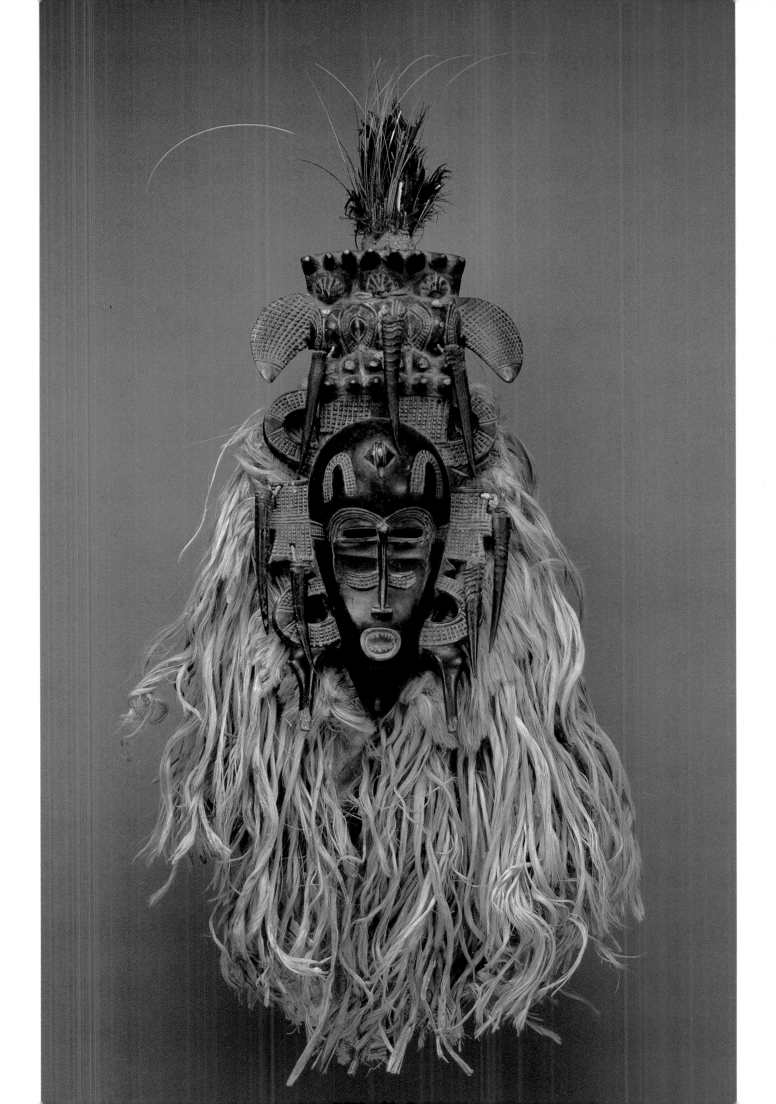

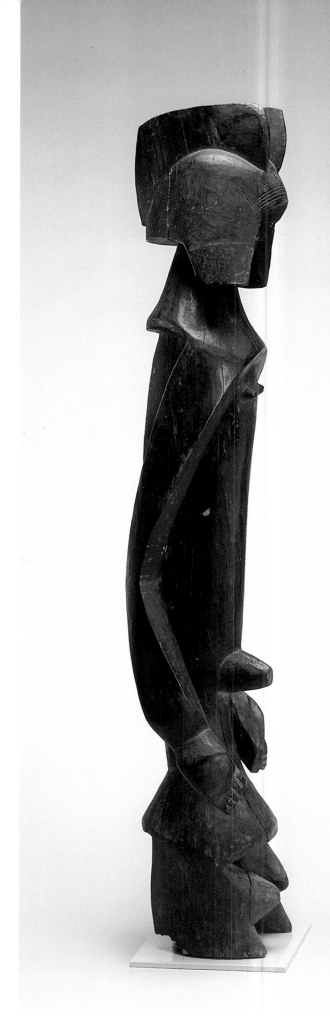

50 Figure (Multiple views)
Nigeria (Mumuye); 19th–20th c.
Wood; H. 36¾ in. (93.3 cm.)
Gift of Paul and Ruth Tishman,
1983 (1983.189)

MUMUYE FIGURE

The Mumuye live in eastern Nigeria, in the valley of the Benue River. Although varied in style, their figure carving reflects the abstract geometric forms characteristic of the Western Sudan. This image exemplifies the creativity with which Mumuye carvers approach human anatomy. Its columnar torso is surrounded by sharply bent arms that wrap continuously across the shoulders, chest, and back, creating the sculpture's jagged, swinging rhythm. The figure's face is almost obscured beneath the massive overhanging brow and the elaborate coiffure or headdress; the heavy flaps at the sides may represent distended earlobes. The figure is almost devoid of anatomical detail, save for the projecting navel and tiny nipples.

Mumuye figures in wood are used in a variety of ways—as oracles and guardians, to facilitate healing, and to reinforce the status of important elders. The neighboring Chamba are known to acquire Mumuye figures and use them as ancestral figures.

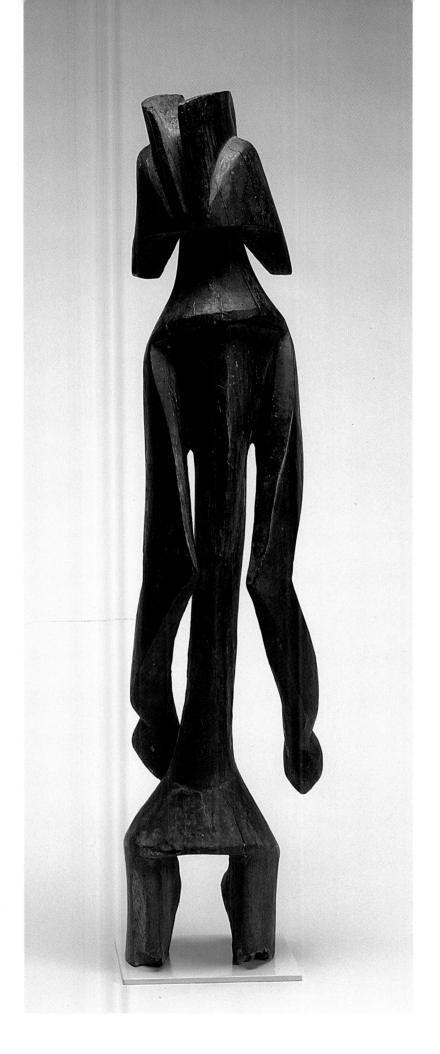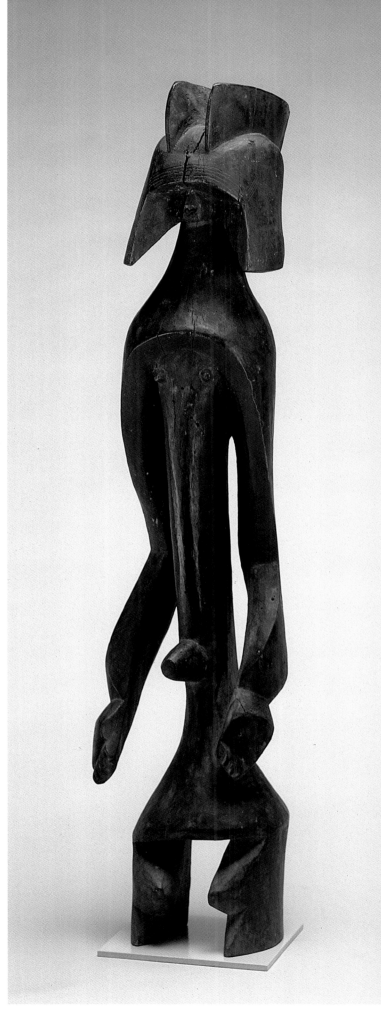

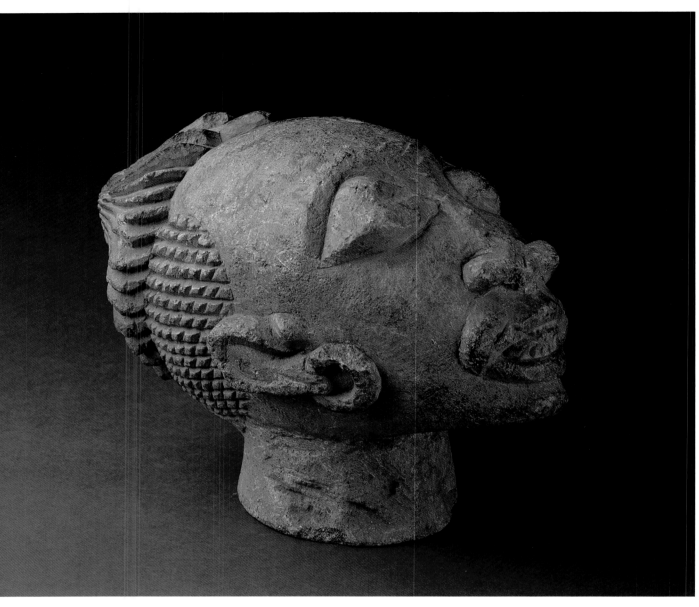

51 *Head*
Sierra Leone; prob. 16th c.
Steatite; L. 14¼ in. (36.2 cm.)
The Michael C. Rockefeller Memorial Collection,
Gift of Nelson A. Rockefeller, 1965 (1978.412.375)

HEAD FROM SIERRA LEONE

The peoples of southeastern Sierra Leone and western Guinea uncover carved stone heads and figures while farming. They attribute the sculptures to previous owners of the land and place them on family altars to insure the fertility of the fields and to serve in divination rituals. The sculptures resemble the art of this area's sixteenth-century inhabitants more closely than that of its present-day occupants, making ethnic attribution extremely difficult. Although carved in soft stone, this massive head has the bulging eyes, broad nose with flaring nostrils, full lips, and prognathous jaw seen on ivory carvings made in the late fifteenth and sixteenth centuries by local artists for the first European visitors to the coast of Sierra Leone. The filed teeth, promi-

nent earrings, and elaborately fluted coiffure of this head also correspond to the Europeans' descriptions of the Africans they encountered.

These sixteenth-century peoples, called "Sape" in contemporary accounts, made sculptures representing their rulers. The larger, more elaborate ones, such as this, probably commemorated men of the greatest importance. When the "Mane" peoples from the north moved into this area in the mid-sixteenth century, the political and cultural environment changed dramatically. The stone heads and figures ceased to be made, and the shrines in which they were kept were abandoned. These durable stone sculptures remain important documents of African art history.

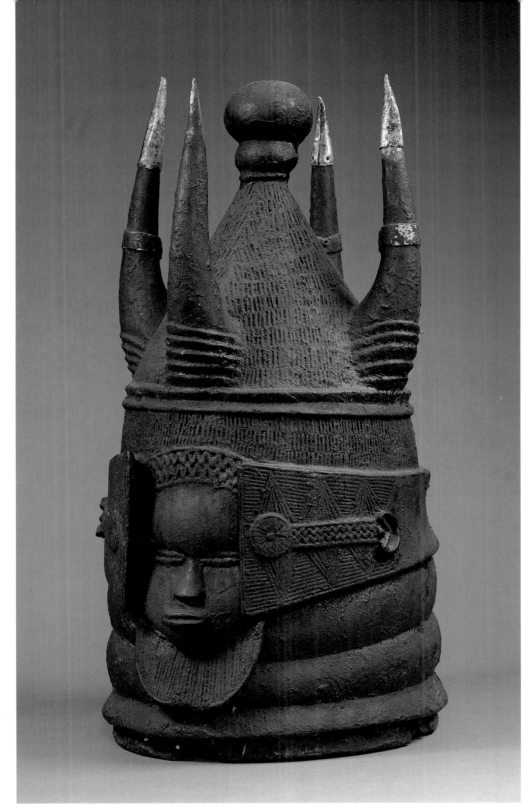

52 *Helmet Mask*
Sierra Leone (Mende); 19th–20th c.
Wood, metal; H. 15 in. (38.1 cm.)
Gift of Robert and Nancy Nooter, 1982
(1982.489)

MENDE HELMET MASK

The Mende have one of few African masking traditions exclusively reserved for women. The masks represent the guardian spirit of Sande, a widespread society responsible for the education and moral development of Mende women. Worn by women at celebrations marking the end of the initiates' training period, these masks convey the Mende ideal of feminine beauty: a broad, smooth forehead, delicately composed features in the lower portion of the face, an elaborate coiffure often incorporating animal or bird imagery, and a sensuously ringed neck. The spirit of Sande is associated with water, and the neck rings may allude to ripples of water, as well as to a woman's prosperity and good health.

This Sande society mask is innovative in the profusion of animal horns that project from the coiffure, a reference to the horns filled with protective, medicinal ingredients worn by Mende women. Also unusual is the band that encircles the back of the head and partially conceals the face. It represents a decorated leather band worn by Mende male performers. The mask also bears a stylized beard, synonymous with the wisdom men achieve with age and experience, and suggests that through Sande, Mende women acquire a knowledge equal to that of men.

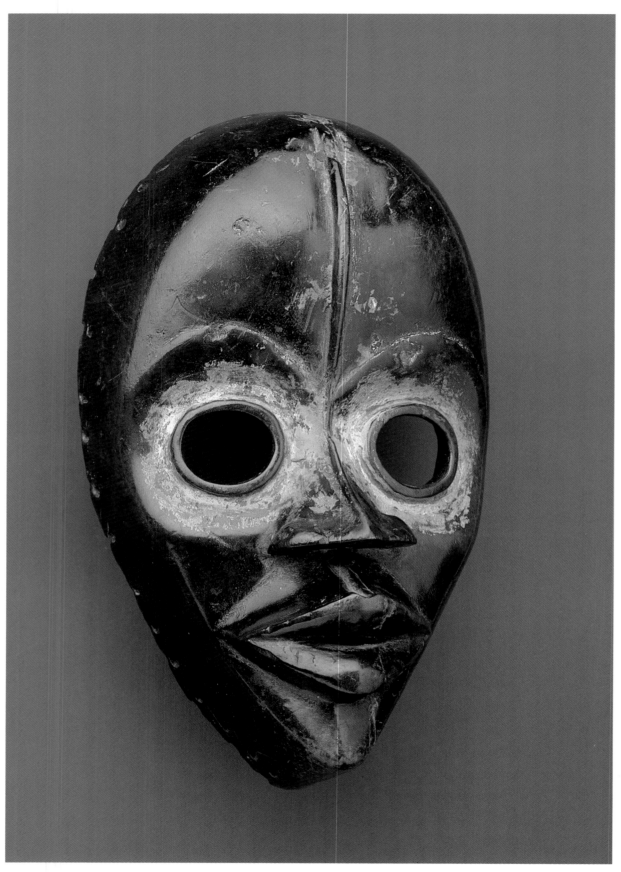

53 *Face Mask*
Liberia and Ivory Coast (Dan); 19th–20th c.
Wood, pigment; H. 9⅝ in. (24.4 cm.)
Gift of Lillian and Sidney Lichter, 1985
(1985.420.2)

DAN FACE MASK

Dan masks embody the powers and spirits of the forest, which may be beautiful or grotesque, male or female, as dictated by the spirit through dreams and translated by the carver into wooden masks. The masks serve to reinforce values that maintain social order. They are worn to honor chiefs, keep the peace, accompany boys to initiation camps, give encouragement to warriors or athletes, and to provide entertainment at village festivals. Elaborate raffia fiber and cloth costumes conceal the identity of the wearer and help to identify the particular role of the mask.

Masks such as this are identified as female masks, *gle mu*. They have beautiful, smooth, oval faces and serene facial features; in dance, their actions are controlled, fluid, and gentle. They contrast with male masks, *gle gon*, which are carved with projecting, tubular eyes and angular facial planes. When danced, the gestures and movements of male masks are aggressive, energetic, and threatening. This female Dan mask is probably of a type known as *gunyega*, characterized by a shiny black surface and round, open eyes. Lightly incised eyebrows and the application of kaolin emphasize the mask's round, gaping eyeholes. A raised line vertically divides the forehead, drawing the eye down to the broad nose and full, modeled lips. Masks of this type are worn by young men in footraces held weekly in the dry season.

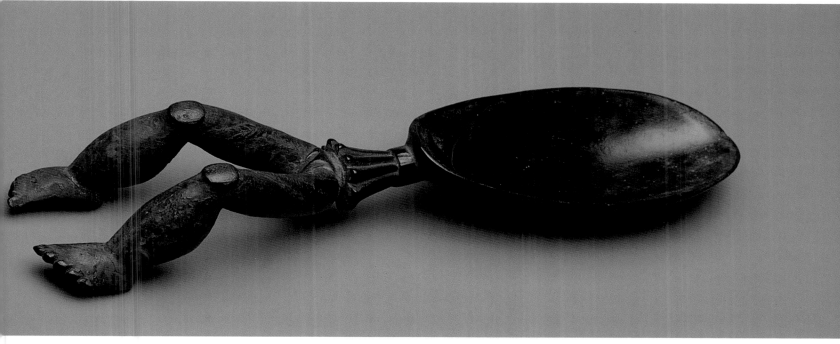

54 *Ladle*
Liberia and Ivory Coast (Dan); 19th–20th c.
Wood, traces of paint; L. 18¼ in. (46.4 cm.)
The Michael C. Rockefeller Memorial Collection,
Bequest of Nelson A. Rockefeller, 1979 (1979.206.264)

DAN LADLE

Large figurative ladles are owned by the most hospitable woman in a Dan village quarter and are symbols of her generosity and wealth. Often the handle is carved in the form of a human or animal head, to indicate the spirit on whom the woman relies to achieve her high rank in the community. The handle of this Dan spoon, however, depicts a woman's legs; the bowl replaces her torso and head. The bent and slightly knobby knees, full muscular calves, and delicate feet reflect Dan stylistic conventions, which emphasize rounded, contained forms and careful attention to anatomical detail. Here, the legs are embellished with delicate raised scarification marks along the thighs.

The owners of such impressive spoons demonstrate their hospitality to members of the village during periodic festivals, when they compete to show the extent of their wealth and generosity by scattering rice, peanuts, and other items along village pathways. These large ladles are used to serve rice during village gatherings and are brandished as dance wands and insignia of office on other occasions. The important women who own them must be prepared to offer hospitality not only to townspeople but to strangers as well, who would be their guests on these occasions. In Dan society, generosity and hospitality are a means of achieving stature in the community.

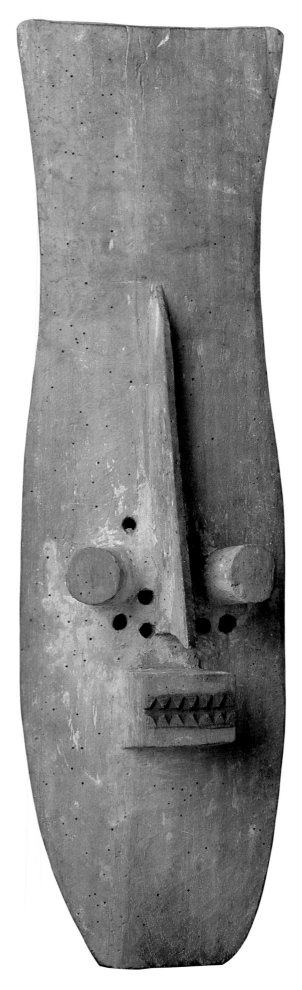

GREBO FACE MASK

The Grebo live in eastern Liberia and the western Ivory Coast. Their social organization relies on a well-developed age-grade system to resolve disputes, emphasize values, and facilitate the socialization of youth. Masks are used by the warriors' age grade to symbolize the spiritual and physical powers required of successful fighters. Their forms are both terrifying and impressive, utilizing projecting horns, an open mouth revealing teeth, and additive materials, such as metal, hair, raffia, and shell to achieve the desired effect. The masks appear at mortuary rituals for members of the age grade; they are also worn in battle and in dances before and after warfare. Although this mask lacks horns and other additive elements, its protruding tubular eyes and open rectangular mouth—with carefully sharpened teeth set off by blue pigment—evoke the aggressiveness expected of warrior masks.

55 *Face Mask*
Liberia and Ivory Coast (Grebo); 19th–20th c.
Wood, pigment; H. 27½ in. (69.9 cm.)
The Michael C. Rockefeller Memorial Collection,
Bequest of Nelson A. Rockefeller, 1979 (1979.206.7)

BAULE FEMALE FIGURE

Baule sculptors create sculpture for two types of spirits—spirit spouses and nature spirits. The Baule believe that every adult is paired with a spouse from the spirit world; a man has a spirit wife and a woman has a spirit husband. A Baule person troubled by misfortune, particularly marital problems or infertility, will seek the advice of diviners, who may report that his or her problems are the result of mystical interventions by a jealous or dissatisfied spirit spouse. The diviner usually advises the person to commission a sculpture to placate the destructive intentions of the spirit spouse. The figure is placed in a shrine in the owner's sleeping room. In the hopes that good fortune will ensue, it is handled frequently and with care and affection.

Nature spirits can also cause problems for Baule men and women, and must also be appeased with a shrine containing sculpture. Although the nature spirits are described as hideous creatures, they prefer sculptures that depict beautiful human beings, with carefully coiffed hair and decorative scarification marks. These are identical in form to figures carved to represent spirit spouses. Figures for nature spirits are often owned by spirit mediums, who use them in the divination process.

Once it has been removed from its shrine context, it is difficult to determine whether a Baule sculpture is a representation of a spirit spouse or a nature spirit. This figure has the closed contours, rounded volumes, and serene facial features typical of many Baule sculptures. Judging from her fallen breasts, it probably depicts a mature woman, one who has already borne children. She has carefully enhanced her appearance with a jaunty coiffure, textured scarification marks, and abundant bead ornaments. The gesture of her arms, clasped behind her back and not hugging her belly as in most Baule sculptures, is enigmatic.

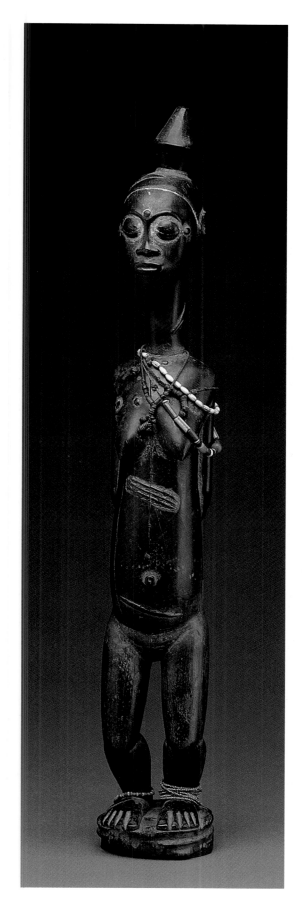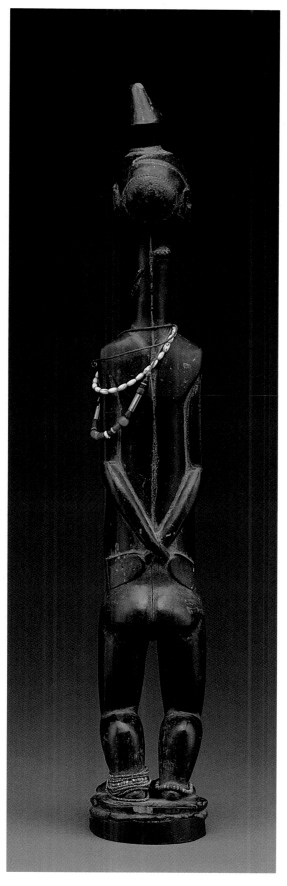

56 *Standing Female Figure* (Front and back views)
Ivory Coast (Baule); 19th–20th c.
Wood, paint, beads, cord; H. 25⅞ in. (65.1 cm.)
The Michael C. Rockefeller Memorial Collection,
Bequest of Nelson A. Rockefeller, 1979 (1979.206.113)

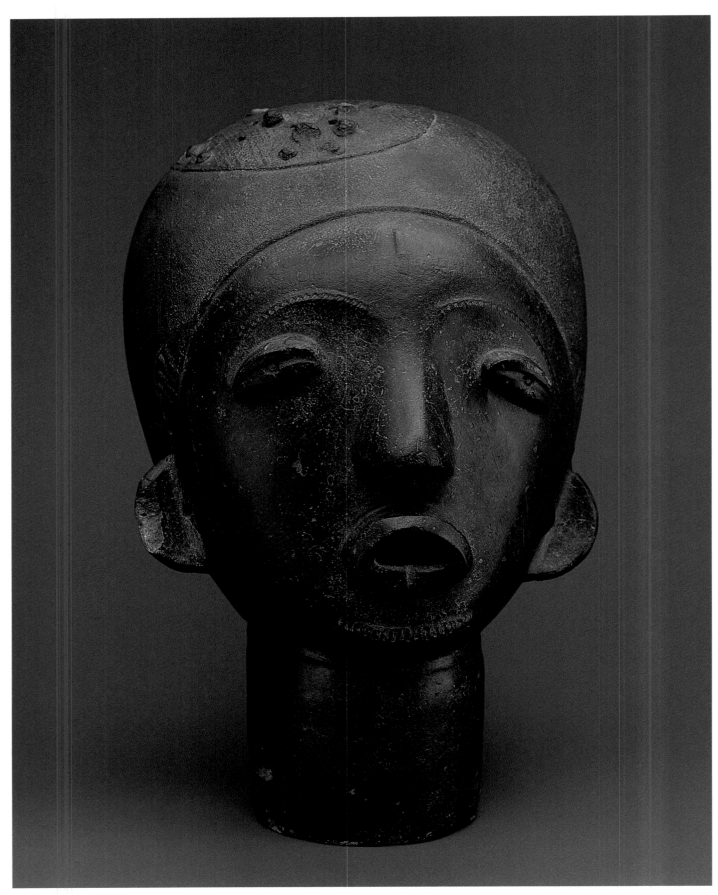

57 *Commemorative Head*
Ghana, Adansi Fomena (Akan); 17th c. (?)
Terra-cotta; H. 12 in. (30.5 cm.)
The Michael C. Rockefeller Memorial Collection,
Gift of Nelson A. Rockefeller, 1964 (1978.412.352)

AKAN COMMEMORATIVE HEAD

The tradition of terra-cotta memorial heads in southern Ghana and the Ivory Coast has been dated to about the seventeenth century, although the tradition has continued to flourish in the twentieth century. The heads, made by women, are placed on the graves or commemorative shrines of members of the royal family and other people of high status. Fragments of smaller heads suggest that full figures in clay were also used as memorials.

In Ghana the tradition of terra-cotta memorial sculpture is strongest in the southern portion of the country, in the regions of Adansi Fomena, Twifo Hemang, and Kwahu. Styles vary according to region. In general, Adansi and Twifo heads are fairly naturalistic while the Kwahu heads are flatter and more stylized. This terra-cotta head is attributed to the Adansi Fomena area, where commemorative heads are characterized by a high degree of naturalism. It has a rounded face, protruding elliptical eyes, an open, projecting oval mouth with full lips, and a delicate triangular nose. The hairline is indicated by an incised line that curves above the forehead. The smooth surface of the face contrasts with the delicately shaped eyebrows and beard and with the circular textured patches of the coiffure. Akan artists use these details, rather than distinctive facial features, to capture the essence of the individual being portrayed.

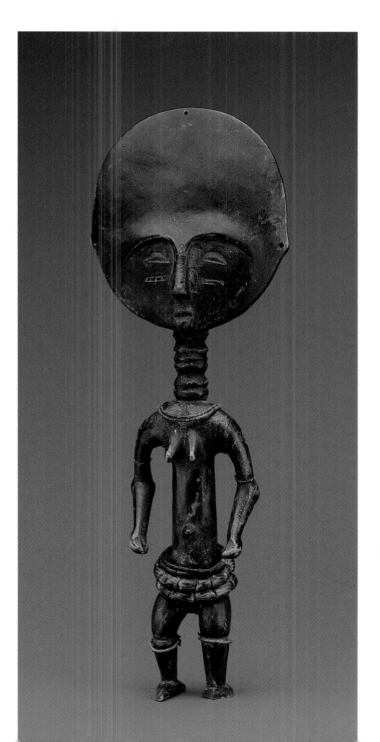

58 *Female Figure*
Ghana (Asante); 19th–20th c.
Wood, beads; H. 10¾ in. (27.3 cm.)
The Michael C. Rockefeller Memorial Collection,
Bequest of Nelson A. Rockefeller, 1979 (1979.206.75)

ASANTE FEMALE FIGURE

The Asante and other Akan groups in southern Ghana carve female figures for use by women plagued with fertility problems. The figures are called *akuaba*, and are believed to ensure the healthy birth of beautiful children. Following a successful birth, the mother may install the sculpture in her own shrine or the shrine of the priest who blessed it. They are also given to young girls as toys.

Asante figures are distinguished by a large, flat disk-shaped head with a high forehead, prominent curving eyebrows that meet the long triangular nose, and tiny facial features set low on the facial plane. The thin edge of the head may be pierced to hold strands of beads and other ornaments. Horizontal scarification marks on the face are medicinal and protect against convulsions. The many rings of the elongated neck indicate good health and beauty. Linear patterns sometimes incised on the back of the head depict hairstyles.

On most Asante *akuaba*, the torso is a simple cylinder terminating in a small round base. Legs and feet are usually not indicated and the stylized arms are carved as tapering cylinders, which project horizontally from the upper torso. The carvings are almost always female, and small breasts are usually indicated. The naturalistic body of this *akuaba* is a marked departure from the highly stylized forms of most examples of the type. Although the round head, attenuated neck, and facial features conform to Asante stylistic conventions, the torso is fully developed with broad shoulders, modeled arms that bend at the elbows, clenched hands, swelling hips, and tiny feet.

FON FIGURE

The city of Abomey, eighty miles north of the coast in the Republic of Benin, was the capital of the Fon kingdom of Dahomey, which began in the early seventeenth century and flourished until the end of the nineteenth century. The extent of Fon influence expanded in the eighteenth century, with the capture of the port city of Ouidah. This strategic location enabled the Fon to prosper as a result of participation in the Atlantic slave trade, an interest that was redirected to the palm-oil trade in the early nineteenth century under the leadership of King Gezo and his son, Glele. The kingdom of Dahomey was renowned for its absolute monarchy, military achievements, and splendid court arts.

Dahomey was also the center for elaborate and dramatic rituals associated with the worship of a pantheon of gods known as *vodun*. This figure, whose arms and lower body have been lost to insects and decay, probably served as a guardian image on a shrine. Fon religious sculptures often incorporate diverse materials that define and direct the object's meaning. Here, for instance, the dog skull that crowns the head and the necklace of vertebrae endow the figure with specific powers—to protect, cure, or influence actions either positively or negatively. A second face, carved on the back of the head, doubles the figure's range of vision and watchfulness. Much Fon art reflects that of peoples, such as the Akan to the west and the Yoruba to the east, who were in contact with Dahomey through trade, warfare, and diplomacy. In this example, however, the austere angle of the mouth and the inscrutable gaze of the grooved, hypertrophic eyes create the majestic, commanding presence that distinguishes Fon works.

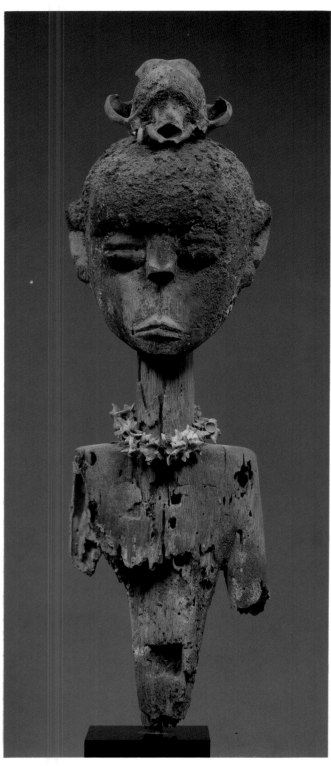

59 *Figure*
Benin (Fon); 19th–20th c.
Wood, bone, sacrificial materials; H. 19½ in. (49.5 cm.)
Purchase, Denise and Andrew Saul Philanthropic Fund
Gift, 1984 (1984.190)

YORUBA HEADDRESS

This unusual headdress reflects the innovation, skill, and imagination of Yoruba sculptors of southwestern Nigeria. Two flat disks with serrated edges serve as opposing faces above a hemispherical cap. The large facial features in high relief are conceived as geometric shapes: bulging oval eyes, triangular nose, and parallel lips. These are stylistic conventions found in many Yoruba carvings, yet they appear surprising and unfamiliar in the context of these flat faces, so different from the rounded, fleshy forms typical of Yoruba art. Long exposure to wood fires has resulted in the headdress's dark smokey surface. Close examination, however, reveals that it was originally painted—and perhaps periodically repainted—with red, yellow, and blue pigments. Three vertical patterns painted on each cheek may represent facial scars; other linear designs are located along the nose and above the eyes on each of the faces. The hornlike projections from the top of the head may represent an elaborate coiffure.

Among the southern Yoruba and their neighbors in the Ijebu area, similar headdresses are worn in masquerades honoring water spirits. Regardless of its function, the mask —deceptive in its apparent simplicity—stands as a striking example of Yoruba artistic skill and ingenuity.

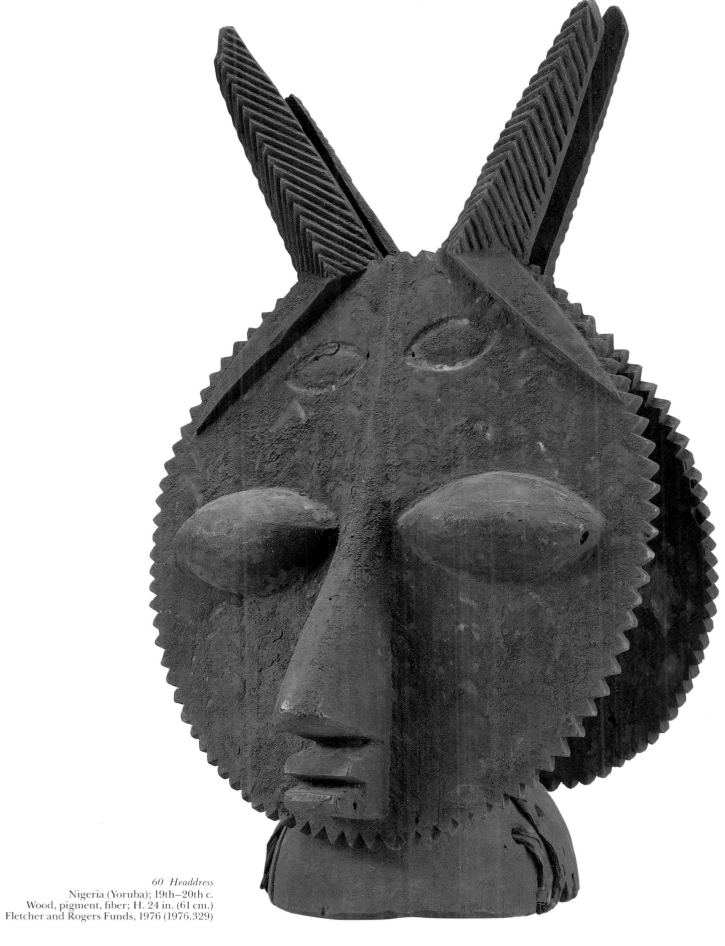

60 Headdress
Nigeria (Yoruba); 19th–20th c.
Wood, pigment, fiber; H. 24 in. (61 cm.)
Fletcher and Rogers Funds, 1976 (1976.329)

BINI-PORTUGUESE SALTCELLAR

The term "Afro-Portuguese" designates a group of ivory carvings, including spoons, forks, horns, and saltcellars, made for Portuguese explorers and traders shortly after their arrival on the coast of West Africa in the second half of the fifteenth century. The two major centers producing these ivory objects are known as Sherbro-Portuguese—for objects made by the Temne and Sherbro-Bullom of coastal Sierra Leone—and Bini-Portuguese—for objects made by carvers of the court of Benin in southwestern Nigeria. In the middle of the sixteenth century, local political upheavals and a decrease in trade relations with the Portuguese signaled the decline of this genre of ivory carving.

Elaborate saltcellars were a common feature in the table settings of European nobility during the Middle Ages and Renaissance, when salt was still a rare commodity. The Afro-Portuguese saltcellars are believed to be based on European metal prototypes, but their styles vary markedly according to their Sherbro or Bini manufacture. Although the subject matter and form reflect European tastes, African aesthetic vocabularies were employed in realizing these elaborately carved objects.

This saltcellar, produced by an ivory carver from the court of Benin, reflects the predilection for meticulous detail in depicting characteristics of leadership and rank. It is comprised of two hemispherical chambers; a third section that served as the lid is missing. It shows four bearded Portuguese men in full regalia. Two of the men are portrayed frontally; elaborately attired in richly textured garments, each wears a cross around his neck. They are flanked by individuals of lesser rank, indicated by their slightly more simplified dress and three-quarter stance. Although essentially European in its form and function, this saltcellar exhibits the same concern for portraying relative rank through details of dress and frontality of pose that characterizes works depicting the king of Benin with his retainers. It also illustrates the preference of Benin artists for filling every available space with carved patterns, creating an ornate surface rich in contrasts of depth, light, and shade.

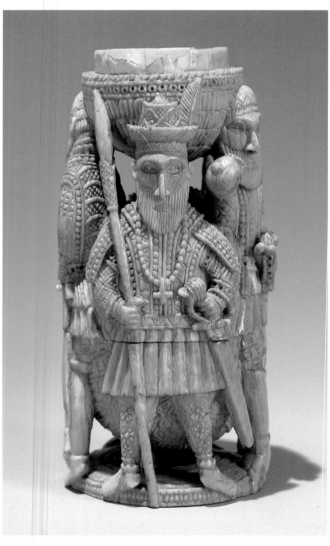

BENIN PENDANT MASK

This ivory pendant mask was probably worn at the hip by the Oba, or king, of Benin; it dates to the early sixteenth century. It is believed to represent a queen mother, an important political leader whose power was centered outside the Oba's palace. The Oba may have worn such a mask at rites commemorating his mother, although today similar pendants are worn at annual ceremonies to rid Benin of harmful spirits.

In Benin, ivory is likened to the color of white chalk, a symbol of ritual purity that is associated with Olokun, the god of the sea. As the source of extraordinary wealth and fertility, Olokun is the spiritual counterpart of the Oba. Ivory fits easily into the constellation of symbols surrounding both Olokun and the Oba of Benin. Not only is it white, but it is itself a form of wealth, and it helped attract the Portuguese traders who also brought wealth to Benin.

The mask is a sensitive, idealized portrait, depicting a face with softly modeled features, bearing inlaid metal and relief-carved tribal marks on the forehead, and wearing a choker of coral beads below the chin. In the projecting flanges above and below the face are carved, stylized mudfish and the bearded faces of Portuguese—two motifs associated with both the Oba and Olokun. Because they live both on land and in the water, the mudfish evoke the king's dual nature as both human and divine. Having come from across the seas, the Portuguese were considered denizens of Olokun's realm who brought wealth and power to the Oba.

61 Saltcellar
Nigeria (Bini-Portuguese); early 16th c.
Ivory; H. 7⅛ in. (18.1 cm.)
Louis V. Bell and Rogers Fund, 1972
(1972.63 a, b)

62 Pendant Mask
Nigeria (Court of Benin); early 16th c.
Ivory, iron, copper; H. 9⅜ in. (23.4 cm.)
The Michael C. Rockefeller Memorial Collection,
Gift of Nelson A. Rockefeller, 1972 (1978.412.323)

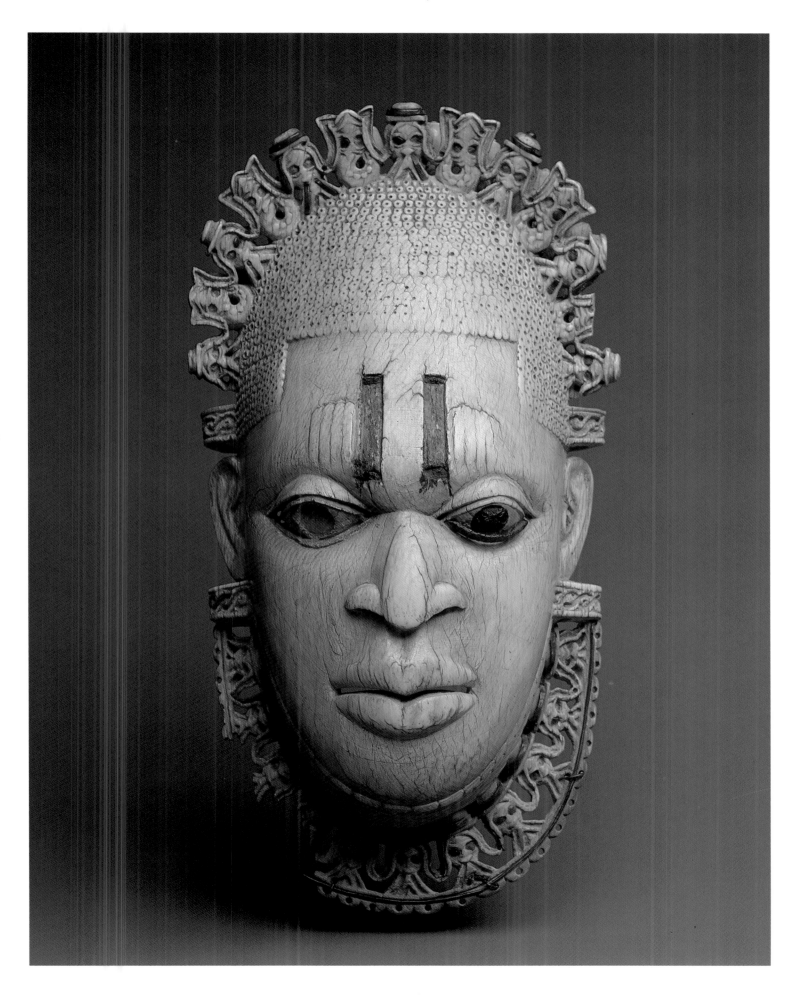

BENIN HORN PLAYER

In the art of Benin, works in bronze can be commissioned only by the Oba, or ruler, or by others with his permission. According to oral traditions, the technique of lost-wax bronze casting was brought to Benin around the end of the fourteenth century from Ife, the ancient kingdom to the north noted for its exquisite cast-bronze commemorative heads. Prior to that time, Benin craftsmen produced hammered and incised, but not cast, bronze ornaments.

Once the technique of lost-wax casting was mastered by the craftsmen of Benin, bronze heads and figures began to appear on the Oba's shrines. This figure of a court musician playing a side-blown trumpet attests to the technical virtuosity of the Benin bronze-casters. The figure's elaborately textured garment depicts the hide of a leopard, an animal associated with the power of the Oba. Similarly, the strands of coral around his neck and chest reaffirm this musician's status in the Benin court, since coral, like bronze and ivory, is a royal prerogative in Benin.

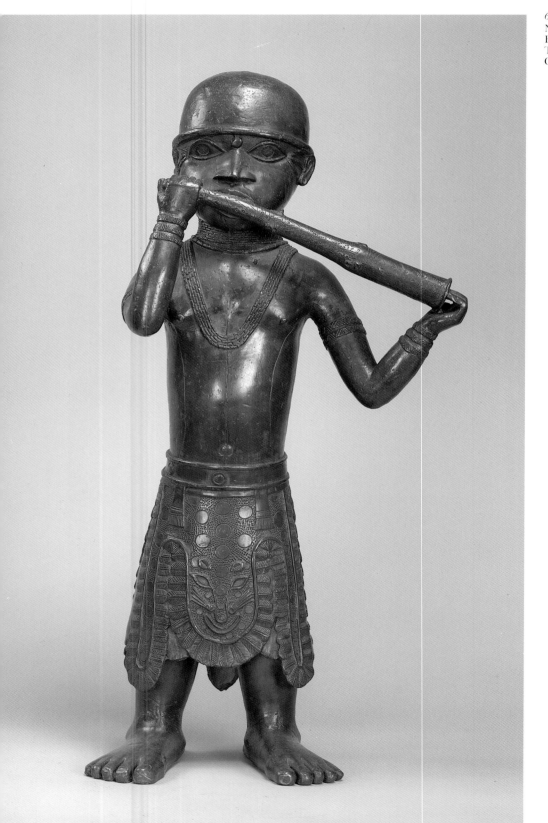

63 Horn Player
Nigeria (Court of Benin); 16th–17th c.
Bronze; H. 24⅞ in. (63 cm.)
The Michael C. Rockefeller Memorial Collection,
Gift of Nelson A. Rockefeller, 1972 (1978.412.310)

BENIN COMMEMORATIVE HEAD

Commemorative heads, which were cast in bronze, adorned the shrines dedicated to the ancestors of the Oba of Benin. The naturalistic style of this head, as well as its thinness and the degree of detail in rendering the facial features and regalia, suggest a mid-sixteenth-century date. The collar and cap with long fringes at the sides and back—all of coral beads—resemble royal dress still worn by present-day Benin leaders. Iron inlays once filled the pupils of the eyes and the rectangular depressions above the nose. A large opening in the top of the head held an elephant tusk, which was carved in relief.

These heads are idealized representations of Benin rulers rather than individualized portraits of the deceased. The softly modeled face, broad nose, full and sensual lips, fleshy cheeks and jaw, all contribute to the naturalism that characterizes Benin heads of this period. The staring eyes and spiral ears show the imprint of Benin stylistic conventions that become even more pronounced in later works.

64 Commemorative Head
Nigeria (Court of Benin); 16th c.
Bronze; H. 9¼ in. (23.5 cm.)
The Michael C. Rockefeller Memorial Collection,
Bequest of Nelson A. Rockefeller, 1979 (1979.206.86)

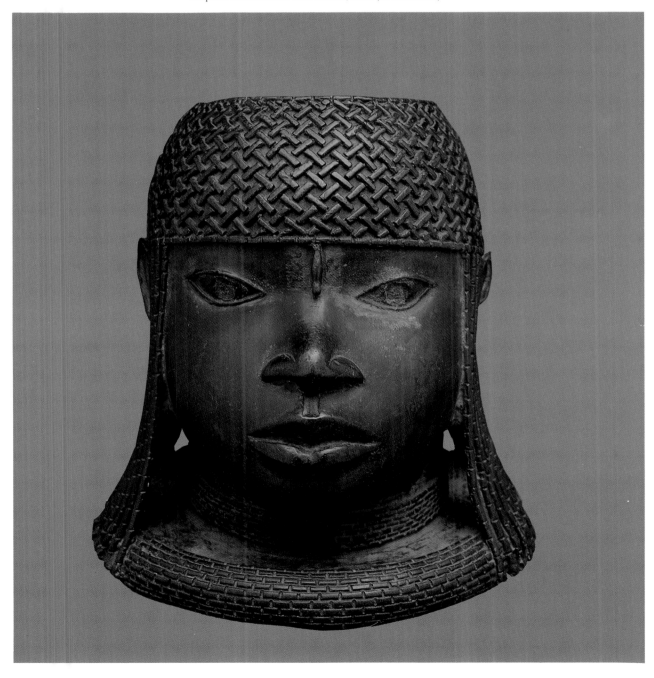

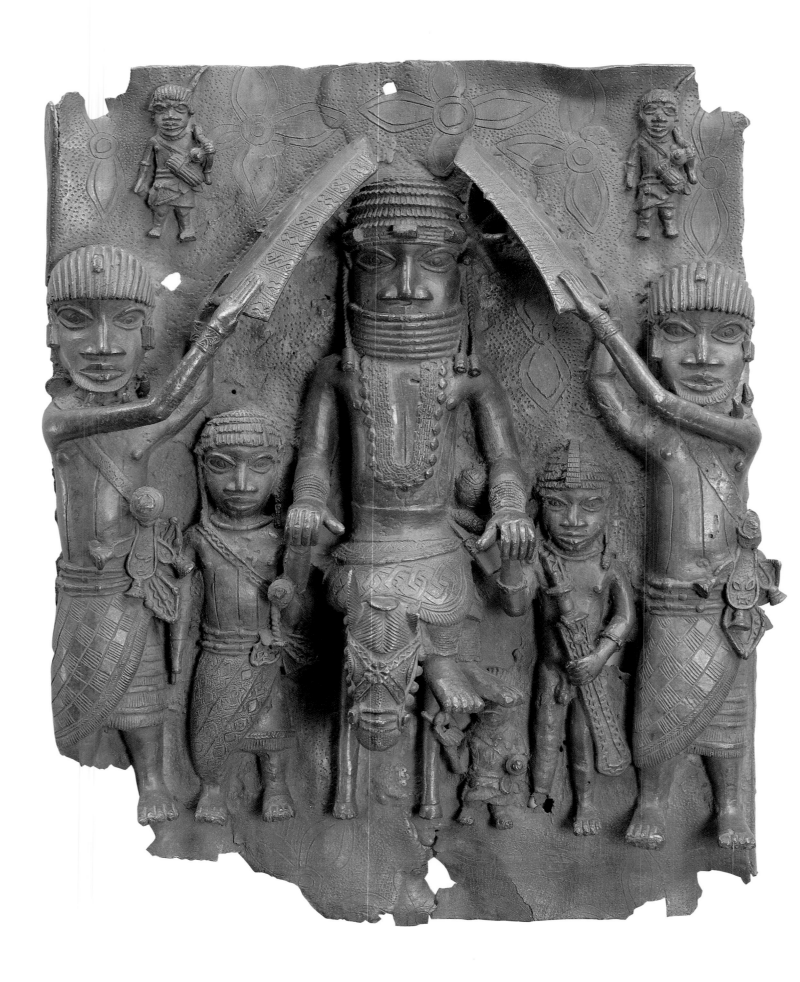

BENIN PLAQUE WITH KING AND ATTENDANTS

The kingdom of Benin was founded in the late thirteenth or early fourteenth century and flourished until the end of the nineteenth century. The hierarchical Benin court was led by the Oba, a divine king assisted by a complex organization of lesser chiefs. The production of traditional Benin arts, under the control of the king, was brought to a halt in 1897, when British troops destroyed the city and looted the palace of its many bronze, wood, and ivory treasures. In 1914, the Benin king was reinstated, and many of the ritual, political, and artistic activities of the court continue to this day.

Cast bronze plaques such as this one once decorated columns supporting the roof of the Oba's palace. Dating roughly from the early sixteenth through the end of the seventeenth century, the plaques are extremely useful as historical documents. They record the daily life of the palace in a wide variety of scenes depicting the Oba and his retinue. This plaque depicts the Oba in full regalia seated side saddle on a horse, a symbol of power and authority. He is flanked by two smaller figures, palace attendants who hold shields over his head. Supporting the king's outstretched hands are two sword bearers, in even smaller scale. Smaller still are two figures hovering in the corners above the Oba, and one below his feet. Artists of Benin used changes in scale to indicate the relative importance of the figures in a group.

The plaque depicts Benin royal regalia in impressive detail. Cloth, jewelry, and headgear differ according to the type of figure and his relative rank within the court hierarchy. The king alone wears a high collar and crown of coral beads. Bronze ornaments, given by the Oba to lesser chiefs and palace retainers, can be seen attached to the knots securing the richly textured wrappers worn by these figures. Quatrefoil motifs incised on the background represent river leaves, and allude to Olokun, the god of the sea, whose blessings caused the Benin kingdom to expand and prosper during the period when plaques such as this were made.

65 *Plaque: Mounted King and Attendants*
Nigeria (Court of Benin): 16th–17th century
Bronze; H. 19½ in. (49.5 cm.)
The Michael C. Rockefeller Memorial Collection,
Gift of Nelson A. Rockefeller, 1965
(1978.412.309)

LOWER NIGER FIGURE OF A WARRIOR

This figure depicts a standing warrior in full regalia. He wears a stiff leather wrapper tied in a point over his hip. In his right hand he brandishes a shield, and in his left he holds a sword (the blade is broken). Around his neck are a large square bell and a necklace made of glass beads and leopard's teeth that would have been filled with protective medicine to ensure success in battle.

The clay core of this cast bronze figure has been dated by thermoluminescence tests between 1455 and 1640. The rectangular marks on the forehead, the cap of coral beads, and the large bell worn on the chest are elements found in the art of Benin, but the figure's vigorous gestures and the upward sweep of his leather waistcloth present a sense of vitality and motion uncommon in Benin art. This and the somewhat rustic style of the figure suggest that it was not made at the court of Benin, but perhaps in a Yoruba center under Benin influence.

66 *Figure of a Warrior*
Nigeria (Ijebu or Owo [?]); 1455–1640
Bronze; H. 12¾ in. (32.4 cm.)
Purchase, Edith Perry Chapman Fund, Rogers, Pfeiffer,
Fletcher and Dodge Funds, Gift of Humanities Fund,
Inc., by exchange, Mrs. Donald M. Oenslager
Gift, in memory of her husband, Geert C. E. Prins Gift,
and funds from various donors, 1977 (1977.173)

67 *Shrine*
Nigeria (Western Ijo); 19th c.
Wood, paint; H. 25½ in. (64.8 cm.)
The Michael C. Rockefeller Memorial Collection,
Purchase, Matthew T. Mellon Foundation Gift, 1960
(1978.412.404)

IJO SHRINE

Among the western Ijo, who live in the Niger River Delta region of coastal Nigeria, shrines of this type represent Efiri or Ivwri, a personal guardian spirit. The Ijo claim that the tradition of Efiri shrines comes from the Edo-speaking peoples to the northwest. The shrines may belong to an individual, a family, or a clan. They are associated with notions of aggressiveness and personal accomplishment and, to a certain extent, may be compared with shrines dedicated to a person's right hand. The latter are found among a number of southern Nigerian peoples, such as the Edo, Igbo, Igala, and Urhobo, as well as the western Ijo.

The principal iconographic elements that comprise an Efiri shrine include a four-legged animal, one or more human figures, and various symbols of power and aggression. The animal, possibly a stylized leopard, is the most important feature in the carving, as it actually represents the spirit. In this carving, the animal is reduced to four legs, a massive rectangular head, and a large gaping mouth with teeth exposed—essential characteristics of a wild and terrifying beast. Four large fangs enhance the ferociousness of the image.

The central human form is male and represents the shrine owner, sitting above or astride the wild animal. The geometric forms used to portray the animal spirit are repeated in the seated figure, notably in his angular head and rectangular mouth, which is open, revealing teeth. Power symbols in the form of specialized headgear, horns, weapons, staffs, and the like are common in these shrines. In his right hand, this figure holds a cup for pouring libations to the shrine; in his left, he holds a fan, a sign of status and wealth. Human heads or skulls adorn the legs of the shrine; they may be protective or refer to success over one's enemies.

68 Cap Mask
Nigeria (Lower Cross River); 19th–20th c.
Wood, leather, metal, bone, cane, paint;
H. 11 in. (27.9 cm.)
The Michael C. Rockefeller Memorial Collection,
Bequest of Nelson A. Rockefeller, 1979 (1979.206.266)

Page 92: text

CROSS RIVER CAP MASK

(Page 91)

Along the Cross River, which flows through the forests of southeastern Nigeria and Cameroon, artists cover face, helmet, and cap masks with skin sheaths that add a startlingly lifelike quality to their wood sculptures. The skin, usually that of an antelope, is stretched taut over the carved form while still soft; as it dries it is held in place by cords and tiny pegs that are later removed. Bone teeth and painted metal eyes are inserted, heightening the impression of realism. The skin-covered masks are ornamented according to local modes of body decoration. In this example of a woman, the two front teeth are cosmetically chipped, and circular tattoos at the temples and wedge-shaped designs painted on the cheeks are indicated. Two floral motifs on the back of the head resemble shaved patterns worn by women in this area, and the inserted wood pegs represent tufts of hair. Cap masks such as this are attached to a basketry cap worn on top of the head; a long cloth gown conceals the rest of the wearer's head, face, and body.

The Ejagham (also known as Ekoi and Keaka) are often credited with the origin of skin-covered masks, although the technique has spread throughout the Cross River area, making ethnic identifications difficult. The Cross River has been a major thoroughfare for trade since the sixteenth century, and consequently there has been much contact and competition between the ethnic groups in this region. Art forms and the right to use them are purchased, often from distant peoples, in an effort to demonstrate wealth and accumulate prestige and fame. Skin-covered masks are owned by associations whose membership is limited by sex, age, wealth, or accomplishment. These groups, which include hunters' and warriors' societies, age grades, women's associations, and societies of the "rich and gorgeous," stage performances to celebrate the initiations and funerals of members.

69 Figure of a King
Cameroon (Bangwa); 19th–20th c.
Wood; H. 40¼ in. (102.2 cm.)
The Michael C. Rockefeller Memorial Collection,
Purchase, Nelson A. Rockefeller Gift, 1968
(1978.412.576)

BANGWA FIGURE OF A KING

The hierarchical societies of the Cameroon Grasslands support a wide range of leadership and prestige arts associated with royalty and persons of high rank. These arts include architectural elements, regulatory society masks, carved human figures, wooden stools, palm-wine containers and drinking vessels, pipes, flywhisks, textiles, and many other objects. In addition to wood, Cameroon royal arts may be made of brass or ivory, and many objects are profusely covered with imported glass beads, a symbol of wealth and status.

Grasslands art is among the most expressive in sub-Saharan Africa. This carving represents a royal ancestor, whose high status is emphasized by the knotted prestige cap and elaborate necklace he wears. The figure displays additional symbols of leadership: in his left hand he holds a pipe with a long stem and small bowl, and in his right is a gourd, a common container for palm wine. The sculpture would have been kept in the royal treasury along with many other objects reserved for use by the Fon, the political ruler of a Grasslands kingdom. Palace art is displayed in the Cameroon Grasslands during royal funeral ceremonies, public appearances by the Fon, and annual festivals. This figure's aggressive stance, open contours, swelling volumes, and expressive facial features—bulging eyes, broad nose, and open mouth revealing teeth—reflect the drama and vitality characteristic of art in the Cameroon Grasslands.

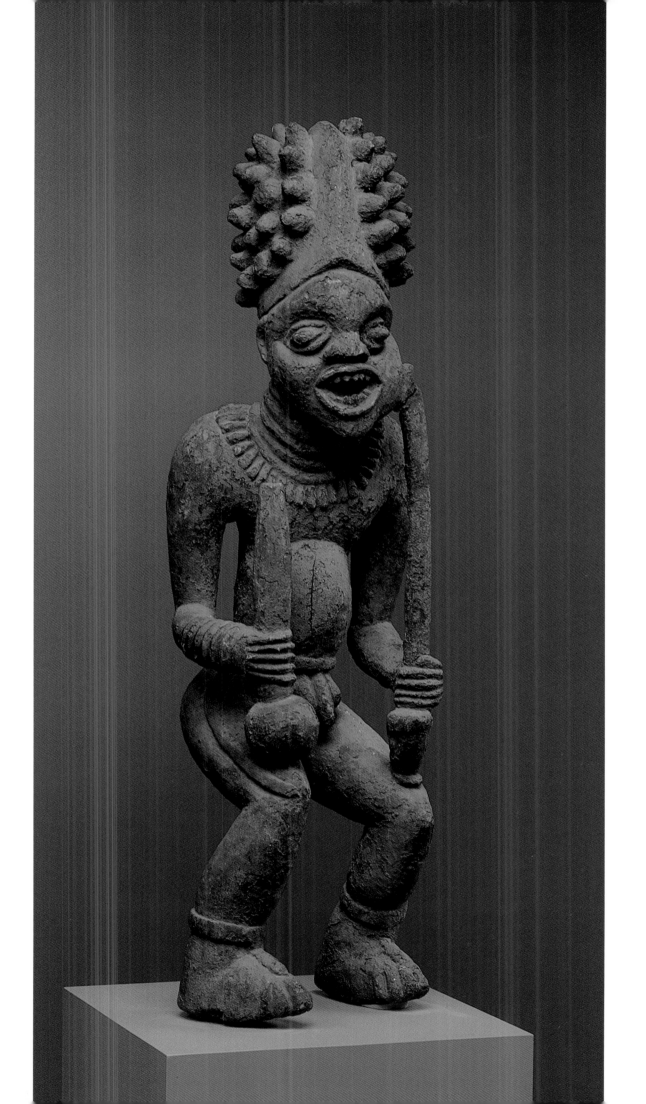

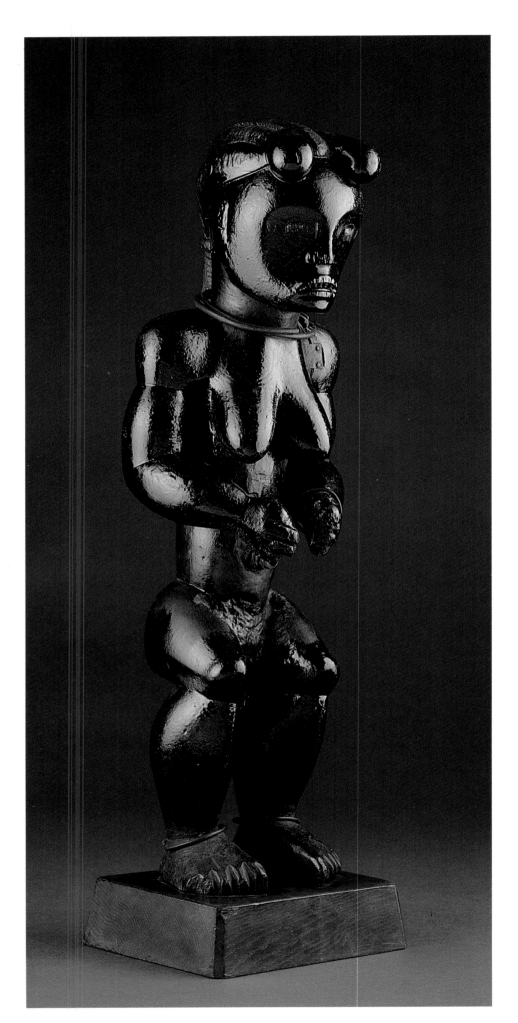

70 *Reliquary Guardian Figure*
Gabon (Fang); 19th–20th c.
Wood, metal; H. 25¼ in. (64.1 cm.)
The Michael C. Rockefeller Memorial
Collection, Gift of Nelson A.
Rockefeller, 1965 (1978.412.441)

Page 96: text

71 *Reliquary Guardian Head*
Gabon (Fang); 19th–20th c.
Wood, metal; H. 18¼ in. (46.4 cm.)
The Michael C. Rockefeller Memorial
Collection, Bequest of Nelson A.
Rockefeller, 1979 (1979.206.229)

Page 96: text

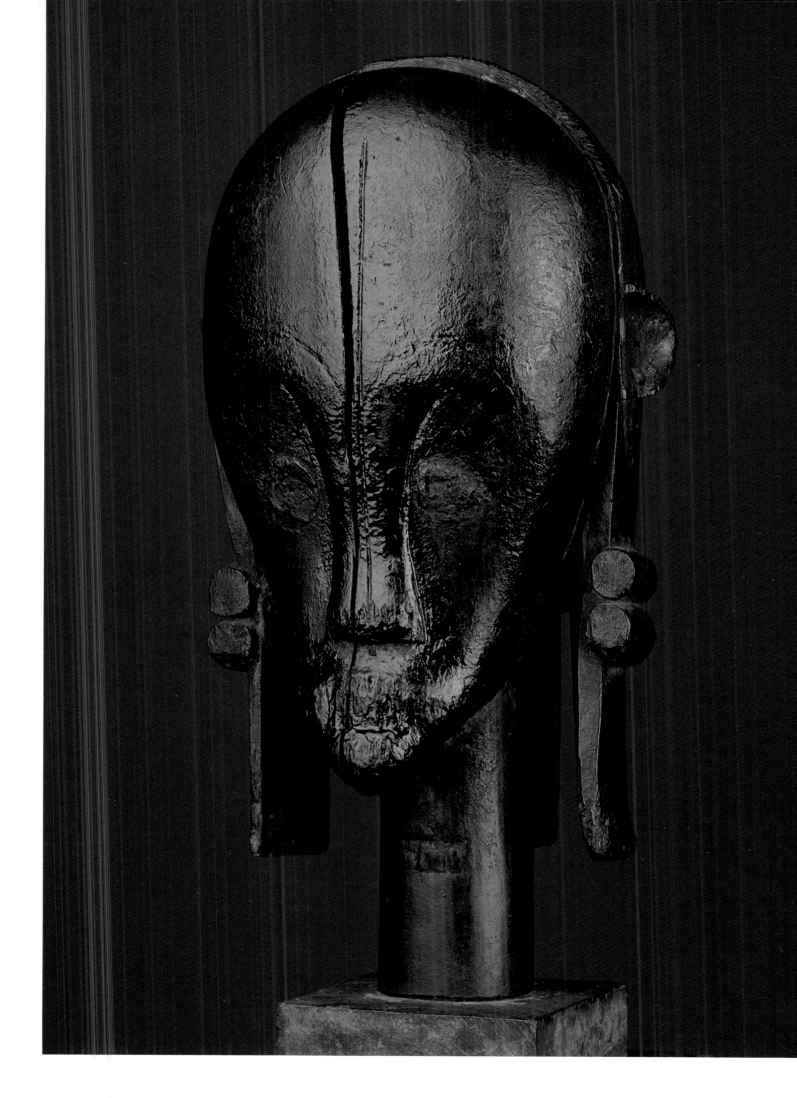

Fang Reliquary Guardian Figure and Head

(Pages 94–95)

Among the Fang of Gabon, wooden figures and heads are placed on top of bark containers that hold the skulls of important clan ancestors. These images are used in the ancestor cult, *bieri*, to guard the sacred contents of the boxes against the forbidden gaze of women and uninitiated boys. Heads and figures may be male or female, and they are embellished with elaborate coiffures, facial scarification, jewelry, horns, and other emblems of power. They have lustrous black surfaces, the result of purifying applications of palm oil that many Fang sculptures continue to exude long afterward.

The sculptures exemplify the qualities the Fang admire in people—tranquillity, vitality, and the ability to hold opposites in balance. This ideal is shown in the reliquary figure, which juxtaposes an infant's large head with the developed body of an adult, and which contrasts a static, symmetrical pose and passive, expressionless face with the tension of bulging muscles.

The Fang head achieves a sense of balance through other means, visible in the interplay of convex and concave surfaces, the contrast of straight lines and sinuous curves, and the subtle gradations in planes. Fang sculpture held special appeal to many early twentieth-century European and American artists. Both these works were once owned by the sculptor Jacob Epstein; the figure on the left, had previously been in the collection of the painter André Derain.

72 Face Mask
Gabon or Congo (Kwele); 19th–20th c.
Wood, paint; H. 20¾ in. (52.7 cm.)
The Michael C. Rockefeller Memorial Collection,
Bequest of Nelson A. Rockefeller, 1979 (1979.206.8)

Kwele Face Mask

Kwele masks appeared in ceremonies of the Beete cult. Like the cults of other ethnic groups in the western Equatorial Forest region, Beete relied on the power of the skulls of deceased family members to combat the negative forces that threatened to destroy the village with famine, disease, or war. Beete involved making a potent medicine to be consumed by the entire village.

The preparations for this great ceremony were extensive, and while they were in progress, masks appeared in the village to create the "hot" atmosphere necessary for the medicine to be effective. The masks (*ekuk*), which represented both forest spirits and children of Beete, would come out in the morning and afternoon to lead the villagers in dancing. The masks were not affiliated with particular lineages and could therefore unite people of rival factions, creating the sense of harmony and cooperation that was the goal of Beete.

There were several types of *ekuk*, with both wooden and fiber masks, representing animals or humans with animal attributes. Downward-curving horns frame this mask's elongated oval head. It is relatively flat, with slight changes in plane clearly delineated by changes in color. At the center is a concave, heart-shaped face highlighted in white, features that link Kwele masks with the carving styles of a number of other groups of the Equatorial Forest region.

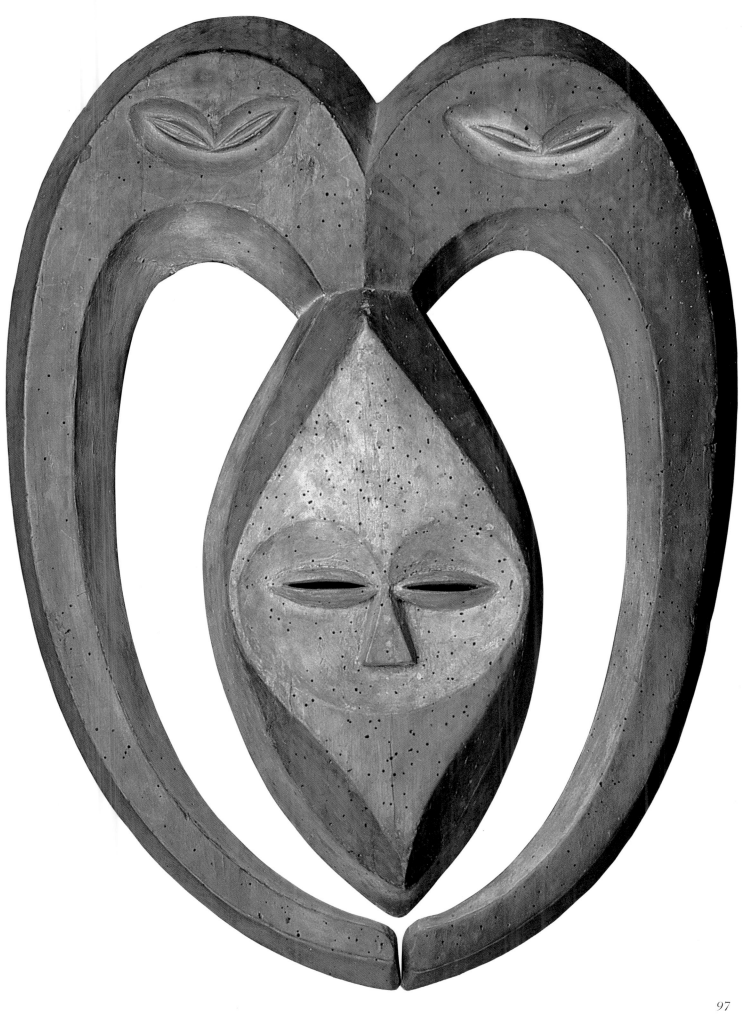

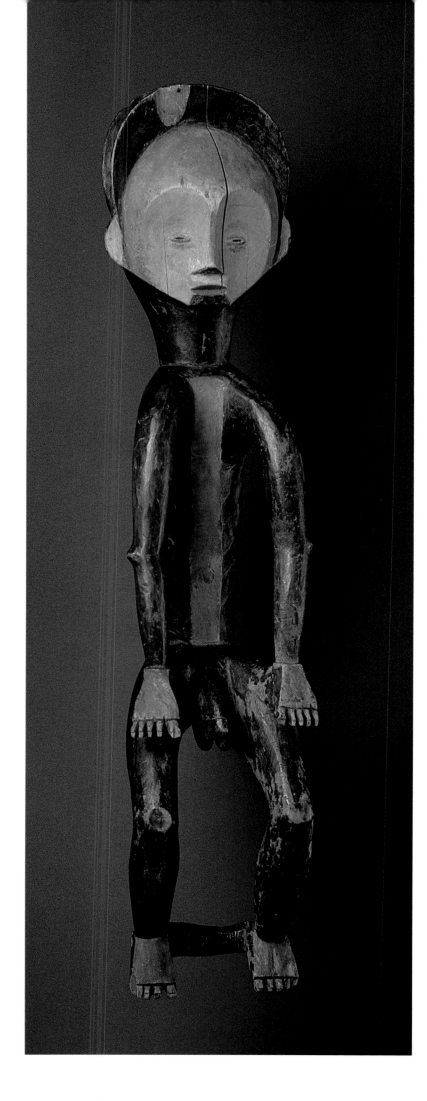

73 *Figure of a Hanged Man*
Zaire (Mbole); 19th–20th c.
Wood, pigment; H. 32⅝ in. (82.8 cm.)
The Michael C. Rockefeller Memorial Collection,
Purchase, Nelson A. Rockefeller Gift, 1968 (1978.412.571)

MBOLE FIGURE OF A HANGED MAN

The social structure of the Mbole, who live in the Lomami River region of north-central Zaire, is dominated by Lilwa, a men's association that commissions masks and figures for use in initiation rituals. This Mbole sculpture depicts a hanged man. Its presence at Lilwa rites warns young initiates and established members alike of their terrible fate should they reveal the secrets of this powerful organization. The figure also serves as a general warning to Mbole society to avoid antisocial behavior, such as witchcraft, adultery, theft, and violence. In the past, Lilwa members carried out the punishment by hanging the transgressors. While not portraits of offenders, the carvings perpetuate their names and their memories.

This figure's forward-thrusting shoulders, rounded back, and bent knees evoke the hanging posture. White pigment emphasizes the face and connotes association with the spirit world. The bulging forehead and heart-shaped face link Mbole sculptures with those of other ethnic groups in the Equatorial Forest, from the Fang, Punu, Kota, and Kwele of Gabon and Congo, to the Lega of northeastern Zaire. The detailed carving of fingers and toes, elbow and knee joints, and genitalia give this image a degree of naturalism not commonly found in Mbole carvings.

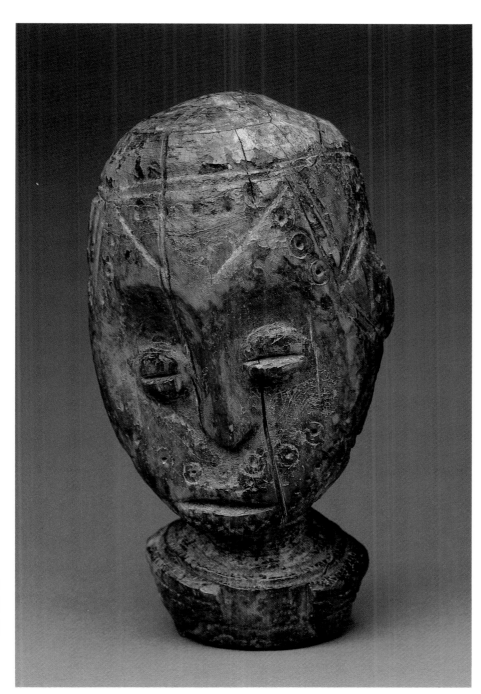

74 Head
Zaire (Lega); 19th–20th c.
Ivory; H. 8½ in. (21.6 cm.)
The Michael C. Rockefeller Memorial Collection,
Bequest of Nelson A. Rockefeller, 1979 (1979.206.207)

Lega Head

The Lega live in northeastern Zaire. Their masks and figures represent the easternmost extension of the heart-shaped face style complex. Most Lega art is associated with Bwami, a men's society responsible for maintaining the social, spiritual, and political equilibrium of the community through teachings that illustrate morally acceptable behavior. Wood and ivory masks, figures, and heads appear in the initiation rites into the highest grades of Bwami. They illustrate proverbs citing both good and bad behavior, and symbolize the spiritual presence and power of the ancestors whose teachings and guidance are passed down through the generations.

Lega objects embody complex and multiple meanings.

Objects made of ivory indicate the great prestige accruing to a man who has pursued the teachings of Bwami to its highest level. Because of their hardness, ivory objects illustrate concepts such as the continuity and permanence of Bwami ideals. Likewise, the smooth polished surface of ivory is compared to the refined and perfected nature of the Bwami initiate. This ivory head is ornamented with incised dotted circles, a motif that represents traditional scarification patterns and alludes to Lega notions of both outer physical beauty and inner moral excellence.

76 Figure
Zaire (Kongo); 19th–20th c.
Wood, nails, cloth, beads, shells, arrows, nuts,
paint; H. 23⅛ in. (58.7 cm.)
The Michael C. Rockefeller Memorial Collection,
Bequest of Nelson A. Rockefeller, 1979
(1979.206.127)

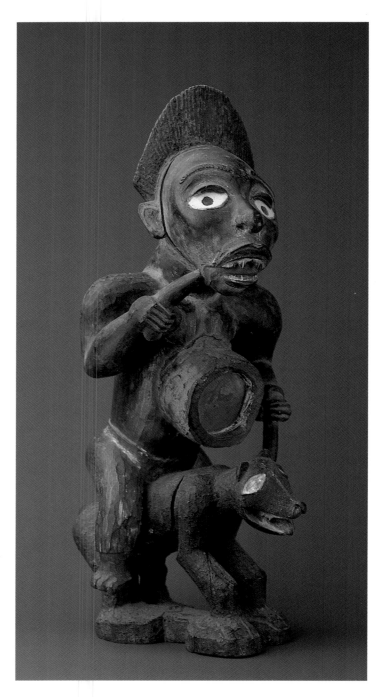

75 *Figure: Man on a Dog*
Zaire (Kongo); 19th–20th c.
Wood, glass, paint; H. 13 in. (33 cm.)
The Michael C. Rockefeller Memorial Collection,
Purchase, Nelson A. Rockefeller Gift, 1966
(1978.412.531)

Two Kongo Figures

The Kongo are noted for figures known as *minkisi* (sing: *nkisi*). These power or oath-taking figures are carved wooden images that incorporate diverse, power-charged ingredients into the completed form. After a sculptor carves such a figure, a ritual specialist inserts the magical, medicinal ingredients that endow it with power into a cavity built up of resin on the figure's abdomen or back. These ingredients may include special earths, stones, bone, bits of metal and glass, bark, leaves and seeds, bird beaks, feathers, and other items. They comprise the medicine that may function positively to protect the owner and his family from disease, misfortune, and the evil intentions of others, or negatively, by directing these powerful forces against sorcerers and enemies. The cavity and its contents are often sealed with a mirror that also serves to deflect evil intentions. As the figure is used and reused, other materials such as nails, bits of cloth, and knotted cords may be added, gradually altering its appearance.

The figure on the left is riding a dog, a motif used frequently in Kongo art to denote the figure's ability to sniff out and hunt down evil. With his left hand he guides the reins of his running mount, and in his right, he holds a medicinal plant believed capable of driving out evil spirits. The tip, which he once held in his mouth, has broken off. The active, asymmetrical gestures of this image are common in Kongo art, and contrast with the more reserved and contained movements seen in most African sculpture. Kongo figural carvings are also noted for their expressive naturalism, especially in the facial features. Eyes are often wide open and emphasized with white pigment or bits of porcelain or glass. The open mouth reveals filed teeth, which the Kongo find beautiful, but which also suggest the figure's aggressive quest to rout out evil.

The figure on the right demonstrates the dramatic alteration Kongo figures undergo to imbue them with power. In addition to the nails that project from the surface of the carving, the figure bears an accumulation of objects attached to a cloth collar. These include miniature human figures, strands of beads and cloth, powder and snuff containers, cowrie shells, arrows, and vegetal material. Except for the serene, softly rounded face, these added elements completely conceal the sculpture. Each element tied onto the figure, and each nail driven into it, represents an oath or vow, or an incident in which the figure's powers were invoked.

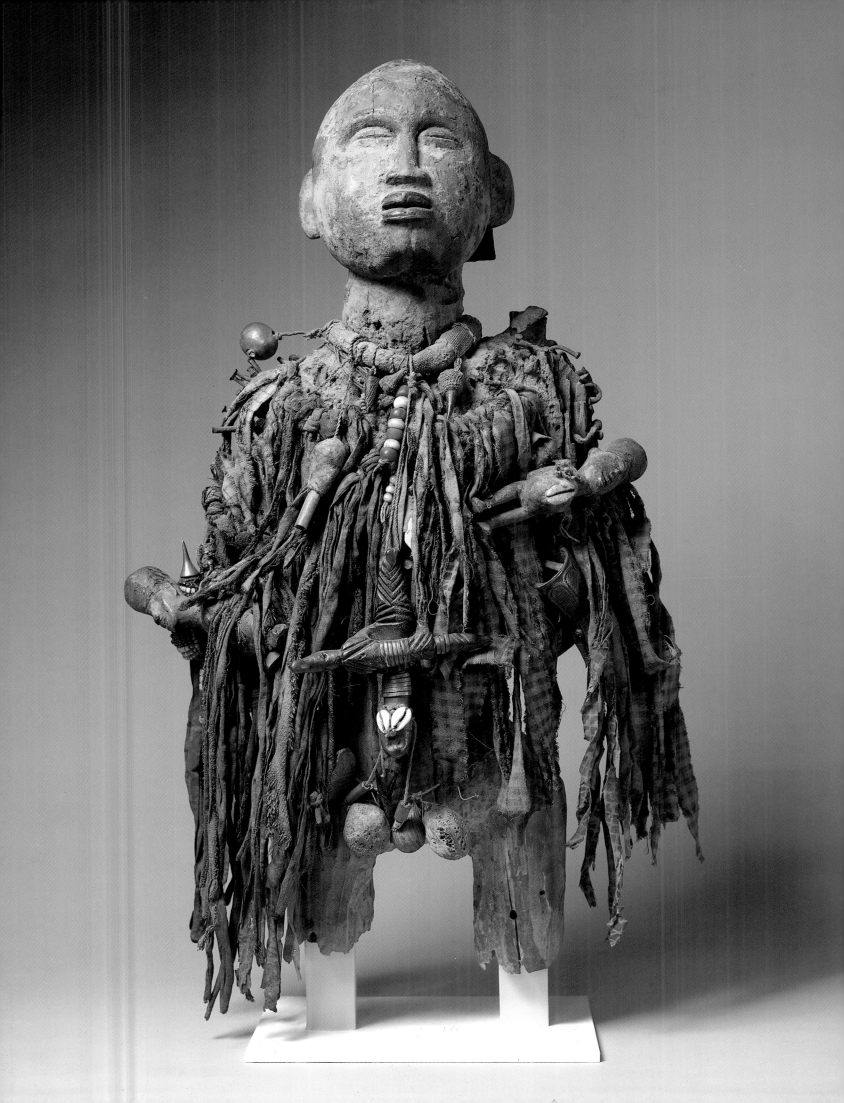

77 *Figure*
Zaire (Dengese); 19th–20th c.
Wood; H. 21¾ in. (55.2 cm.)
The Michael C. Rockefeller Memorial Collection,
Gift of Nelson A. Rockefeller, 1969 (1978.412.520)

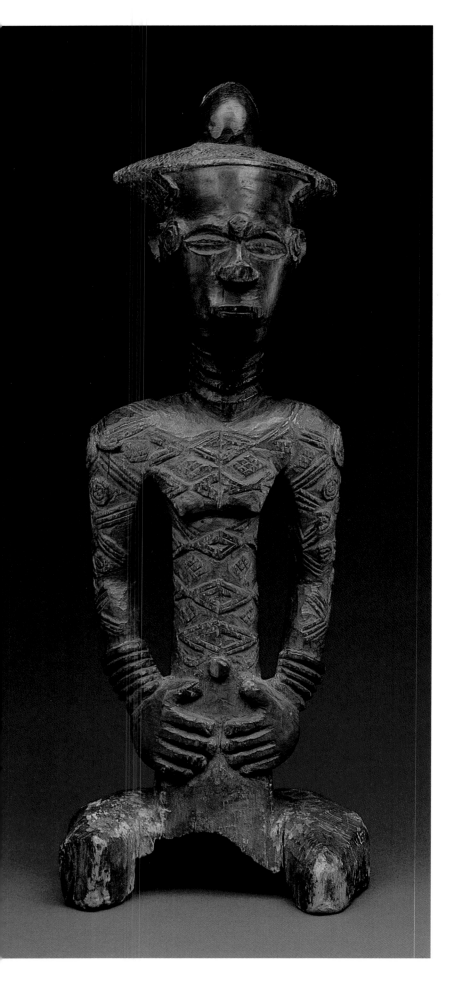

DENGESE FIGURE

The Dengese of central Zaire live to the north of the power-
ful Kuba kingdom. Although the Kuba eventually surpassed
the Dengese chiefdoms in size, wealth, political power, and
abundance of art works, royal historians recall a period in the
distant past when the Kuba paid tribute to a Dengese ruler.
The two groups share many of the same symbols of author-
ity, among them luxurious raffia-cloth garments, leopard
skins, ceremonial weapons, and musical instruments.

Dengese political power is in the hands of the Itoci, initi-
ated men who at great expense acquire the right to wear
insignia of rank. Dengese figures depict these dignitaries,
who are identified by a plaited raffia-fiber hat with a raffia-
covered wooden cylinder projecting from the top. The sculp-
tures are conceived as half-figures, and the elongated torso
terminates in a semicircular base that may actually represent
stylized legs. The figures achieve a fair degree of naturalism
through the depiction of the broad shoulders, muscular
chest, and rounded torso and arms. The elaborate coiffure
and cap, neck rings, and bracelets confirm the individual's
high rank. Dengese figures reflect the stylistic influence of
their Kuba neighbors. This is particularly evident in the fig-
ure's swelling forehead, emphasized by the shaved angular
hairline, and his broad facial features. The close association
between the Dengese and the Kuba is further suggested by
the figure's complicated geometric scarification patterns,
which are reminiscent of decorative motifs found on Kuba
cut-pile cloth and intricately incised wooden objects.

LUBA NECKREST

Many Africans sleep on wood neckrests, which support the neck and leave the head and elaborately coiffed hair free. Some ornate hairstyles can take up to fifty hours to create and can last two to three months if properly protected. Such coiffures are a sign of wealth and privilege, an indication that the wearer has the leisure to devote to her appearance and is not likely to engage in strenuous labor. Although small and intimate in function, the carved wood neckrests often match the aesthetic appeal of the hairstyles themselves.

This neckrest was made by a Luba artist known as the "Master of the Cascade Coiffure" because of the hairstyles that characterized his works. Sculptures attributed to this artist feature sharp jutting forms that enclose open space. In this example he has also introduced movement, making the figure raise one knee and bend the other behind her, and a sense of humor—the figure's raised left hand supports her hair just as the object itself is intended to do.

78 Neckrest
Zaire (Luba); 19th c.
Wood, beads; H. 6⅜ in. (16.2 cm.)
Gift of Margaret Barton Plass in honor of
William Fagg, C. M. G., 1981 (1981.399)

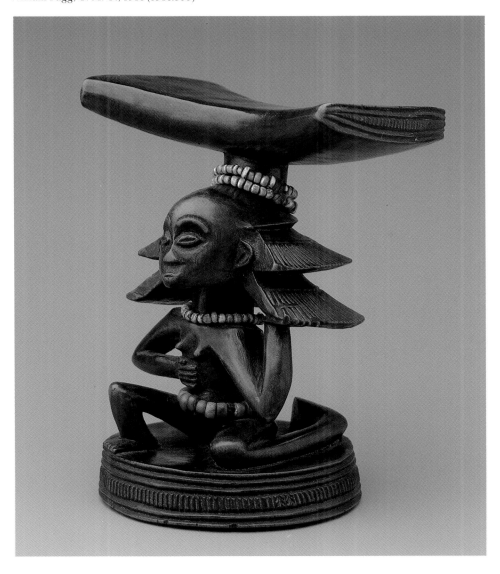

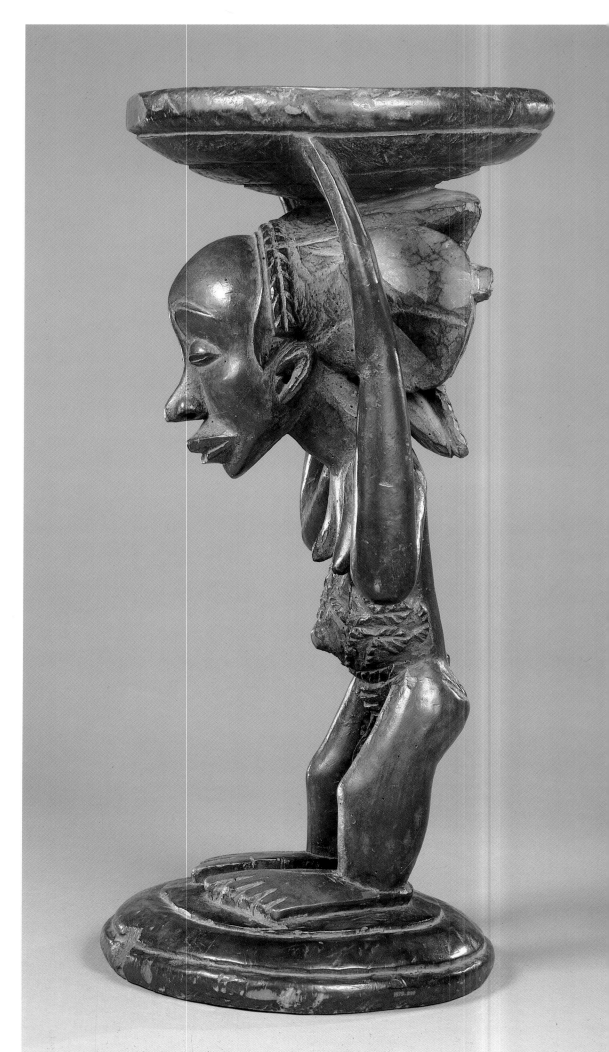

79 Stool
Zaire (Luba-Hemba;
The Buli Master); late 19th c.
Wood; H. 24 in. (61 cm.)
Purchase, Buckeye Trust and
Charles B. Benenson Gifts,
Rogers Fund, and funds
from various donors, 1979
(1979.290)

Opposite: front view

Page 106: text

104

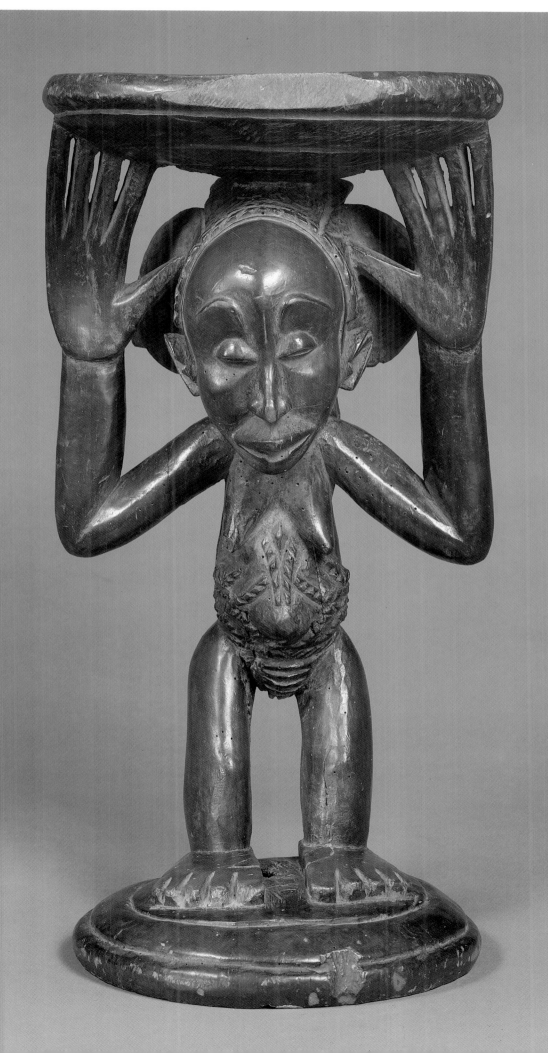

80 Female and Male Figures
Zaire (Tabwa); 19th–20th c.
Wood, beads; H. 18¼ in., 18½ in. (46.4 cm., 47 cm.)
The Michael C. Rockefeller Memorial Collection, Purchase,
Nelson A. Rockefeller Gift, 1969 (1978.412.591,592)

Luba Stool with Female Figure *(Pages 104–105)*

This Luba chief's ceremonial stool was carved by the Buli Master, one of the best-known individual carvers of traditional African art. The stool is one of about twenty carvings attributed to this artist, who was named after a village in eastern Zaire where a number of his sculptures were collected. Many of these works entered European collections around 1900, and it is believed that the Buli Master was active in the middle to late nineteenth century. A single figure in this style was recently found about 100 kilometers from Buli; its owners identified it as the work of Ngongo ya Chintu, a famous carver of the nineteenth century, possibly the man we know as the Buli Master.

This stool is supported by a standing figure who holds up the round seat with the tips of her elongated fingers. Her torso and buttocks are embellished with intricate raised scarification patterns, and she is further adorned with a projecting four-lobed coiffure that forms a cross at the back. The Buli Master's unique style is evident in the figure's elongated face, prominent cheekbones, and emotional intensity.

Stools with caryatid figures were among the most significant possessions of a Luba chief, who would be seated on such a stool during the investiture ceremony that confirmed his right to rule. Luba royal insignia often depict women whose high status is indicated by their elaborate, time-consuming coiffures and ornamental scars. Women, particularly the female relatives of the king, were instrumental in expanding and unifying the Luba kingdom. By marrying chiefs in outlying areas, these women created a bond of kinship between the provinces and the royal court.

Tabwa Female and Male Figures

The Tabwa live in southeastern Zaire and northeastern Zambia, in the area bordered by Lakes Tanganyika and Mweru. Beginning about 1860, their arts flourished in response to the sudden increase in power and wealth that Tabwa chiefs experienced during the height of the slave and ivory trade. The Tabwa drew upon the art forms of neighboring peoples with more established traditions of leadership arts, such as the Luba to the west, the Hemba and Boyo to the north, and the Nyamwezi to the east. Tabwa sculpture declined rapidly in the early decades of the twentieth century under the impact of Christian missionaries and colonial administrators.

Tabwa figure sculptures are noted for their decorative surface treatment, which often takes the form of symmetrical patterns of raised cicatrices arranged in parallel lines on the forehead, cheeks, torso, and back. These patterns conform to traditional modes of body decoration, and were intended to be both erotic and symbolic. For the Tabwa, scarification was a means of perfecting the body through motifs alluding to positive social values and cosmological principles. In addition to scarification patterns, Tabwa body arts include bead jewelry and elaborate hairstyles; the female figure has a short, textured caplike hairstyle adorned with horn medicine containers, while the male's coiffure is long, plaited, and drawn to the back of the head.

Tabwa wood figures represent the ancestors; this pair probably depicts important members of a Tabwa chief's lineage. They functioned as protective images and as a visual reinforcement of political authority.

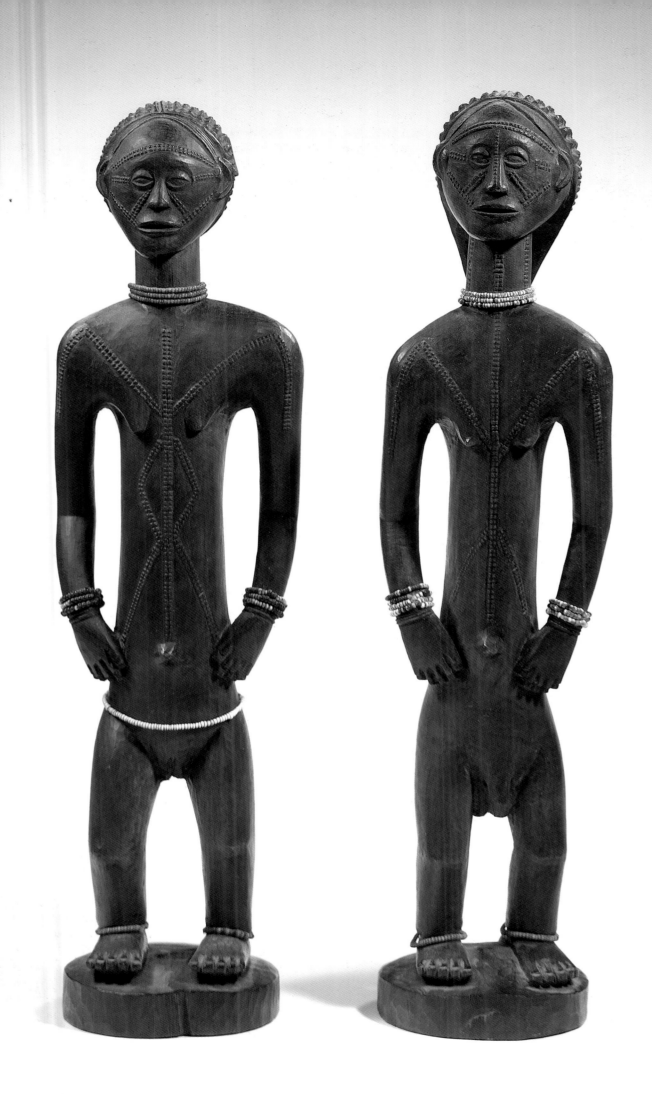

THE AMERICAS

In the late Pleistocene epoch, probably some forty thousand years ago, when Canada was covered with an ice cap almost three thousand meters thick, Asian hunters made their way onto the American continents. During that Ice Age the shallow waters between Siberia and Alaska receded, making a land bridge on which the first "Americans" crossed into an arctic country similar in every way to the arctic Asia they had left. As the cold and ice came and went during the following millennia, new arrivals moved farther east and farther south, and, by 10,000 B.C. man had reached the very limits of the continents. At about this time, too, the Ice Age was ending, and the northern land bridge disappeared; the Americas were isolated from the Old World.

Ancient Americans then began their own development, and from late in the second millennium B.C. until the middle of the second millennium A.D., civilizations of social complexity and artistic richness flourished. The most successful were those of Mesoamerica and Peru. In Mesoamerica, the area composed primarily of modern-day Mexico and Guatemala, the first great art was made by the Olmec peoples, and in Peru by the peoples of Chavín. Many centuries later the Aztecs and Incas ruled these respective lands, and would dominate them until the New World was invaded by the Spaniards in the early sixteenth century.

The newly arrived conquerors were the first collectors of ancient American art, an art referred to today as Precolumbian. (Precolumbian, which literally means "before Columbus," is the general term applied to all the peoples and civilizations of pre-European America.) The initial encounters with Precolumbian art produced awe and astonishment among the unprepared viewers, and much was sent back to Europe. There the works intrigued kings and popes and inspired curiosity among the learned. News of the great discoveries in the new and strange lands was disseminated quickly. By the end of the sixteenth century, however, interest in the Indian kingdoms of the Western Hemisphere had waned, and it was not until the nineteenth century that it was rekindled.

The renewal of interest in Precolumbian art began in the early part of that century, when scientific travelers such as the erudite Alexander von Humboldt journeyed to the New World to take back to Europe all manner of information, specimens, theories, images. By the end of the century these travelers included collectors who were diligent in their efforts to fill the exhibition halls of the newly founded natural history museums. In Spain in 1892, the four hundredth celebration of the discovery of America focused much attention on the ancient heritage of Indian America and created a local involvement with that heritage among the participating Latin American republics that has not diminished since.

The twentieth century has seen the burgeoning of New World archaeology as an academic discipline, and the opening up of Precolumbian America to an awareness and scrutiny unattainable before. Sophisticated methods of excavation, documentation, and analysis, plus the numbers of practitioners currently working in the field, have led to an unprecedented amount of information that grows almost daily. In all of the ancient Americas, writing systems were developed only in Mesoamerica, leaving vast stretches and countless peoples without a posthumous voice. The findings of archaeological investigation are thus necessary to gain a measure of understanding of these ancient peoples.

The peoples of Precolumbian America were many and varied. They spoke a multitude of languages, lived in widely diverse environments, organized themselves with varying degrees of social complexity, and in general responded to the challenges of civilized life with solutions that differed from many of those of the Old World. Ancient American art was equally multifaceted. It was made to serve a wide variety of functions, in materials that range from the precious to the humble, in shapes of tradition and invention, and in dimensions that are monumental or the size of a thumbnail. Today these differences and diversities are a challenge to the modern viewer, as heretofore little-known peoples, places, histories, beliefs, and objects are accessible to

those who are interested, and to pursue them is to be rewarded with revelations of a new world.

Today the study of Precolumbian America usually follows geographic breakdowns, a scheme that will be used here. Moving from north to south and reflecting the collections of The Metropolitan Museum of Art, the organization that follows is: Mesoamerica, the Caribbean Islands, lower Central America, northwestern South America, and Peru.

Mesoamerica

Ancient Mesoamerica extended from present-day northern Mexico south to Honduras, a large stretch of land that had two regions of particularly significant Precolumbian history: the Mexican area to the west of the Isthmus of Tehuantepec, and the Maya area to its east. The Mexican and Maya peoples, while closely allied in many aspects of life and thought, nonetheless spoke disparate languages, were governed by separate hierarchies of rulers, planned and built cities in different ways, and dedicated monuments of distinct configuration to themselves and their gods. Although their art and architecture shared many aspects, here too individual stylistic character existed.

The many common aesthetic features of the two areas may have originated in a mutual artistic "ancestor." Both the Mexican and Maya peoples were indebted to the Olmecs, the politically powerful and artistically gifted inhabitants of the coastal swamps of southern Veracruz and Tabasco at about 1000 B.C. The Olmecs appear to have formalized many of the concepts upon which significant achievements in art and architecture were made, achievements substantially elaborated by later peoples. As master sculptors, the Olmecs left a sculptural legacy of monumental works of basalt, small personal objects of jade, and carefully crafted ceramic figures and vessels that, while infinitely significant in itself, reverberated profoundly throughout the Precolumbian era. Types of objects, materials used, methods of manufacture, iconographic systems, scale, function, and placement, were among the many influential aspects of the sculpture, during both Olmec and later times.

The Olmecs were at home in the low-lying swamps of the Gulf Coast, a hot, humid region where they built their main centers. Small in comparison to the grandiose cities of later eras in Mesoamerica, the centers of San Lorenzo in Veracruz and La Venta in Tabasco flourished, sequentially, from about 1200 to 600 B.C. San Lorenzo, the earlier of the two, was built on an artificially enlarged plateau. Its civic and ceremonial heart was made of earth mounds and rectangular courts that were studded with stone sculpture, not one example of which is thought to have survived the centuries in its original location. Among these sculptures are the Colossal Heads, enormous basalt carvings (the largest stands almost ten feet tall) of helmet-encased heads that may depict dynastic rulers. In spite of their great size, the heads are worked with a sensitivity and realism that greatly enhance their astonishing presence.

Although evidence has been found in many parts of Mesoamerica, the exact nature of the Olmec "expansion" is unclear. The question is debated among specialists, as indeed is the actual locus of Olmec origins, but conclusive evidence has eluded modern excavators. Olmec remains are chiefly artistic in form and come from such widely separated locales as the highland valleys of central Mexico, Guerrero to the west, and El Salvador far to the south. They are either small, portable—and tradeable—items of jade and other greenstones, well-finished ceramic vessels and figures, or relief sculptures on living rock. Paintings on such rock are also known.

By the middle of the first millennium B.C., Olmec power was declining, and other peoples were beginning the processes of coalescence and growth that would culminate in the rise of cities. The greatest of Mexican cities was Teotihuacán, built in a central highland valley of the same name. Teotihuacán was and is a legendary place. In its own day, the city's religious, political, economic, and artistic clout was such that no area of Mesoamerica remained untouched by one or more aspects of it. Centuries later, when the Aztecs ruled Mexico, Teotihuacán was revered as the birthplace of the sun, and sacred pilgrimages were made to its ruins. Today foreign tourists to Mexico City routinely visit *las ruinas*, where the great Pyramids of the Sun and the Moon —originally immense temple platforms—challenge them to climb the rugged imposing stairways, and to look down on the remains of America's earliest great city.

Teotihuacán's era of splendor lasted from the first through the seventh century A.D. Built on a grid system with a strong central axis, it was rigorously planned. The central axis, now called the Street of the Dead, begins at the Pyramid of the Moon and proceeds south for a full three miles. At the top of the street, civic and religious constructions cluster; massed pyramid-temples, royal palaces, luxurious residential buildings, and the great marketplace were located in this area. "Downtown" Teotihuacán was meant to impress resident and visitor alike. An ancient building boom/urban renewal project in the third and fourth centuries changed the face and size of the city and gave it its extant aspect. The metropolis is estimated to have had a total of 150,000 to 200,000 inhabitants in about A.D. 600.

While the largest, Teotihuacán was not the only Mexican capital to rise to prominence in the first millennium A.D. In other regions local centers, each with its own special qualities, prospered during these centuries. Monte Albán, the jewel-like capital of the Zapotec peoples, protected itself high on a beautiful hilltop in Oaxaca. In Veracruz, the inhabitants of Tajín added large relief-decorated courts to their ornate city. The eighth-century downfall of Teotihuacán, however, was to have an effect on them all. The civic and ceremonial center of Teotihuacán was burned, and with the destruction its population dispersed and its power and prestige declined rapidly. The disaster was to have a ripple effect throughout Mexico, signaling the beginning of a period of shifting political and ethnic struggles, of old timers displaced and newcomers succeeding. Far to the south, beyond the Isthmus of Tehuantepec, even the Maya area was touched by the fall of Teotihuacán.

East of Tehuantepec, the Maya area was large. It included territory in southern Mexico and Yucatán, Guatemala and Belize, and also parts of El Salvador and Honduras. Its

Precolumbian history was a long one, as was that of Mexico. Its highest period, that of its most visible remains, occurred in the first millennium after Christ, when Maya city-states, ruled by dynastic families, vied with one another for political ascendancy. Rivalry for artistic supremacy, too, prevailed among them. Elaborate feats of religious and secular building were undertaken, feats that have left behind some of today's most renowned New World archaeological sites. Palenque and Yaxchilán in Mexico, Tikal and Quiriguá in Guatemala, and Copán in Honduras are among the more spectacular of Maya ruins. They have intrigued outsiders ever since travelers began to visit them in the nineteenth century. Each site has its own artistic character, largely bestowed upon it in the seventh and eighth centuries when ambitious kings, eager to aggrandize themselves, their families, and their accomplishments, commissioned new works at an amazing pace.

Tikal, in the rain-forest lowlands of Guatemala's Petén district, was perhaps the grandest of all Maya centers: Fully five Great Temples, built in the eighth and early ninth centuries, and so designated because of their huge size, today tower like sentinels above the high forest canopy. The North Acropolis, Tikal's ritual core, was initiated as a sacred place in about 200 B.C., when ceremonial structures were erected on it. By A.D. 900, when Tikal was in full decline, an estimated total of one hundred buildings, primarily pyramid-temples, had been raised on the by-then massive platform of the North Acropolis. Between A.D. 292 and 879, large stelae bearing relief likenesses of fully accoutred rulers were carved at Tikal. The ruler images were accompanied by hieroglyphic inscriptions including dates that can be correlated to the Christian calendar and so are known exactly. Tikal declined, as did the other lowland Maya sites, for reasons as yet undetermined, although explanations have long been sought by modern researchers.

The ancient Maya left records of their intellectual as well as material attainments. They were accomplished at arithmetic and calendrics, and put astronomy at the service of their complex calendars. Their writing, too, in hieroglyphic form, was significantly accomplished. In all of Precolumbian America, writing systems were developed only in Mesoamerica—the earliest traces date to 600 B.C. in Oaxaca —and the Maya system was particularly complex. The Maya put hieroglyphic inscriptions on all manner of things— stuccoed onto buildings, worked into stone sculpture, painted onto pottery vessels, incised on jade, shell, and bone objects. Such inscriptions usually have to do with kings and queens and their right to rule. The reporting of dates relative to these rulers was also an important aspect of the Maya hieroglyphic system.

As the Maya centers in the lowlands of the Petén and surrounding regions weakened, those to the north on the Yucatán Peninsula began to take on prominence. Uxmal, with its handsome, well-resolved architecture, was to flourish into the eleventh century, and Chichén Itzá, farther east in the scrub vegetation of the peninsula, grew to be the greatest city of its era in Mesoamerica. Chichén experienced the presence of Toltec peoples from central Mexico whose arrival has traditionally been placed at A.D. 987. The buildings for which the renowned site is known—the commanding pyramid-temple called the Castillo, the Great Ball Court, the Temple of the Warriors, and the Court of the Thousand Column Colonnade, for instance—are so unlike Maya works that they are believed to illustrate Toltec presence. By the beginning of the thirteenth century, Chichén Itzá, too, was to have lost the source of its power.

Far to the north, the Mexican Toltecs had their own capital at Tula. In the central highlands, close to the earlier Teotihuacán, Tula was at its height in the tenth century when the Toltecs are said to have reached Yucatán. Tula's greatest fame, however, lies in legend, for it was believed to be the home of the ruler-priest Quetzalcoatl, the Feathered Serpent. Quetzalcoatl was deified and became the ultimate Mesoamerican culture hero, responsible for many aspects of learning and civilized life. Great honor was accorded him and his original home at Tula. The Toltecs were further honored by the peoples who came after them. The Aztecs, the last in the line of indigenous central Mexican rulers, revered the Toltecs as ancestors and as wise men.

The Aztecs were a barbarian people from the north when they settled in the Basin of Mexico in the fourteenth century. A ragtag group, they had traveled searching for a place to settle when they finally located one on an island in Lake Texcoco. There they founded their capital, Tenochtitlán, in 1325. Their precipitous rise to dominion over Mexico began about a hundred years later, when they defeated their overlords, the rulers of Azcapotzalco, the political power and major city on the lake. With that victory, the Aztecs began the formation of what would prove to be the most powerful Indian state ever to exist in North America.

More is known today about the Aztecs than about earlier Mesoamerican peoples because a great deal of information about them was written down after the Spanish Conquest of the early sixteenth century. With this information, much late-period Mexican history can be reconstructed. The names of the rulers and the dates of their reigns are recorded; Aztec gods are identified and their powers remembered; myths and poetry still survive. Sources such as these relate that under the astute leadership of Itzcoatl (r. 1428–40) and Montezuma I (r. 1440–69) the foundations of the Aztec state were firmly laid. The Aztec rulers influenced every aspect of life—politics, religion, art, even history was rewritten—creating the Mexican world the Spaniards were to encounter in 1519.

Aztec art, while it includes all the arts that a powerful preindustrial society could produce, from architecture to sculpture to luxury objects to crafts, for ceremonial or military or funerary or everyday purposes, achieved a particular high point in its sculpture. Great, symbolically complex stone sculptures were carved as strong, fierce images of imposing character. These monumental sculptures were placed among the many temples and palaces of Tenochtitlán, turning it into an imperial capital. Stone sculpture proliferated in central Mexico as well, and carvings of deity images were placed in shrines and sacred places throughout the countryside. Deity images were made in other mediums besides stone; wood, resin, bone, clay, and even dough were used. These images were adorned for special occasions with paper

decorations, capes, and jewelry and could carry banners, weapons, and the like.

With the arrival of the Spaniards under Fernando Cortés in the Basin of Mexico, and with the imprisonment of the Aztec ruler Montezuma II (r. 1502–20), the Precolumbian era in Mesoamerica was drawing to a close. The end came in 1521, after the long and bloody seige of Tenochtitlán, when the imperial city was destroyed, its inhabitants diseased and defeated. Upon its ruins was to rise a new metropolis, built by Spaniards and now called Mexico City.

The Caribbean Islands

In ancient times, the Caribbean Islands were inhabited by peoples who began migrating out of South America's Orinoco River Basin in Venezuela perhaps as early as the fifth millennium B.C. They moved from island to island northward across the chain of the Lesser Antilles until they reached the islands of the Greater Antilles—Jamaica, Puerto Rico, Hispaniola, and Cuba—where the journey ended. Successive migrations, all from the Orinoco Basin, brought peoples of differing knowledge and skills northward, and by the sixth century A.D. the islands had established their own manners and customs, which, while firmly rooted in South American origins, were nonetheless clearly their own. The artistic culmination of island developments was the art of the Taino peoples of the Greater Antilles. In about A.D. 1000, the Taino began the amplification and elaboration of Caribbean forms into works of art of great individuality, an evolution that was still in progress at the time of the Spanish conquest some five hundred years later. Works made of stone, bone, shell, wood, ceramic, and textile survive today, many of them made for ceremonies within a religious system of considerable complexity.

It was on the Taino island of Hispaniola that the first European settlement in the New World was founded. Christopher Columbus built the small fort of La Navidad there in December of 1492. Located in the northwestern region of the island, La Navidad was within the territory of Goacanagari, one of the five Taino chiefs then ruling Hispaniola. The 28,000-square-mile island had an estimated population of 400,000 people, primarily living in villages close to the shoreline, as communication by waterway around and between the islands was the norm. The island populations were decimated quickly after Columbus's discovery, through the excessive demands for labor and tribute and the dissemination of European diseases.

Lower Central America

Lower Central America is a region that has been detailed by modern archaeological researchers in order to give shape to the area's Precolumbian cultural boundaries. The outlined territory includes present-day El Salvador and Honduras below the Maya area, and all of Nicaragua, Costa Rica, and Panama. The physical geography of the long, narrow region is divided into three parts, with a lowland section on each coastal side and a highland hump running between them. The Atlantic/Caribbean side is much the larger of the two coastal regions and is made up primarily of lush tropical rain forests, while the Pacific side is narrower, drier, and less overgrown. In Precolumbian times, lower Central America was influenced on the western or Pacific side by Mesoamerica, and on the eastern or Atlantic side by northern South America. The Isthmus of Central America was thus not only the physical meeting place of the North and South American continents, but also a meeting place, if not an overlapping place, of the distinct cultural traditions of these continents.

Although there was a considerable diversity of peoples in the long, tapering Isthmus, artistic beginnings are thought to date to about the same time throughout the region. By 300 B.C., local chiefs appear to have been sufficiently well established to give rise to a taste for luxury goods such as carefully made and well-finished pottery vessels. In some areas, objects of volcanic stone, such as decorated grinding tables (metates)—used for grinding primarily but not exclusively corn—began to be carved, and by the time of Christ, personal ornaments of jade and similar jadelike stones were placed with the honored dead. Jade was used in northern and central Costa Rica and is an example of the influence of Mesoamerica, where the carving of jade ornaments had long been practiced.

Jade ornaments would be replaced by those of gold as the centuries passed. Goldwork and its technology were introduced into the Isthmus from South America in the first centuries after Christ, and among the early gold objects were those with strong links to Colombia in the south. Worked gold objects were first deposited in Isthmian burials at about this time, and at Sitio Conte in central Panama—perhaps the most famous of all Central American gold-yielding sites —gold objects were placed in important burials from about the fifth to the ninth centuries. Gold would remain a favored medium for the fabrication of personal ornaments in Panama and Costa Rica until the sixteenth century.

As the population of the Isthmus grew, political relationships became increasingly more complex, and toward the end of the first millennium A.D. there was a marked increase in the number of warrior communities. The location and construction of many sites were chosen for defensive concerns, and warrior imagery appears in art.

Northwestern South America

At the northwestern tip of South America today is the country of Colombia, with its long sea coasts—the Atlantic/Caribbean and the Pacific—and a mountainous interior. The great Andean mountain chain rises in Colombia, stretching to the southwest through Ecuador, Peru, and Chile, and running thousands of miles to the bottom of the continent. Geographically, the mountains divide western South America into three parts: the low coastal regions, the high intervening Andes, and the lowlands of the giant Amazon basin. Each of these sizeable regions had Precolumbian populations of differing cultural patterns and different histories, which ar-

chaeological research has begun to unravel in recent years. Caribbean Colombia in the northeast, primarily a wet, low-lying, tropical region, had close ties to Caribbean Central America in Precolumbian times. Southwestern Colombia had closer connections to Ecuador, and it is possible that early, seminal influences came from this southern region.

Caribbean Colombia and Caribbean Central America appear to have had similar ancient histories, with chiefdoms existing by the time of Christ. The elaboration of luxury goods as an indication of power and rank followed. In Caribbean Colombia, gold was an important luxury item, and it was much used for personal ornaments. The Sinú region, with its three ancient provinces of Zenufana, Finzenú, and Panzenú, of which accounts were recorded after the Spanish conquest, was famous for its gold, and the Tairona peoples, living farther east in the Sierra Nevada de Santa Marta, were master goldsmiths. They produced—apparently in the last centuries before the conquest, when gold had been worked in Colombia for about a thousand years—some of the most exquisitely detailed cast-gold objects of the ancient Americas.

The earliest American remains of cultural significance come from the Pacific coast of Ecuador. Small stone and ceramic images of women and men, dating from the third to the second millennium B.C., are among its better-known manifestations. Ecuador continued as a cultural frontrunner during the subsequent millennium, when its contributions to southwestern Colombia may have been made. During the first millennium A.D., considerable regionalism, with its attendant stylistic diversity, was to characterize southwestern Colombia. Gold was widely used here for personal ornaments as it was in Caribbean Colombia. Among the many gold styles, that associated with the Quimbaya region is much favored today. Originally identified in the nineteenth century, Quimbaya gold includes well-modeled, well-finished works of technical sophistication that date to the last half of the first millennium A.D. At the end of that millennium, southwestern Colombia went through a period of unification that resulted in a greater uniformity of style—at least in goldwork—during the remaining Precolumbian centuries.

Peru

On the western side of South America, the three-part geographical division of lowlying coast, intervening mountains, and tropical lowlands is pronounced in Peru. The narrow Pacific coast is cooled by the Humboldt current that runs its cold water alongside the coastal lands, turning them into deserts with little or no rainfall for long stretches. The aridity of the Peruvian coast has preserved a great deal of Precolumbian art and architecture that would not have survived in wetter environments. Adobe architecture, wood sculpture, and textiles are among the many things that have endured in greater quantity there than elsewhere in the Americas.

Temple architecture and fancy ceramics were produced in Peru by the middle of the second millennium B.C. Built on the coast and made of adobe, the early temples are consistent in plan, with numerous rooms arranged U-fashion around a court. They are clear antecedents to the stone-faced temple at Chavín de Huántar high in the central Andes. Although the Chavín temple, which dates from the ninth to the second century B.C., has long been associated with early Peruvian artistic developments and has given its name to them, recent archaeological research has revealed that it is a recipient and not an instigator of the significant artistic tradition. The stone sculpture of the temple has an intricate and highly specific symbolic system that has equivalences in objects of many other mediums. Ceramic, bone, wood, textile, gold, and adobe objects are all embellished with the intricate imagery that is found throughout much of early Peru. Under what circumstances the similarity of these features arose is not yet known.

The arid coastal valleys of both the north and south were inhabited by peoples who shared, more or less directly, in the early iconic system evidenced at Chavín. During the last millennium before Christ, the inhabitants of the southern Ica Valley, for instance, made ceramic bottles and bowls that emphasized Chavín-type feline imagery. In the north, in the valleys of Chicama, Moche, and Jequetepeque, Chavín presence was very strong.

By 200 B.C., when Chavín's influence was ebbing, other regional developments had already begun. Some of the most extraordinary textiles ever produced in the Americas were being made on the southern coast. On the Paracas Peninsula, a projecting spit of coastal desert, the honored dead were wrapped and buried in great bundles of woven and embroidered textiles, fabrics rich in color and invention. Over four hundred such mummy bundles were put in a necropolis on the peninsula; the larger of the bundles contained hundreds of fine textiles, among them wearing apparel such as mantles, tunics, loincloths, turbans, and belts. In the nearby Ica Valley, Chavín-inspired symbolic elements on pottery gave way to new imagery based on agricultural and other deity cults.

In the early centuries after Christ, the Moche—or Mochica as they are also known—began to be politically dominant in the northern valleys where Chavín remains were prevalent. The Mochica built their capital in the Moche Valley, the area in which the enormous adobe brick Huaca del Sol stands today. The Huaca, a giant stepped pyramid, was the largest man-made structure in ancient South America. Although it has been seriously damaged by time and treasure seekers, the great pyramid still looms impressively and enigmatically over the valley floor. During their six- or seven-hundred-year reign, the Moche consolidated a powerful kingdom along the north coast from the Nepeña Valley in the south to Lambayeque in the north, but by the end of the eighth century their political fortunes were spent and outside influences began to be felt.

Both the technological and stylistic heritages of the earlier Chavín era were present in Moche work. The Moche were master craftsmen, and today are known particularly as metalsmiths and potters. Gold, silver, and copper were all worked during Moche times, gold and silver for personal ornaments, copper for both ornamental and functional forms. Copper was often cast into complex sculptural shapes, one indication of the Moche people's great command of the

casting technique. Technical facility also characterizes Moche ceramics, which have a deliberate naturalism of form that has made them particular favorites of modern viewers. The portrait-head vessels are especially appreciated; research has not been able to prove that these actually depict specific persons.

Much to the south, in the altiplano of Peru and adjacent Bolivia, other peoples were on a trajectory that culminated in the formation of the first Andean cities. Both Tiwanaku, near Lake Titicaca in Bolivia, and Wari, in the Ayacucho Valley of Peru, were large, powerful centers that dominated the south during the second half of the first millennium A.D. The ruins of Tiwanaku are particularly imposing. They were first described in the sixteenth century, when they were said to be the oldest in all of the Andes, and the monolithic figure sculptures found at the site were called "small giants." Today, the term is still apt as the imposing, columnar figures are the most remarkable sculpted monuments of the southern highlands.

Another equally remarkable Tiwanaku monument is the so-called "Gateway of the Sun," a carefully smoothed stone "gate" some ten feet high. It has a doorlike opening centered at the bottom, and relief images carved across the top. A main, frontal, staff-bearing figure, and rows of winged attendant figures in profile fill the relief space. Similar figures are found on many contemporaneous objects, and they are thought to be images of a sacred or ritual nature. These visual themes are widespread in art and are taken to indicate the enormous influence that Tiwanaku had in ancient times.

Wari shared in these artistic and religious themes and was at one time considered to be a satellite of Tiwanaku. Current research, however, supports the view that Wari was an independent state, although one that had a religion closely related to that of Tiwanaku. Wari was also an expansionist state; its emissaries actually reached the central and northern coasts of Peru in the eighth century. There they encountered the moribund Moche kingdom and contributed to a time of disturbance and change. In the centuries that followed, other political entities were to coalesce in the north. One, in Lambayeque, had its focus at Batán Grande; another was at Chan Chan in the Moche valley. Chan Chan, the capital of the Chimú kingdom, would grow to astonishing size and wealth before it was conquered by invading Inca armies in the fifteenth century.

Batán Grande had a three-thousand-year history; some fifty archaeological sites have been uncovered. The area, called Sicán in ancient times, also included such extensive burial grounds that it is thought to have functioned as a special religious-funerary precinct. Between the ninth and eleventh centuries, Sicán grew particularly rich and powerful under the guidance of a dynasty of ambitious men. One form their ambition took was the amassing of great quantities of gold objects for their personal tombs. Modern reports tell of three exceptionally rich Sicán tombs wherein the numbers of gold and silver objects reached the hundreds. Many other, somewhat less impressively furnished burials are also known from this area. Among the distinctive Sicán objects are large gold masks, often embellished with surface color and added decorations. Tall beakers, many bearing the image of a "Sicán Lord," were another type of object frequently placed in Sicán burials.

The Chimú, the Sicán neighbors to the south, would eventually incorporate the Lambayeque region into their own kingdom. The Chimú prospered hugely with these territorial additions, and made of their capital at Chan Chan a distinctive desert city. Enormous walled compounds, built for kings, dominated the cityscape, while smaller noble compounds added dimension to the adobe-built metropolis. The nine regal compounds, known as *cuidadelas*, were constructed between 1200 and 1470 and were generally rectangular in plan, covering an average area of 466,000 square feet. Large open courts and audience rooms for the transacting of the king's business, palace rooms for housing the royal family, and storerooms for containing and protecting the amassed wealth of the kingdom were all located within the walled compounds. The "servants' quarters" were there as well. Among the Chan Chan inhabitants who lived on a less grand scale were the many craftsmen. Metalsmithing was a Chimú specialty, continuing the long tradition of metalworking in northern Peru.

In the fifteenth century, the Chimú kingdom, and indeed all of Peru, was conquered by the Inca peoples of Cuzco. The Inca armies burst out of the southern Andean highlands —from the general area of the earlier cities of Wari and Tiwanaku—and conquered territories that stretched along western South America for 3,400 miles, from Ecuador in the north to central Chile in the south. Under a dynasty of able rulers, the Inca went from being a small mountain kingdom to a vast empire in less than ninety years. Military men and administrators of great ability, the Inca rulers carefully managed their empire until civil war broke out between two brothers, pretenders to the throne. The war was barely over when the Spaniards, led by Francisco Pizarro, arrived by sea in 1532. The triumphant brother, Atawallpa (r. 1532–33), on his way to Cuzco to assume the imperial powers, went to meet the invading Spaniards. In the main square of the mountain city of Cajamarca, Atawallpa was ambushed, imprisoned, and held for ransom. The enormous ransom, paid in gold and silver, did not gain him his freedom, and with his death the following year the Precolumbian era in Peru came to an end.

Julie Jones

OLMEC BOWL

Precolumbian America has produced few works of art of greater appeal to the contemporary viewer than those made by the Olmec peoples of early Mexico. A politically aggressive and intellectually precocious people, the Olmecs lived in the coastal swamps of the southern Gulf of Mexico at the turn of the first millennium B.C. Their aesthetic accomplishments, primarily a body of sculpture of pervasive formal clarity and symbolic richness, were important for all the subsequent history of art in Mesoamerica.

Whiteware bowls illustrate particularly well the Olmec interest in balanced form. Such bowls are known in different shades of white, including the pure white of kaolin, a clay available in the Gulf Coast area. They are made in full, rounded shapes thought to have been inspired by the naturally occurring forms of gourds. This example, which has a generous, almost sensuous outline and fluted sides, was differentially fired to produce the "clouds" of color that enhance the surface. Such clouds, while seemingly random, are calculated in placement, and indicate both great control of the firing process and a conscious desire for apparently spontaneous effects. The resultant color is a combination of ivory, gray, and muted oranges, an understated scheme of sophistication and refinement.

OLMEC "BABY" FIGURE

Lifesize baby figures are perhaps the most intriguing of all Olmec ceramic works. Although their human features and postures are not symbolically complex and are easily understood, the significance of these figures in Precolumbian times is far from clear. They may have been early forms of Mexican deities or emblems of royal descent, or both.

Baby figures are white-surfaced—if not entirely made of white clay—and hollow. Seated, they are not clothed, although they may have worn special garments in ancient times. Some portray well-fed children expressing infantile gestures. Holding a chubby finger to its mouth, this figure is a fine example. An elaborate helmet (or perhaps a special hair arrangement) is colored red-pink with powdered cinnabar. Such touches of red-pink are common about the heads of Olmec whiteware figures, both large and small. While the color contrasts well with the monochrome surfaces, the powdered cinnabar was probably used more for symbolic than artistic reasons.

Most intact Olmec ceramics have been found in burials in the central Mexican highlands. Preservation conditions in the wet climate of the Gulf Coast are so poor that the acid soils erode even well-fired ceramic material. This figure is said to come from the highland site of Las Bocas in Puebla.

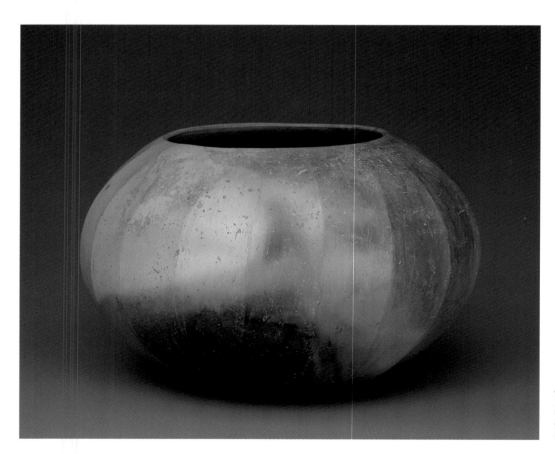

81 Bowl
Mexico (Olmec); 12th–9th c. B.C.
Ceramic; H. 4½ in. (11.5 cm.)
Gift of Arthur M. Bullowa, 1982
(1982.207.4)

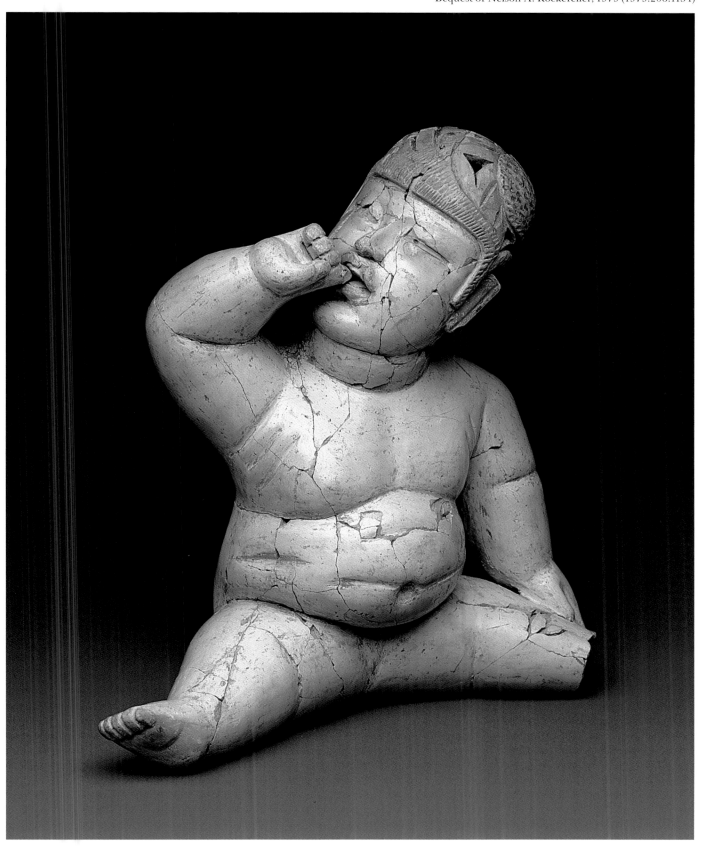

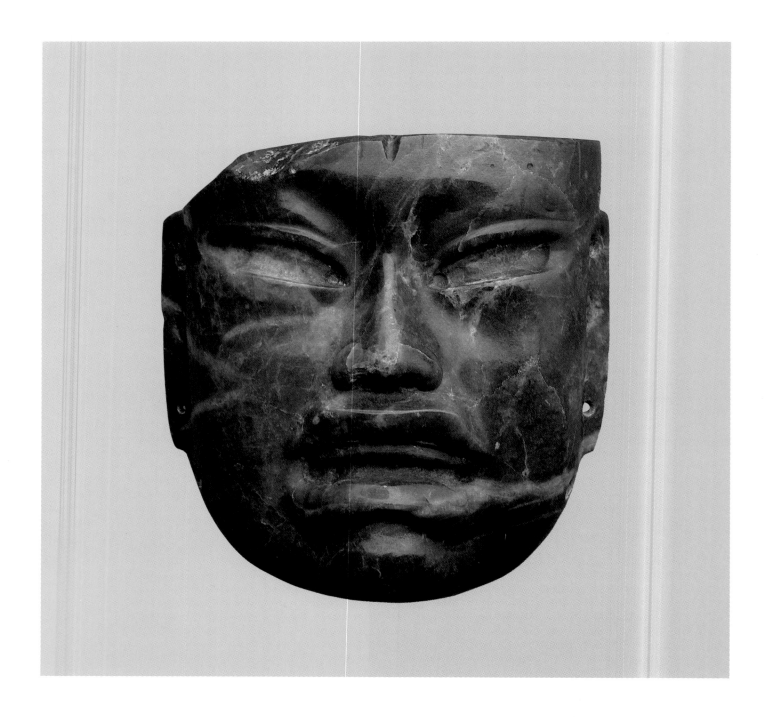

Olmec Mask

The Olmec peoples were masters at the working of jade, the American gemstone known mostly in shades of green. In the first millennium B.C., the Olmecs used jade and other jadelike stones of green hue for a variety of objects, from personal ornaments to figures and masks of ceremonial and/or mortuary intent. Some masks were naturalistic in size—that is, big enough to cover the face—and were among the larger of the Olmec jade objects; others were worn as chest ornaments. The mask illustrated here is of face size, but it is not pierced for either seeing or breathing. It may have been used as part of an elaborate headdress—it would fit just above the forehead of the wearer—or it could have

been the burial mask of an important personage or ruler.

The baby-face features of this mask have been rendered with great delicacy. Details of the face have a fleshy, almost lifelike quality that belies the hardness of the stone from which they were wrought. Special attention has been given to rendering the puffiness around the elongated eyes and separating the round chin from the square jaw, for instance. The pug nose is small and discreet, while the toothless, open, crying mouth has full, well-shaped lips. The mouth is often the most prominent feature of Olmec masks and frequently bears a significant amount of symbolic detail. The eyes of the mask may originally have been inlaid.

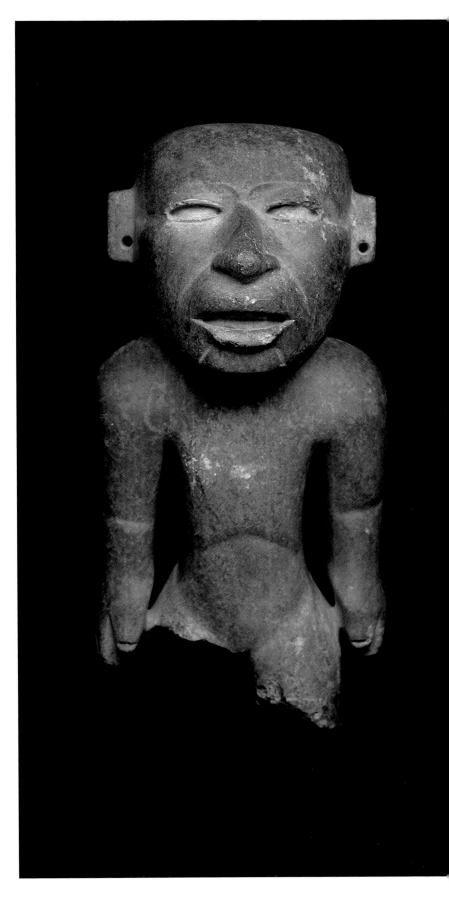

TEOTIHUACAN FIGURE

The ancient city of Teotihuacán is situated in the central Mexican highlands not far from modern Mexico City. Cosmopolitan and wealthy, Teotihuacán dominated much of Mexico from about the second to the seventh century. Architecturally, the city was both grand in scale and severe in outline, and these qualities appear in other art forms as well. The city's main artistic enterprise was wall painting, done in extensive design programs on stuccoed surfaces; the color schemes were muted, and a deep maroon-red predominated. Freestanding or architectural sculpture was relatively rare.

Among the sculptural works associated with the city are masks and human figures of stone whose features are simple and expressions serene. The facial features of this group of objects tend to uniformity and usually include the squared-off "ears"—here with holes for ornaments—and wide eyes and open mouth, either or both of which were apparently inlaid with shell. This figure has a particularly substantial lower jaw that gives the head a most assertive quality. Many Teotihuacán stone figures on this scale are rendered almost flat, but this is one of the few with considerable three-dimensional bulk. While details such as rib cage, elbows, and wrists are indicated, it is probable that when it was in use the figure was dressed in special costumes.

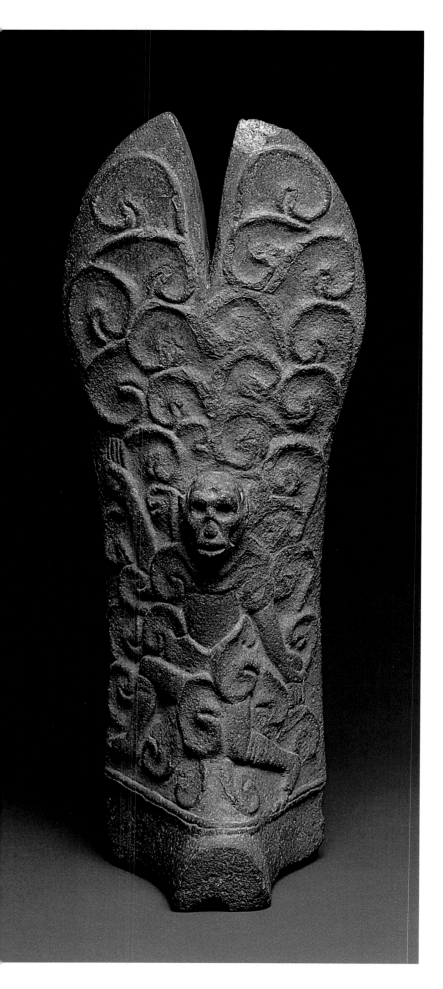

Tajin Palma

The state of Veracruz lies along much of the coast of the Gulf of Mexico, where in Precolumbian times the inhabitants were prolific makers of works of art in all mediums. An important aspect of Veracruz art was the stone sculpture stylistically associated with the city of El Tajín in the central part of the state. The forms of these stone sculptures are unusual but they correspond to items of equipment used in the ritual ball game. This game was played with a very hard rubber ball, and parts of a player's body had to be protected. The protective equipment included a particularly large belt to which other elements were added. One of them was a tall, flared piece today called a *palma*.

A stone representation of a *palma* is illustrated here. Its front face is decorated with an overall pattern of volutes from which emerges a human figure with a skeletal head. The figure is apparently running, as if emerging from the volutes, and raises a right hand high, perhaps in salutation. The skeletal head calls attention to the death-related imagery common on the *palmas*. A great many of the representations on ball-game items, up to and including reliefs in the ball courts themselves, carry messages relating to death and sacrifice.

85 Palma
Mexico, Veracruz (Tajín); 6th–9th c.
Stone; H. 18⅝ in. (47.6 cm.)
The Michael C. Rockefeller Memorial Collection,
Gift of Nelson A. Rockefeller, 1963 (1978.412.16)

Tajin Yoke

For many centuries, the ancient Mexicans played a ball game that was of serious religious and/or political implication. The game took place on a special court with special equipment, and in central Veracruz between about the fourth and the ninth centuries, it was of such compelling importance that no less than ten ball courts were built at El Tajín, the largest city in the region. A significant amount of stone sculpture that replicated the shape of the ball-game equipment was also produced. The major item of protective gear, the wide belt worn as padding around the waist and hips, became a popular form of commemorative sculpture, where it appeared commonly in a horseshoelike shape. These stone belts are called yokes, a name given them in the nineteenth century before the derivation of their shape was understood.

The most elaborate stone yokes are completely covered with patterning. The image on this example is of a frog or toad, a representation that was used on yokes for many hundreds of years. It is believed to have been an earth monster associated with death and the underworld. The wide head of the frog is splayed across the front of the sculpture, and from its mouth comes a large tongue that overlaps the bottom of the yoke. The legs of the frog are worked out onto the sides.

TAJIN PLAQUE

The relief sculpture of central Veracruz dating from the middle centuries of the first millennium A.D. was exceptionally ornate in its cumulative patterning. The use of volutes as secondary design elements was pervasive; the bearded, profile head worked on the front of this slate disk is fully surrounded by them. The profile is that of a richly dressed man whose pointed beard is made of more volutelike shapes. He wears a nose bead, a three-strand necklace knotted at the back, and important ear ornaments with counterweights in the shape of a tooth or claw. A close-fitting cap, whose crosshatched lines suggest that it is a net cap, adorns straight, cropped hair. A knotted double band keeps the cap in place.

The plaque is thought to have been a mirror back, although no evidence of a reflective surface remains on the other side. Traditionally the carved backs had mosaics of carefully cut and fitted iron pyrite pieces polished to form the "mirror." Mirrors had a number of sacred uses and meanings in Precolumbian times. Their specific significance in central Veracruz when this plaque was made is unknown, but mirrors were variously associated with brightness and light, with rulership, and with divination.

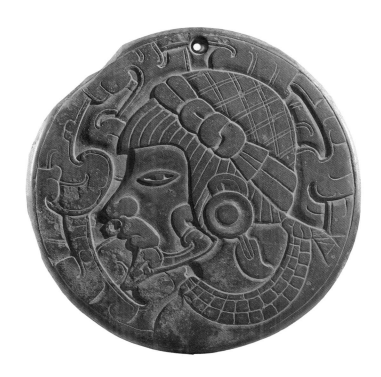

87 *Plaque (possibly a mirror back)*
Mexico, Veracruz (Tajín); 6th–9th c.
Slate; D. 6 in. (15.2 cm.)
Museum Purchase, 1900 (00.5.991)

86 *Frog Yoke*
Mexico, Veracruz (Tajín); 6th–9th c.
Stone; L. 15¾ in. (39.4 cm.)
The Michael C. Rockefeller Memorial Collection,
Gift of Nelson A. Rockefeller, 1963 (1978.412.15)

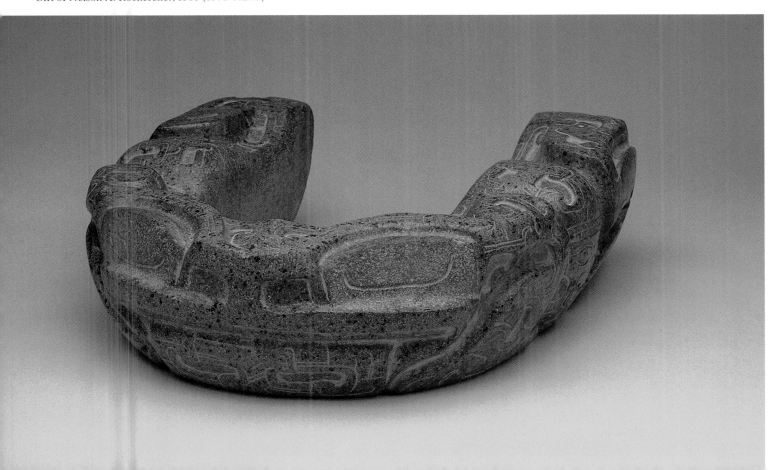

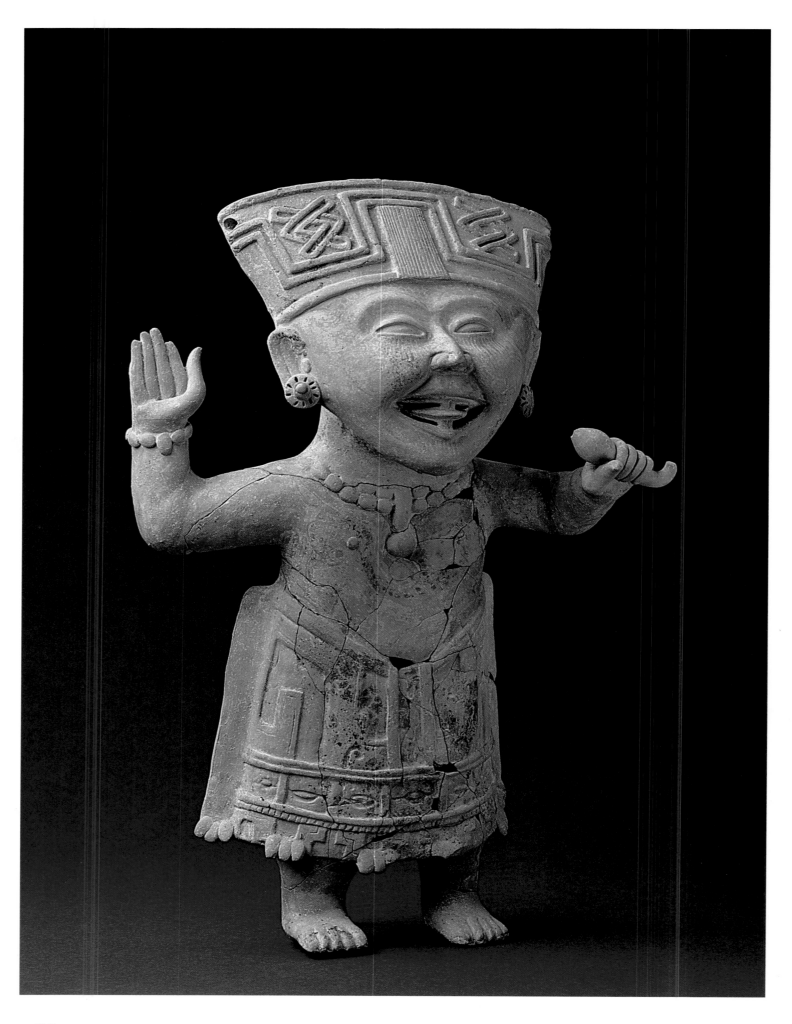

Remojadas "Smiling" Figure

The ceramic products of Veracruz were particularly success-ful in their concern with the contrast between patterned and plain areas of finished surface. Such a contrast is illus-trated here where the raised pattern of the figure's skirt and hat distinguish them plainly from the figure itself. Surface color can make this distinction also, but the basic difference between figure and costume in many Veracruz sculptures was made in the material of the ceramic itself. Human figures, in various guises and costumes, make up the largest portion of this ceramic sculpture, and the dis-tinction between wearer and costume is frequently seen.

The "smiling" figures of the Remojadas area of central Veracruz have been so named for the wide grins that trans-form their faces. It gives the figures an engaging quality quite remarkable within the general severity of Mexican im-agery. This figure holds what is probably a rattle in its left hand. Large numbers of the ceramic figures have been found buried in caches where many appear to have been broken upon placement.

OVERLEAF:

Maya Seated Figure *(Pages 122–123)*

Time, insects, and moisture have destroyed most Precolum-bian sculpture in wood, but a handful of such objects have miraculously survived. This wood figure probably owes its existence to the sturdy dry walls of a chamber, perhaps a tomb, where in ancient times it was placed, protecting it from the tropical environment in which it was said to have been found. Seated, and richly dressed, the figure was carved sometime in the sixth century by a master Maya carver.

The noble bearing of the figure clearly bespeaks a person-age of importance. He sits with legs and feet tucked under him, and wears a fringed kilt, or hip cloth, tied in place by a fancy belt knotted at the waist in front. Another belt of the same pattern is worn over the shoulders, stole fashion. Sus-pended from the neck is a carefully detailed mask, which is supported in front by the figure's joined hands. The ear ornaments are very grand and consist of three large circu-lar earflares bound together to form a chain that ends in a dramatic, long-nosed profile head. A full mustache and hair, implying a partially shaven and patterned head, are unusual. Pairs of grooves under the arms and on the knees of the figure indicate that at one time a now-missing object was displayed there, perhaps a rectangular plaque or "mirror."

88 "Smiling" Figure
Mexico (Remojadas); 7th–8th c.
Ceramic; H. 18¾ in. (56 cm.)
The Michael C. Rockefeller Memorial Collection,
Bequest of Nelson A. Rockefeller, 1979 (1979.206.1211)

89 Seated Figure
Mexico or Guatemala (Maya); 6th c.
Wood; H. 14 in. (35.5 cm.)
The Michael C. Rockefeller Memorial Collection,
Bequest of Nelson A. Rockefeller, 1979 (1979.206.1063)

Pages 122–123: side and front views

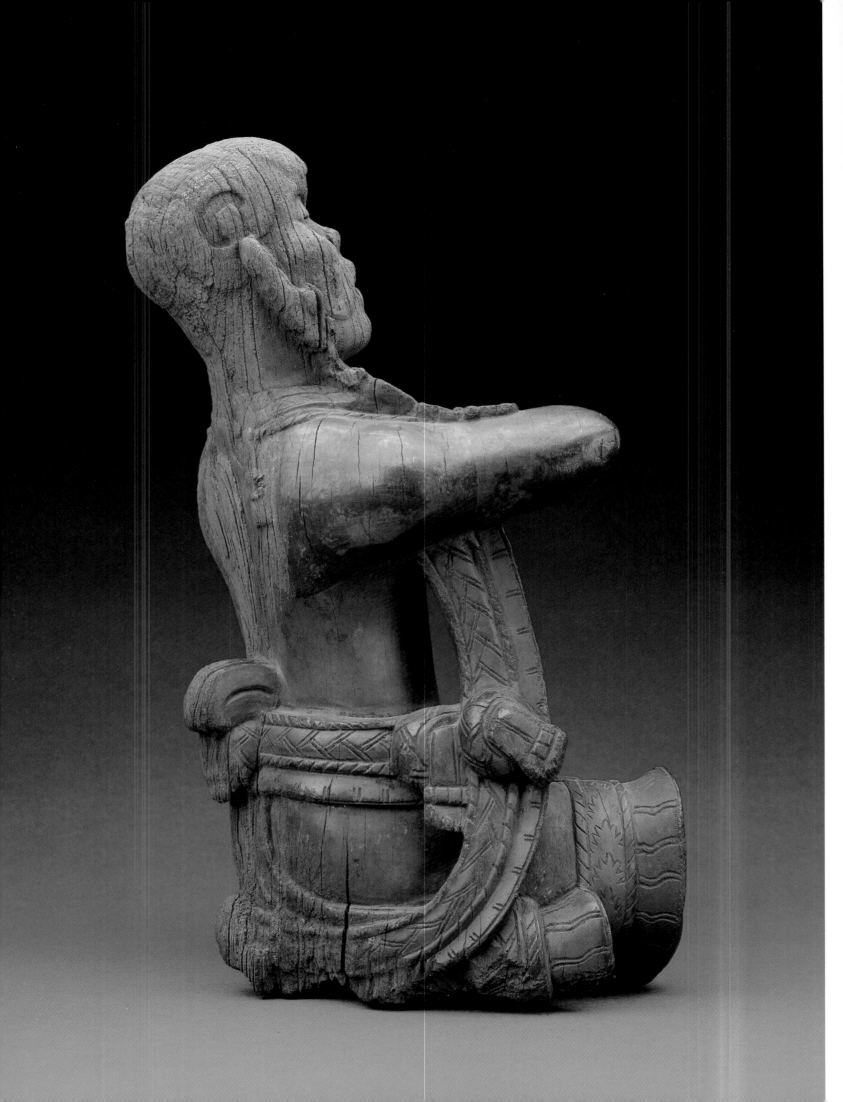

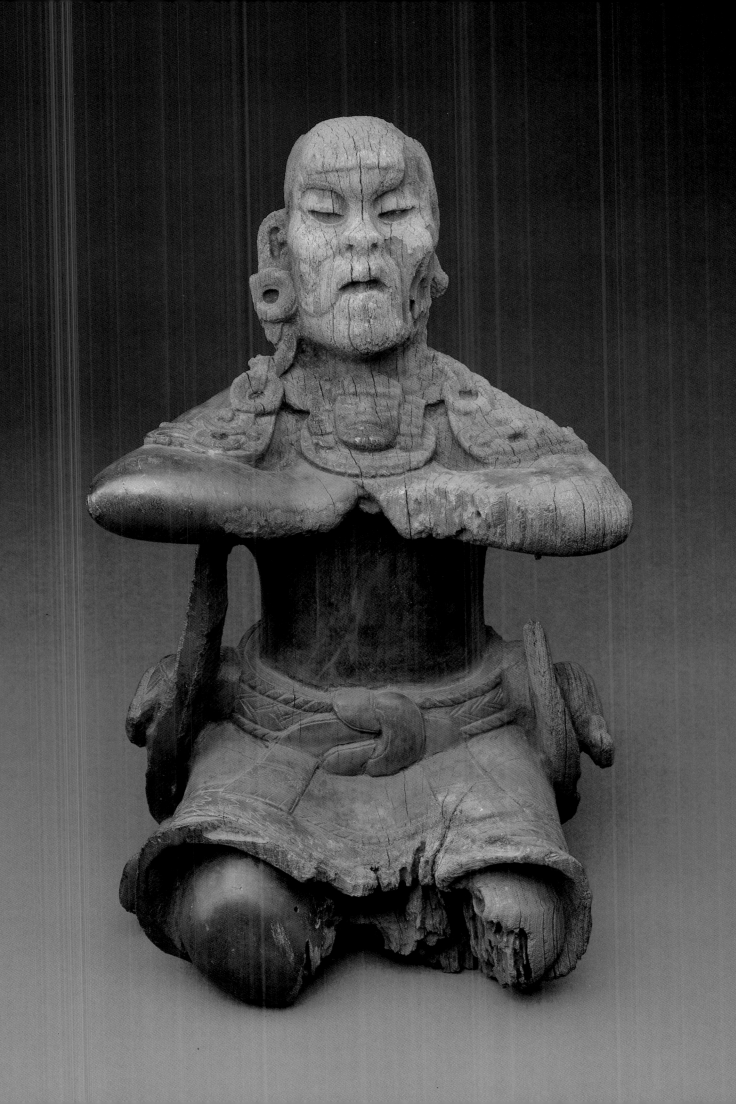

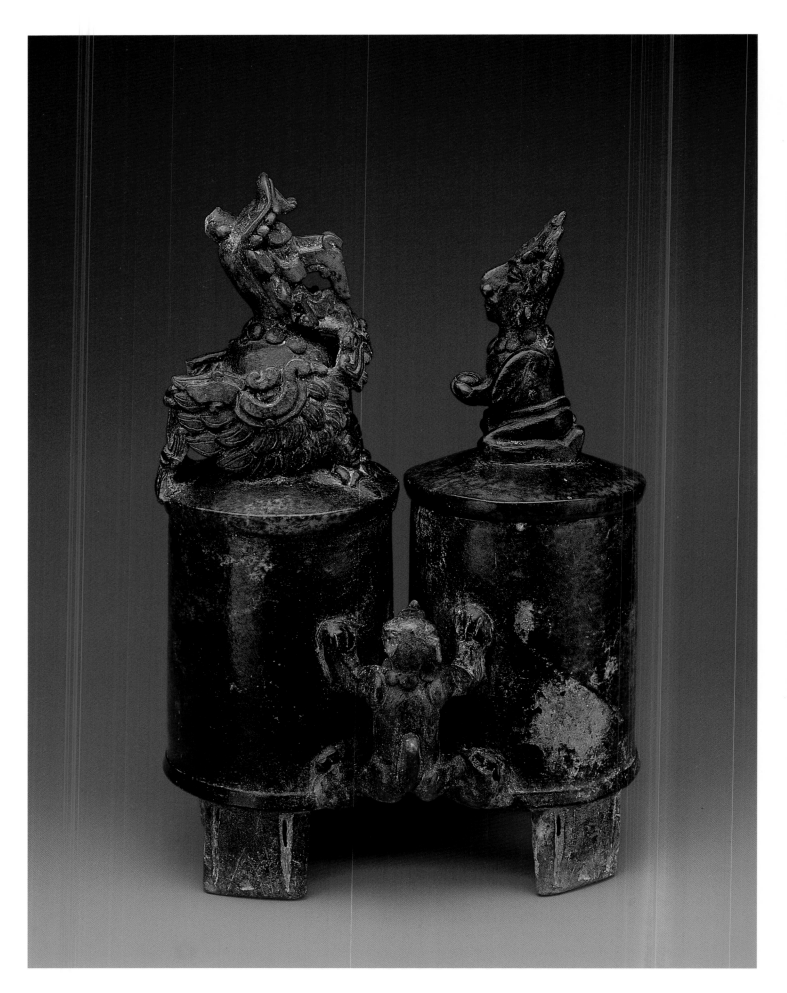

90 Double-Chamber Vessel
Mexico or Guatemala (Maya); 5th c.
Ceramic; H. 11⅞ in. (35.3 cm.)
The Michael C. Rockefeller Memorial Collection,
Gift of Nelson A. Rockefeller, 1963 (1978.412.90)

MAYA VESSEL

In southern Mexico and adjacent Guatemala, the Maya peo-
ples were a cultural entity distinct from their northern Mexi-
can neighbors. Although the two peoples—the Mexican and
the Maya—shared many significant aspects of Precolumbian
life and thought, numerous equally significant differences
distinguished them. Maya art is one of those distinguish-
ing features, for it had a long internal history that, although
it interacted from time to time with developments in Mex-
ico, was quite particularized. One episode of interaction oc-
curred in the late fourth and fifth centuries when a certain
kind of ceramic vessel was made in both regions. The ves-
sels were fired to a warm, rich red-brown color, had legs,
more or less straight sides, and at times lids. The present
example is a very elaborate version of this pan-Mesoamerican
ceramic vessel.

The illustrated vessel has two cylindrical chambers that
interconnect on the inside and are joined on the outside by
a large splayed feline. On the top are a large bird and a
human figure; the human figure is on the removable lid.
(The bird does not come off.) Bird and figure actually form
a scene, for the human figure kneels in front of the big bird
and presents an offering to him. The bird is believed to
represent a mythological creature of particular import to
the ancient Maya.

MAYA COSTUMED FIGURE

The ancient Maya occupied a large area of southern Meso-
america, and while their history was a long one, the art for
which they are best known was produced during a span of
about two to three hundred years. These centuries, called by
archaeologists the Late Classic Maya period (A.D. 600–900),
were extraordinarily vital for the making of works of art.
Ceramic figurines, for instance, that were fabricated as
early as the second millennium B.C. in the Maya area be-
came objects of outstanding quality in the Late Classic pe-
riod. The late figurines are named for the island of Jaina
off Mexico's Campeche coast, where many were deposited
as burial offerings.

A full-feathered costume is worn by the imposing, paunchy
figure in this Late Classic ceramic work. A long shield in the
left hand (the right probably held a weapon), associates him
with war and warriors, as does the feathered costume, since
bird costumes were at one time worn by Maya warriors. The
scowling, baggy-eyed, jowly face has areas that are colored
the same blue as the feathered costume.

The figure is actually a whistle. Many of the Jaina figu-
rines were made either as whistles or rattles. How and when
they functioned is conjectural; one supposition is that they
were used during funerary ceremonies.

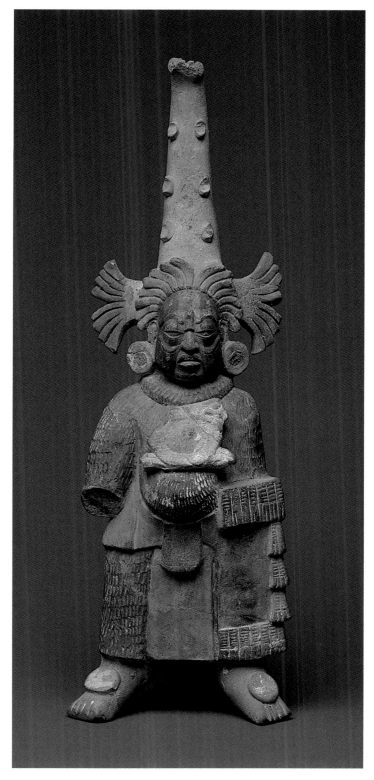

91 Costumed Figure
Mexico (Maya); 8th c.
Ceramic; H. 11½ in. (29.2 cm.)
The Michael C. Rockefeller Memorial Collection,
Bequest of Nelson A. Rockefeller, 1979 (1979.206.953)

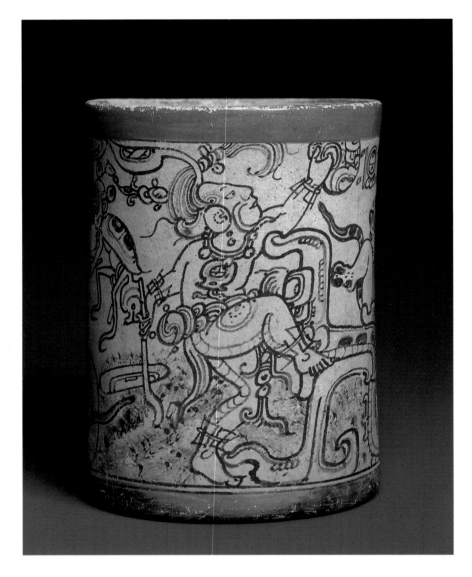

92 Vessel with Mythological Scene
Mexico or Guatemala (Maya); 8th c.
Ceramic; H. 5½ in. (14 cm.)
The Michael C. Rockefeller Memorial
Collection, Purchase, Nelson A.
Rockefeller Gift, 1968 (1978.412.206)

Opposite: rollout view

Maya Vessel with Mythological Scene

During the eighth century, the ancient Maya made numerous straight-sided ceramic vessels that were painted with elaborate, multifigured scenes. Many of the painted scenes were mythological in content, depicting events that took place in the underworld, the realm of the Lords of Death. Such a scene is illustrated here, in a rollout photograph that unfurls the image from the body of the vessel as a continuous surface. The monochrome painting or drawing is done in what is called the "codex style," because of its similarity to

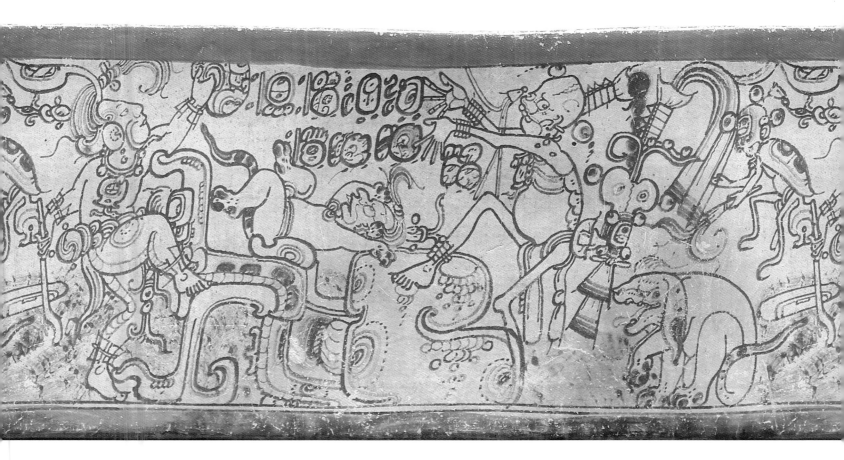

that of the few Precolumbian Maya books, or codices, that exist today.

In this scene, a deity known as Chac-Xib-Chac is engaged in a lively sacrificial dance. Chac-Xib-Chac is young and vigorous and wields a long-handled axe in his right hand, intending to sacrifice the Baby Jaguar lying in front of him on a huge monster-head altar. The Baby Jaguar, a manifestation of another deity, known simply as GIII, is identified by his jaguar paws and tail, and he, arms akimbo, is equally animated. One of the Lords of Death appears at the other side of the altar gleefully waiting to receive the sacrifice. Although present interpretations of the specific meaning of this scene vary, it is generally read to imply a triumph over death itself.

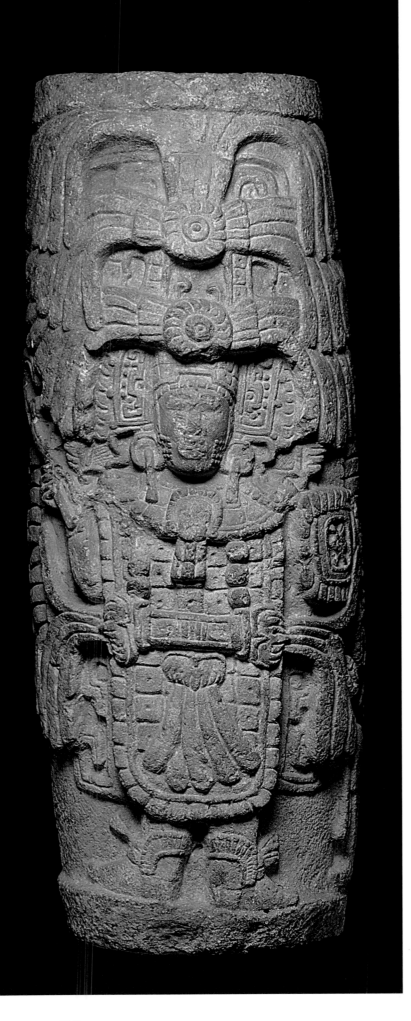

MAYA COLUMN

Maya temple buildings were elaborated with complex sculptural programs in which a great deal of attention was focused on façades, doorways, and roofs. Columns were part of these sculptural programs, and in areas of the Mexican states of Campeche and Yucatan, they were used to flank important doorways. The themes found in the architectural sculpture were usually details of the exploits and accomplishments of the ruling families of the particular region. The figure carved in high relief here, although he cannot now be identified, was probably a member of such a dynasty.

The figure wears a very ornate costume of the sort reserved among the ancient Maya for major ceremonial occasions. A great, tiered headdress with swaths of feathers to each side, and a robe covered with decorative plaques (perhaps of jade) are the main costume features. Many other significant elements are worn, however: large ear ornaments; a wide collar with a frontal mask; decorated, high-back sandals—all proclaiming the wealth and power of the wearer. Further, the figure holds a scepter in his right hand and a shield in his left, below which a small attendant figure appears.

A similar column, in the collection of the Worcester Art Museum (Massachusetts), is thought to be a mate to the present example.

93 Column with a Costumed Figure
Mexico (Maya); late 8th–9th c.
Stone; H. 68½ in. (206 cm.)
The Michael C. Rockefeller Memorial Collection,
Gift of Nelson A. Rockefeller, 1963 (1978.412.88)

TOLTEC EAGLE RELIEF

This relief sculpture is one of two similar limestone panels that were among the first Precolumbian works to enter The Metropolitan Museum of Art. They were given to the Museum in 1893 by the well-known American painter Frederic Church, who wintered in Mexico during the late years of his life. When the reliefs were given to the Museum, they were said to have been found in the northern part of the Mexican state of Veracruz, a region that is not today considered consistent with their style and imagery. Style and image place them in central Mexico during the early centuries of the second millennium A.D., when the Toltecs dominated the region from their legendary capital at Tula. At Tula, the pyramidal base of one of the major temples, Pyramid B, is decorated with relief panels that include eagles rendered in profile consuming human hearts.

In ancient Mexican thought, the eagle was closely identified with the sun. It was usually associated with the daytime sun—which one source calls a "soaring eagle"—as the sun at night made a perilous journey through the darkness of the Underworld. In Mexican creation myths, the gods voluntarily sacrificed themselves in order to provide nourishment for the newly created sun. Man, too, was made to share in the task of feeding the sun the blood, perforce human, that it needed to complete its journey each day.

94 Eagle Relief
Mexico (Toltec); 9th–12th c.
Limestone, traces of paint; H. 27½ in.
(69.8 cm.)
Gift of Frederic E. Church, 1893 (93.27.1)

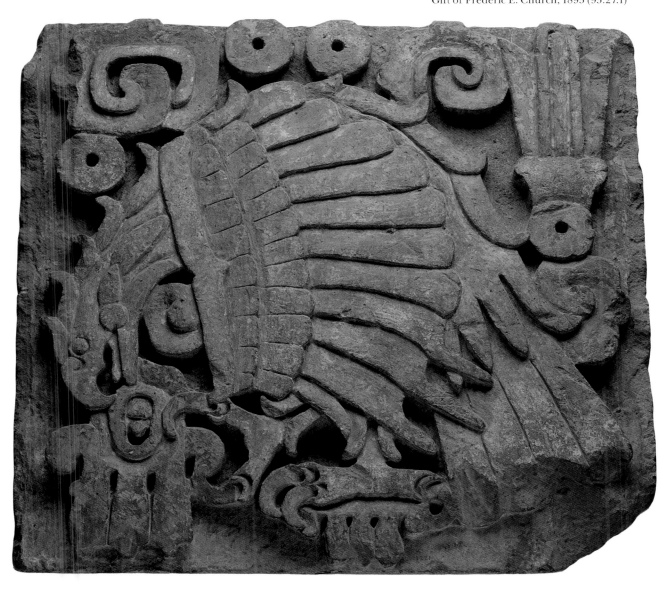

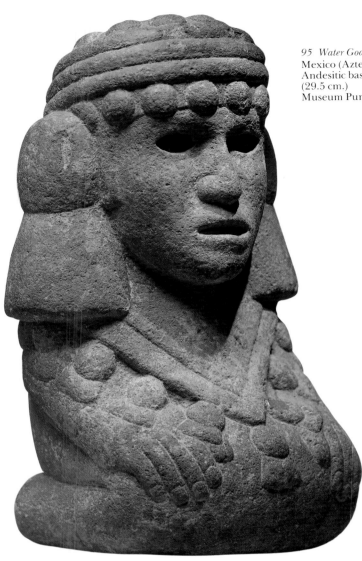

95 *Water Goddess (Chalchiuhtlicue)*
Mexico (Aztec); 15th–early 16th c.
Andesitic basalt, paint; H. 11⅝ in.
(29.5 cm.)
Museum Purchase, 1900 (00.5.72)

96 *Seated Standard Bearer*
Mexico (Aztec); second half 15th–early 16th c.
Laminated sandstone; H. 25 in. (63.5 cm.)
Harris Brisbane Dick Fund, 1962 (62.47)

AZTEC WATER GODDESS

The Aztecs were a mercenary, warrior people from the north who managed to establish themselves in the great Basin of Mexico in the early fourteenth century when they founded Tenochtitlán on an island in Lake Texcoco. Two hundred years later, when the Spaniards arrived, the Aztecs were the political overlords of much of the country. Tenochtitlán was the richest of cities, full of temples, palaces, and monumental sculpture. Aztec-style sculpture had proliferated throughout central Mexico, and deity images existed in quantity at sacred places such as caves, springs, and roadside shrines.

Among the deity images are a sizable group of female fertility figures that represent *Chalchiuhtlicue*, goddess of water and springs. The goddess is depicted as a very fine lady wearing a fancy shawl (*quechquemitl*) and a distinctive headdress. The headdress consists of a multistrand browband knotted at the back and embellished with balls of cotton along the top and bottom. In addition, there are large bulbous tassels over the ears that fall well onto the shoulders. These deity images are quite serene and are thought to represent an ideal Aztec female type. The sculptures were originally painted; a considerable amount of red remains on this example.

AZTEC STANDARD BEARER

Aztec temple-pyramids were the last in a sequence of similar structures that were built in Mesoamerica over a period of about two thousand years. The great pyramidal platforms on which the temples sat changed configuration over the centuries, and during Aztec times they became the mighty twin pyramids, or "towers" as the Spaniards called them, that in Tenochtitlán's Main Temple were dedicated to the ancient Mexican god of rain, Tlaloc, and the Aztec patron deity and war god, Huitzilopochtli. The temple buildings themselves were not large, because their intimate spaces were reserved for priests and initiates. The public had no access to them. Wide flights of stairs led from the plaza floors to the high platforms that could also support large incense burners and figures of standard bearers.

Stone sculptures of standard bearers survive today; their ancient role is usually identified by the holes that appear through their fists, believed to have held the staff that bore the standard. Such an opening can be identified in the now-damaged right hand of this seated figure. The figure comes from Castillo de Teayo, an Aztec enclave in northern Veracruz, and it combines cosmopolitan Aztec stylistic features with the use of sandstone, a local Veracruz material.

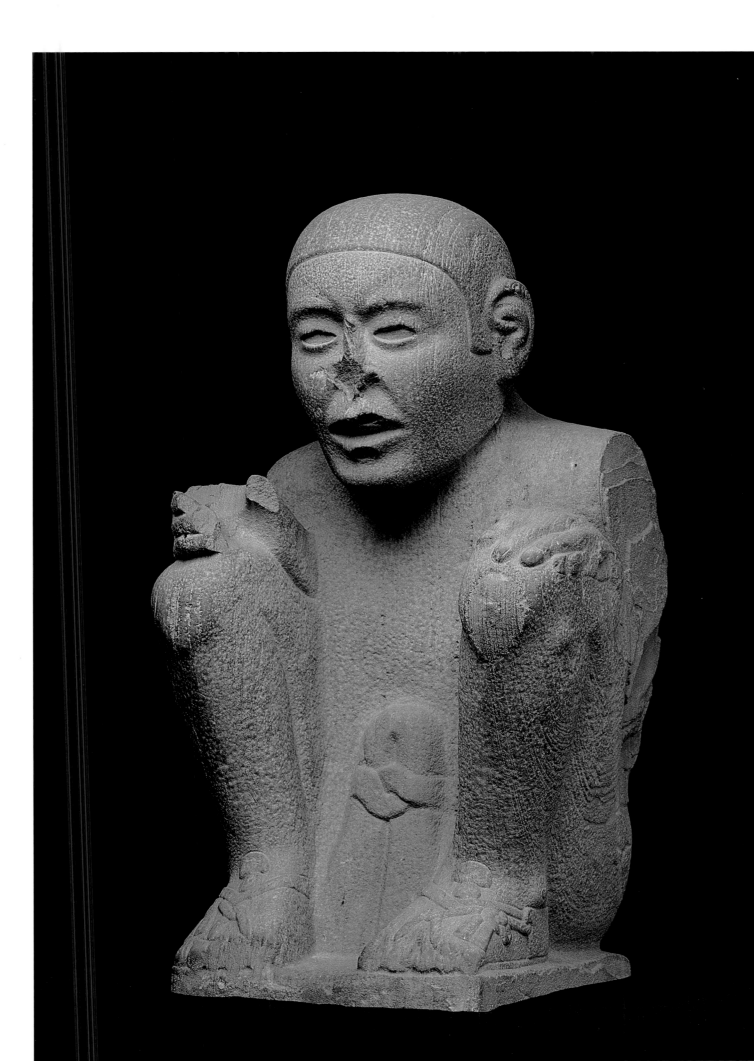

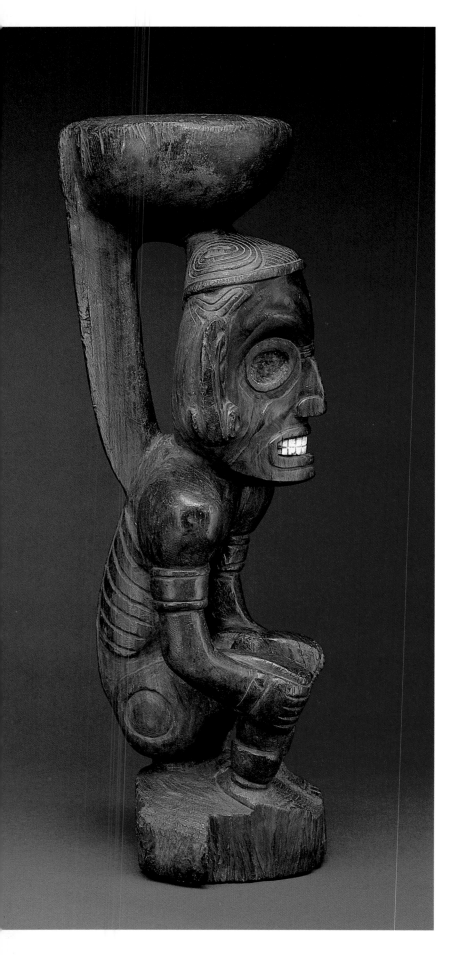

TAINO IDOL

The Greater Antilles, that is the islands of Cuba, Hispaniola, Puerto Rico, and Jamaica, produced the most distinctive works of art of all of the Caribbean Islands during Precolumbian times. The Taino peoples were responsible for these works, accomplished by the amplification and elaboration of traditional Caribbean materials and forms in a highly individual manner. Ritual objects of particular significance to the Taino were the *zemís*, or idols, made of stone or wood in different shapes. The *zemís* could be named and personally owned, and were dressed and fed on special occasions.

The *zemís* in the shape of a crouched, emaciated human figure with a platelike surface on the top of the head, are thought to have been used in ceremonies that included the taking of hallucinogenic snuff, or *cohoba*. The snuff was placed on top of the *zemí* and inhaled through small tubes to the nostrils. The altered states of consciousness induced by the snuff were important to divination and curing rituals, among others.

97 Zemí
Dominican Republic (Taino); 10th–15th c.
Wood, shell; H. 27 in. (68.5 cm.)
The Michael C. Rockefeller Memorial Collection,
Bequest of Nelson A. Rockefeller, 1979 (1979.206.380)

Opposite: detail

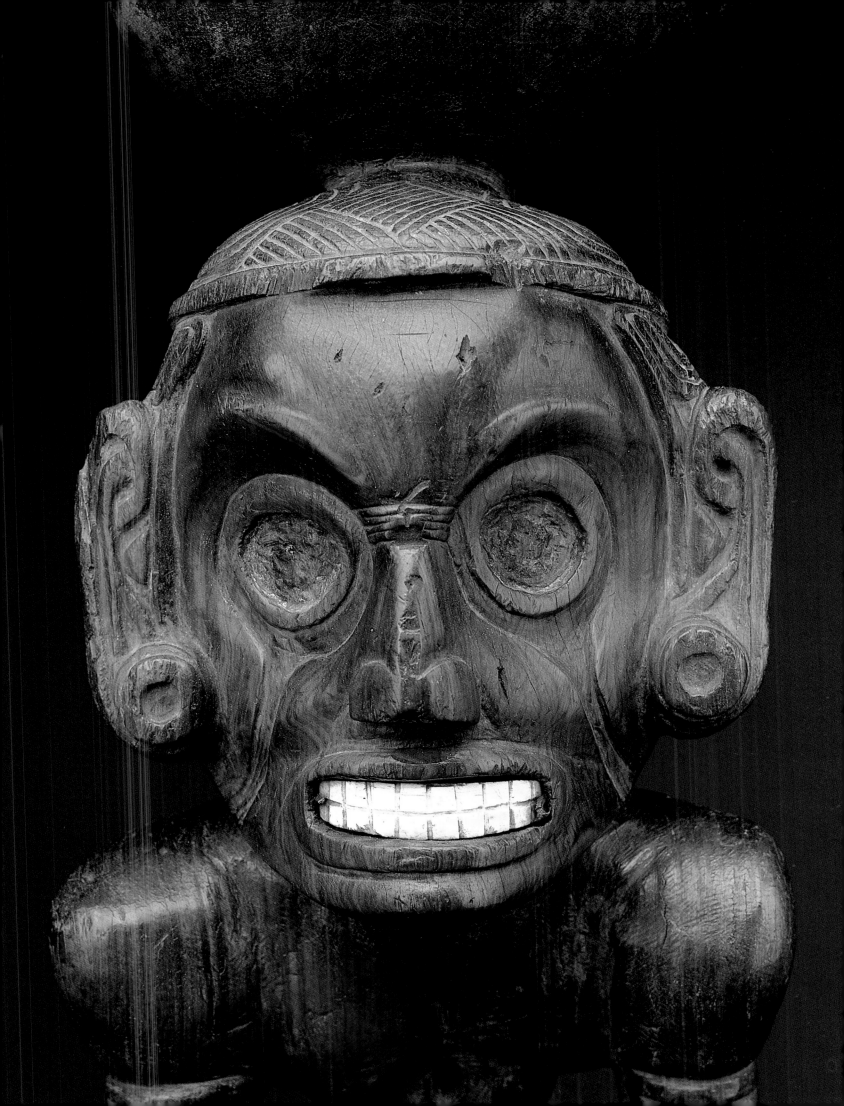

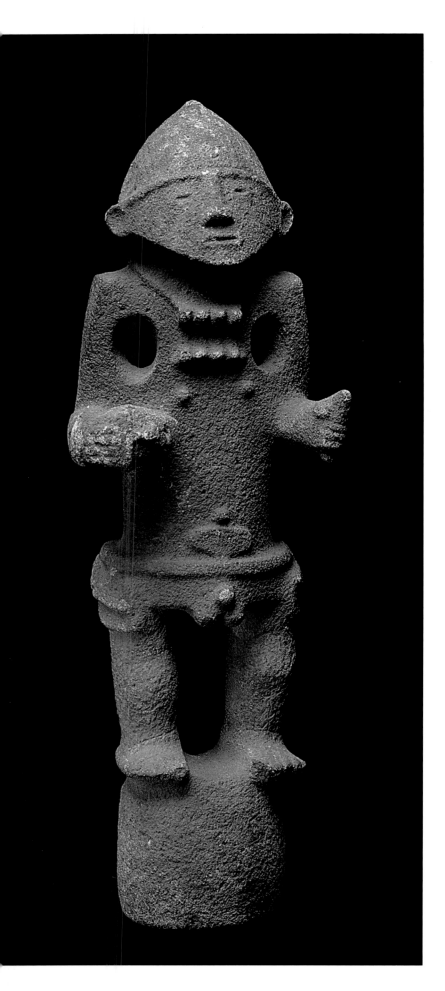

Costa Rican Warrior Figure

The Isthmus of Central America today includes Costa Rica and Panama, two countries which in ancient times bridged the gap culturally as well as physically between Mesoamerica and South America. Costa Rica particularly had contact with peoples and ideas, both northern and southern, that gave rise to a complex Precolumbian history. During the last six or seven hundred years of its Precolumbian history, a strong tradition of figure sculpture in stone unfolded in eastern and central Costa Rica. Much of this sculpture was in human form, worked in standardized poses. Militarism, possibly occasioned by an expanding population putting pressure on existing resources, led to an imagery that glorified warrior exploits. Triumphant warriors displaying axes and trophy heads appear frequently among these works, as do bound prisoner figures.

The warrior here holds a trophy head in his right hand and a short axe in his left. He wears a close-fitting conical cap and a decorated belt. Around his neck is suspended a large pendant that is similar in detail to known objects in gold. There is some evidence that gold was considered a protective substance in Precolumbian Central America and that warriors wore their important gold ornaments into battle.

98 Warrior with Trophy Head
Costa Rica, Atlantic Watershed; 8th–11th c.
Stone; H. 29 in. (73.7 cm.)
The Michael C. Rockefeller Memorial Collection,
Bequest of Nelson A. Rockefeller, 1979 (1979.206.922)

Linea Vieja Bird Pendant

Jade and jadelike stones were worked in northern and central Costa Rica from about the time of Christ until the middle of the first millennium A.D. They were used primarily to make personal ornaments, such as pendants, ear ornaments, and beads. The pendants, by far the most numerous of these objects, were worn suspended about the neck on a thong or cord, and were produced in a wide variety of colors and shapes. Bird imagery was a special favorite, with birds and differing bird-human combinations widely distributed. The bird depicted here is a toucan, the large downturned beak of which is the pendant's salient feature. The bird itself is anthropomorphic; it has an upright human body with arms and hands held close to the front of the waist. In place of the figure's feet is a trophy head.

The use of jade in Costa Rica has led to the assumption that the material was locally available in Precolumbian times. Blue-green jade, a stone that is characteristically used in many of the best Costa Rican objects, is of particular interest not only for its wonderful color, but because its apparent northern distribution implies the existence of an ancient Mesoamerican trade route in jade. In spite of repeated efforts to locate Costa Rican jade sources, none has yet been discovered.

100 Double Eagle Pendant
Costa Rica or Panama (International Style); 5th–10th c.
Gold; H. 4⅜ in. (11.1 cm.)
The Michael C. Rockefeller Memorial Collection,
Bequest of Nelson A. Rockefeller, 1979 (1979.206.538)

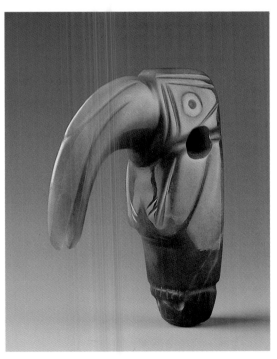

99 Bird Pendant
Costa Rica (Linea Vieja); 1st–5th c.
Jade; H. 2⅝ in. (6.7 cm.)
The Michael C. Rockefeller Memorial Collection,
Bequest of Nelson A. Rockefeller, 1979 (1979.206.1138)

ISTHMIAN DOUBLE EAGLE PENDANT

The birdform pendants of Central America are perhaps the most well-known type of Precolumbian gold object. Made to be worn suspended about the neck, they were fabricated in many sizes, from those that are less than an inch in height to others of more than five inches. While the pendants differ in specific details, the basic configuration is usually the same. They have extended wings over open, splayed tails, and heads and beaks that project strongly forward. Single birds are the most common, although double images, like this one, also occur. These pendants are stylized representations of birds of prey and appear to have functioned as protective emblems.

Bird pendants were first seen being worn by the peoples along the coast of Central America during Christopher Columbus's last journey to the New World, in 1502. Columbus's discovery of gold, and the announcement of it in Europe, was instrumental in bringing to an abrupt close the long history of the early civilizations of America, for after Columbus came the many adventurers who, avid for gold, conquered and despoiled all of the native American kingdoms within less than fifty years. While many aspects of Precolumbian life and thought continued into Spanish colonial times, the independent, indigenous civilizations did not survive the initial encounter with gold-hungry Europe.

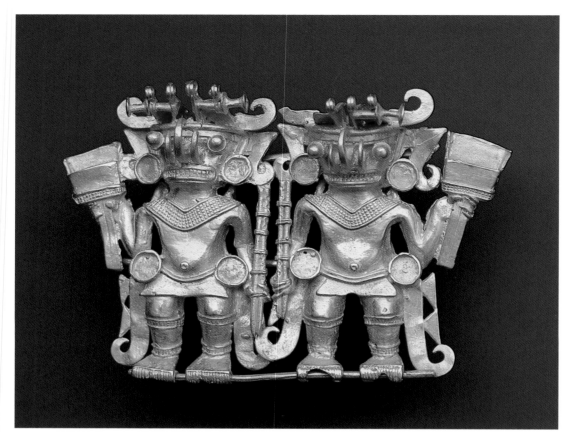

101 Double Figure Pendant
Panama (Parita); 12th–14th c.
Gold; H. 3⅛ in. (7.9 cm.)
Gift and Bequest of Alice K. Bache,
1966, 1977 (66.196.34)

PARITA DOUBLE FIGURE PENDANT

Panamanian goldwork includes an important group of pen-
dants that represent figures with bat masks. The bat attri-
butes are a large, thin, looped-up nose and round eyes that
project forward on stalks. The figures carry paddle-shaped
clubs, by which they have been identified as warriors. Their
fierce features are also appropriate to warriors; the bat at-
tributes may have been derived from the fearsome vampire
bats that inhabit areas of Panama. These bat-faced warriors
are often paired, depicted frontally side by side, with their
clubs held head-high to the outside. These paired warriors
also hold staffs or spears in their inside hands, and they are
very richly dressed. Large headdresses, big collars, and ear
ornaments adorn each figure. At their waists are streamers
that carry a crocodilian pattern. The original inlays in the
paddle-clubs are now gone; such inlays were usually made
of shell, a material that contrasts well with the texture and
color of gold.

Many of the warrior pendants are said to come from the
Azuero Peninsula, where the ancient site of El Hatillo is
located on the banks of the Parita River. At the time the
pendants were made, in the late centuries before the Span-
ish conquest, gold had been worked in Panama for about a
thousand years.

VERAGUAS FIGURE PENDANT

Gold pendants cast in various sophisticated combinations of human and animal shapes are characteristic of Precolumbian Central America. At their simplest, they depict human figures wearing animal masks and having the hands and/or feet of an animal. In other combinations, specific human or animal features can be differentiated only with difficulty. Here, the male figure wears a crocodile mask—identified by the long, square-ended snout. He has human feet, and arms that may be conventionalized wings. Top and bottom "framing" bars were customarily found on pendants from the southern Costa Rican–northern Panamanian region, where their integration into the overall design scheme was

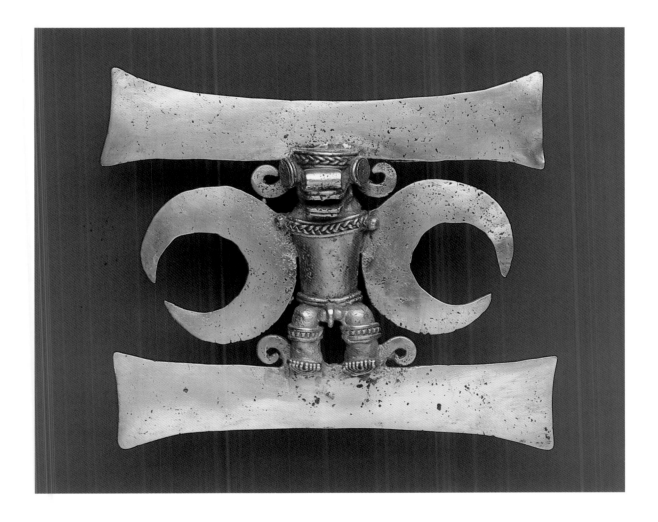

102 Stylized Figure Pendant
Panama (Veraguas); 11th–16th c.
Gold; H. 4¼ in. (10.8 cm.)
The Michael C. Rockefeller
Memorial Collection, Bequest of
Nelson A. Rockefeller, 1979
(1979.206.777)

handled in different ways. In this pendant, the horizontals are not part of the figure, and are visually so strong that they become abstract linear elements that interact with the circular shapes of the "wings."

Among the oldest of the earth's creatures, crocodilians include crocodiles, alligators, and caimans. They are found in both the Old and New Worlds, and the American varieties are known in Precolumbian art, where they appear in different guises at different times. Crocodile symbolism is common in Central American art, where it can take either zoomorphic or anthropomorphic form.

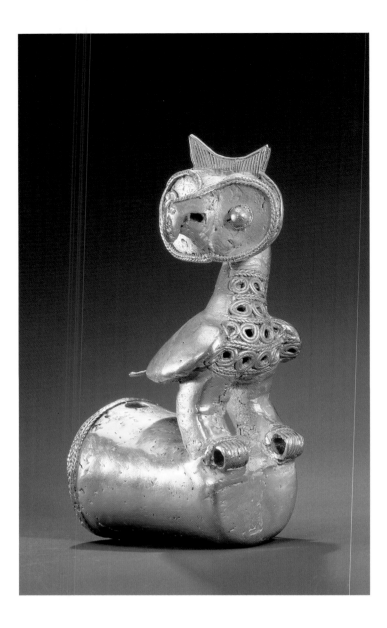

103 Bird Finial
Colombia (Zenú); 5th–10th c.
Gold; H. 4¾ in. (12.1 cm.)
The Michael C. Rockefeller Memorial Collection,
Bequest of Nelson A. Rockefeller, 1979 (1979.206.920)

104 Figure Pendant
Colombia (Tolima); 5th–10th c.
Gold; H. 7⅛ in. (18.1 cm.)
The Michael C. Rockefeller Memorial Collection,
Bequest of Nelson A. Rockefeller, 1979 (1979.206.497)

ZENU BIRD FINIAL

The finials, or staff heads, that come from the Caribbean lowlands of northeastern Colombia are very personable in their imagery. This three-dimensional cast finial of an owl, for example, does not exhibit the aggressive qualities of birds that are so often rendered in Precolumbian gold objects. The owl is both sprightly and grand, and certainly not martial in aspect. It is placed on a caplike element thought to fit onto a staff of rank or office. Many long-billed, regal birds appear on these objects. The spiraled openwork on the owl's chest, while a stylistic device known from other bird finials, adds a special flamboyant note here. The tight curls, punctuated by their dark centers, are a pleasing contrast to the smooth polish of the bird's wings.

During the first millennium of the Christian era, the Caribbean lowlands were divided into three provinces—Zenufana, Finzenú, and Panzenú—and each was known for its special contributions to the whole, known as the Gran Zenú. Zenufana, through which flowed both the Cauca and Nechí rivers, was the source of raw gold. Finzenú produced the goldsmiths. Worked gold was amassed by the ruling families as a symbol of position and importance in life, and used as burial offerings at death.

TOLIMA FIGURE PENDANT

There is a great deal of stylistic variety among the gold objects of Colombia, reflecting the diversity of ancient cultural traditions. The pendants of the so-called Tolima style from southwestern Colombia are one group that is particularly cohesive. They are noted for their flat, abstract shapes and for the consistency with which set patterns were used. One of the Tolima pendants is illustrated here. While the latticework mid-section is unusually elaborate, the wings, anchor-shaped tail, and rabbitlike ears atop the head are standard features of these objects. Opinions differ on whether bats or insects are represented. It has also been suggested that the projections on the underside of the wings and along the sides here may represent feathers, making bird representations also a possibility.

The strong outline and insistent flatness of the figures —only the details of the face, mouth, nose, and eyes are raised—give the pendants a dramatic simplicity that sets them apart from many Precolumbian gold ornaments of this type. While the great amount of detail and the peculiarities of angle when suspended make many pendants difficult to discern from a distance, the Tolima pendants are immediately perceivable, a quality surely intended by their makers.

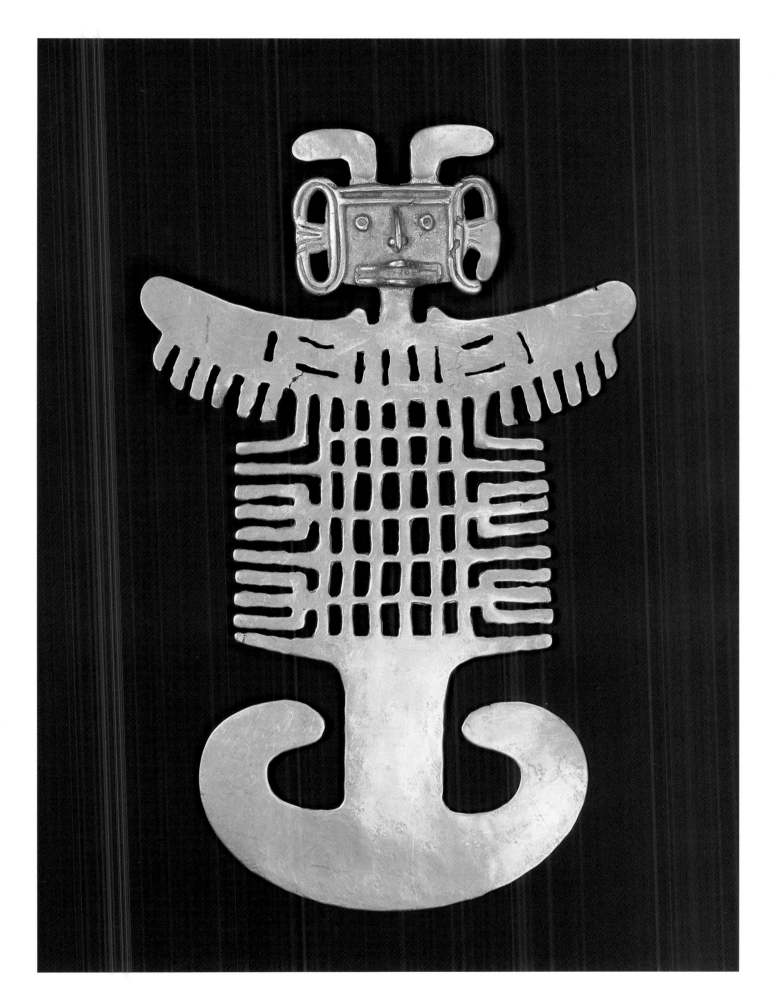

Capuli Pendant

In the Andes of southern Colombia, there is a high plateau that extends from the department of Nariño well into Ecuador, and the art of this plateau is markedly uniform. In gold, the styles of the area show both northern, or Colombian, and southern, or Ecuadorian, components at the same time that they have their own distinctive character. In this pendant, the Colombian tendency to abstraction, illustrated in the preceding pendant, can be seen to have been carried yet further. Anthropomorphic and zoomorphic references have been completely eliminated, and what remains is a pendant that is line itself. It looks as if it had been conceived by some ancient calligrapher. Even the ring for suspension, which projects centrally above the upper bar, has been integrated into the overall design. The suspension rings on Precolumbian pendants—they all have them—are seldom visible from the front.

One of the lower projections of this pendant has an ancient repair. Such repairs were made to correct a manufacturing defect or to rectify damage caused by use.

105 Pendant
Colombia or Ecuador (Capulí); 7th–12th c.
Gold; H. 5¾ in. (14.6 cm.)
Bequest of Alice K. Bache, 1977 (1977.187.21)

TOLITA FIGURE

The most expressive ceramic sculptures of Precolumbian South America are those from the Colombian–Ecuadorian border area on the Pacific coast. Named differently in each country, the sculptures are known as Tumaco in Colombia, and Tolita in Ecuador, and they range from very small to almost lifesize. The bent and wrinkled figure here is a large and particularly forceful rendition of a known type. Lines of schematized wrinkles emphasize the shape of the long chin, prominent cheekbones, and extremely baggy eyes. A close-fitting cap, or closely cropped hair, is the only adornment on the intentionally elongated head. Such head deformation was undertaken during childhood and was considered to be a mark of distinction. The figure still has the ceramic ornaments at wrists and neck, but nose and ear ornaments are missing. These were presumably made of other materials, perhaps even gold, and separately inserted through the holes in the septum and along the rims of the ears. They must have added a startling note of contrast to the white color and dusty texture of the ceramic figure.

Influence from Mesoamerica to the north, where large, hollow ceramic figures were more common than in South America, may be present in the Tumaco-Tolita works. This influence, if such it was, is thought to have arrived by sea.

106 Fragmentary Figure
Ecuador (Tolita); 1st–5th c.
Ceramic; H. 25 in. (63.5 cm.)
Gift of Gertrud A. Mellon, 1982
(1982.231)

OVERLEAF:

TEMBLADERA BOTTLE *(Pages 144–145)*

The Chavín era in Peru, during the middle centuries of the first millennium B.C., was artistically and intellectually inventive. Chavín objects are widely distributed throughout many areas of Peru, but the greatest number come from the north coastal valleys of Chicama, Moche, and Jequetepeque, where they have been discovered in tombs. Ceramic vessels—frequently bottles with different spout shapes—make up the greater portion of these mortuary offerings. Fired to muted, matte tones of gray, black, and tan, the vessels have either highly polished or incised surfaces.

Tembladera is a group of burial sites in the Jequetepeque Valley that has given its name to a particular aspect of Chavín style in ceramics. This tall bottle, with its well-preserved surface paint, is said to come from Tembladera. An incised and modeled feline head in profile is worked on the front. The head is upended, and the long, conventionalized snout has teeth that continue almost to the top of the "nose." A looped-over tongue projects from the mouth. A smaller feline profile appears on the opposite side of the bottle. The feline associations are probably those of the jaguar, the most impressive wild cat of the Americas.

107 Spouted Bottle
Peru, Chavín (Tembladera); 5th–4th c. B.C.
Ceramic; H. 12⅜ in. (31.4 cm.)
The Michael C. Rockefeller Memorial Collection,
Purchase, Nelson A. Rockefeller Gift, 1967
(1978.412.203)
Pages 144–145: front and back views

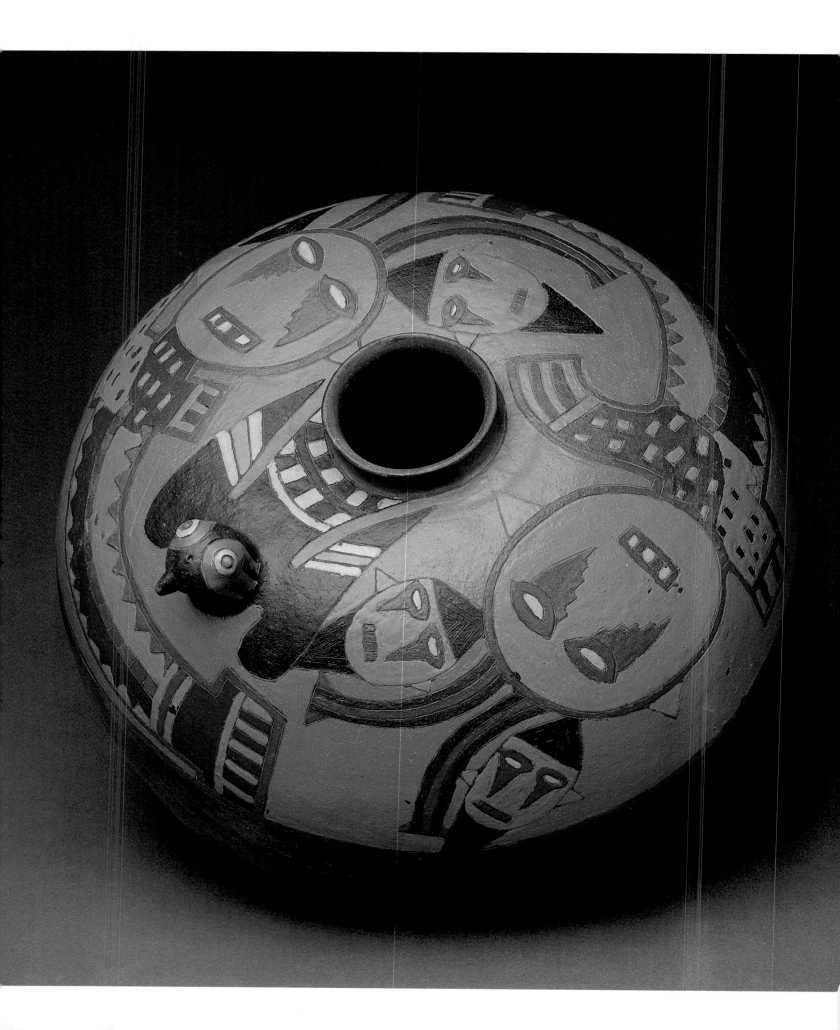

PARACAS STORAGE JARS *(Pages 146–147)*

These large ceramic jars are decorated on their upper surfaces with incised and painted designs. The boldly executed designs depict a trophy-head deity whose two-dimensional body encircles the top of the jars. Two trophy heads are attached to the deity's head, one on either side of the antenna-like projections. Trophy-head symbolism is said to have been occasioned by the appearance of a trophy-head cult that came to dominate the art of the Paracas region of Peru, supplanting the earlier feline-based imagery. The new depictions are characterized by greater freedom of invention and ease of handling. The designs are no longer so stringently geometric in their patterning as were the earlier works; color areas are larger and brighter, and their combinations are more ingenious.

The bright color on these vessels, which was applied after firing and is thus fragile, has remained remarkably intact. The southern Pacific coast of Peru, where the Paracas region is located, is very arid. Because of this extreme dryness—some rivers that come down out of the Andes, for instance, do not carry enough water to reach the sea—the preservation conditions for burial offerings are very good.

MOCHE EAR ORNAMENTS

A popular object of personal adornment in the ancient Americas was the ear ornament. In Peru, ear ornaments of precious metals reached very large sizes, and during Moche times a particularly impressive group of them that had mosaic images on their wide frontals was made. The mosaics are of materials such as turquoise, chrysocolla, quartz, pyrite, and spondylus shell. In this pair, the mosaics depict winged, bird-headed (or masked) runners. The runners, thought to be messengers, carry small white bags in their outstretched hands. Bird beaks and eyes are sheathed in gold. It is interesting to note that the images are reversed from one frontal to the other, a common Peruvian practice.

The Moche peoples dominated the northern Pacific coast of Peru during much of the first millennium A.D. At their capital city of Moche they constructed the largest man-made structure in South America, the huge, adobe brick Pyramid of the Sun. By the eighth century, Moche political power on the coast had waned.

109 Pair of Ear Ornaments
Peru (Moche); 3rd–6th c.
Gold, shell, stone; D. 3⅞ in. (10 cm.)
Gift and Bequest of Alice K. Bache,
1966, 1977 (66.196.40,41)

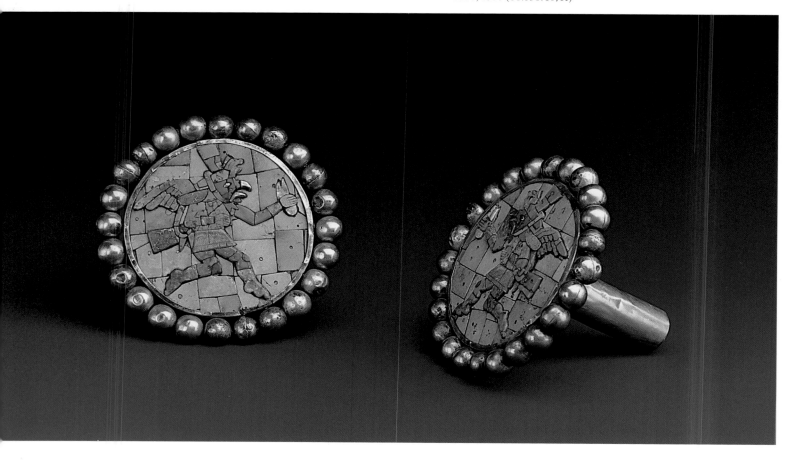

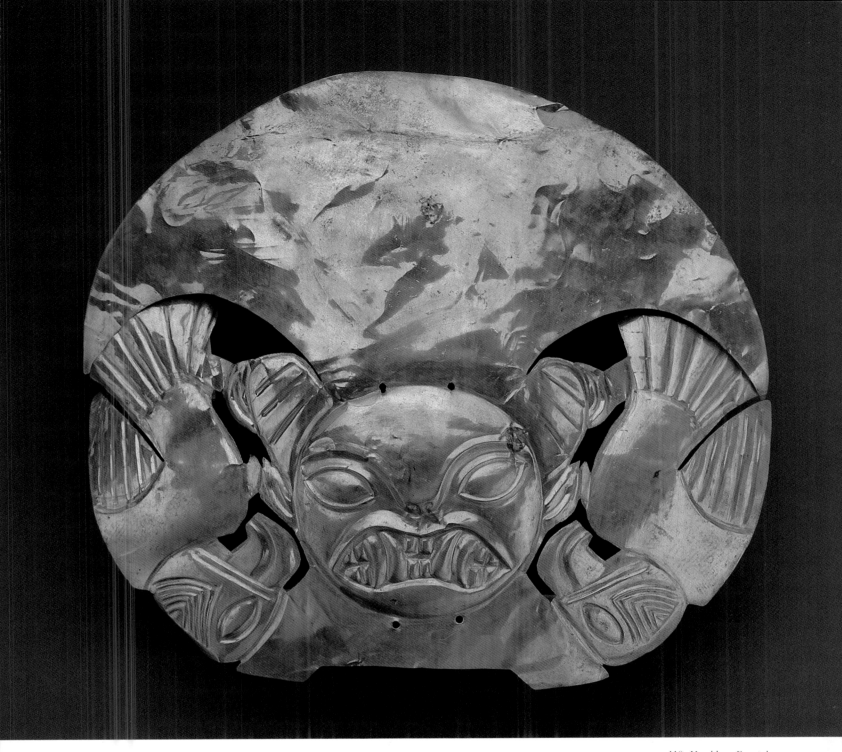

110 Headdress Frontal
Peru (Moche); 3rd–6th c.
Gold; H. 9⅜ in. (23.8 cm.)
The Michael C. Rockefeller Memorial Collection,
Bequest of Nelson A. Rockefeller, 1979
(1979.206.1151)

MOCHE HEADDRESS FRONTAL

Some of the largest remaining Precolumbian gold ornaments are the headdress frontals believed to have been made for attachment to turbanlike headpieces. Such headpieces—with or without gold attachments—were important throughout the Precolumbian world. A great deal of information about the wearer—social rank, profession, nationality—was conveyed by them, and perforce they became inordinately complex in composition. Basic was the support, whether textile or basketry, cap or turban, onto which the rest was attached. The all-important frontal, the most emblematic part, was center front. Crests or fans of feathers, animal and bird parts, fur tails, or back flaps, were all among the many other elements that could be part of a major headdress.

This frontal is worked with a central feline face. A big, snarling, fanged mouth, considered to be a sign of a supernatural being, gives the face a malevolent air. To each side of the face is an upside-down parrot in profile. The central crest is a pulled-out fan and, as the metal is not rigid, it would have swayed majestically with any movement of the person wearing it.

149

MOCHE STIRRUP-SPOUT BOTTLE

The stirrup-spout vessel—so named for the similarity of the spout form to that of a riding saddle stirrup—was a much-favored bottle shape in Precolumbian Peru. It has been suggested that the peculiarity of the double-branch/single-spout shape was to prevent evaporation. The stirrup spout was used on ceramic vessels in northern Peru for about twenty-five hundred years. Early in the first millennium B.C., the stirrup-spout bottle was elaborated into sculptural depictions of a wide range of visual phenomena. The human figure appeared among them in many roles and guises, some seemingly "everyday" in aspect, while others were of a more noticeably ritual or sacred character.

The figure wears a headdress that has a small feline face at the center. Such animal-fronted headdresses were commonly depicted in Moche art, and actual headdresses exist in which the central element was designed like fox or bird heads. The turbanlike headpieces to which they were attached also included fur and claws in the case of the fox or feathers in that of the bird. They are believed to have been emblematic of rank or profession. The figure may originally have had inlaid eyes and have worn decorations on the nose, ears, and wrists.

NASCA DRUM

Ceramic drums with central, bulbous sounding chambers were made in southern Peru before the advent of the Christian era. Extant examples are few, and the images on them are similar but not uniform. Among the most elaborately finished are those produced in the valley of the Río Grande de Nasca on the Pacific coast. Nasca drums are surfaced with the many colors commonly used on ceramic vessels. A favored form was one in which a fat-bodied figure was worked into the shape of the instrument, as in this example. With rotund body spreading out equally on all sides, and legs drawn up to the front, the figure sits atop the long, wide mouth of the drum over which a skin would have been stretched. This particular drum form did not continue to be made much after this one was produced.

The figure here is symbolically complex; a snake emerges from under the chin and a killer whale outlines each eye. The killer whales are in profile and show the "two-tone" color differentiation normally given them in Nasca depictions. Actually the largest of oceanic dolphins, the whales are black with white bellies. They were important in Nasca-period Peru, when they became anthropomorphized mythical beings and were so represented in art.

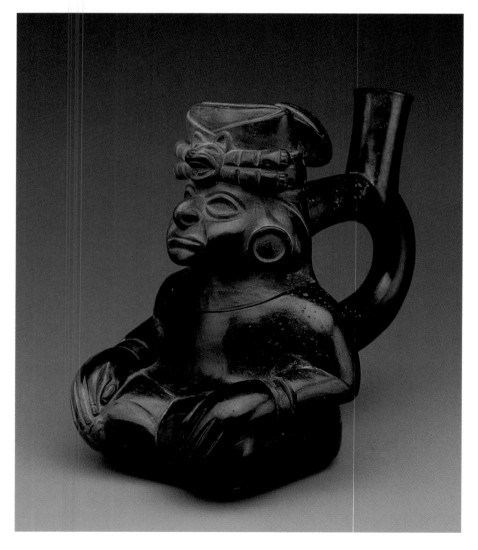

111 Stirrup-Spout Bottle
Peru (Moche); 2nd–5th c.
Ceramic; H. 6⅜ in. (16.2 cm.)
Gift of Henry G. Marquand,
1882 (82.1.30)

112 Drum
Peru (Nasca); 2nd–1st c. B.C.
Ceramic; H. 17¾ in. (45.1 cm.)
The Michael C. Rockefeller Memorial Collection,
Gift of Mr. and Mrs. Raymond Wielgus, 1964
(1978.412.111)

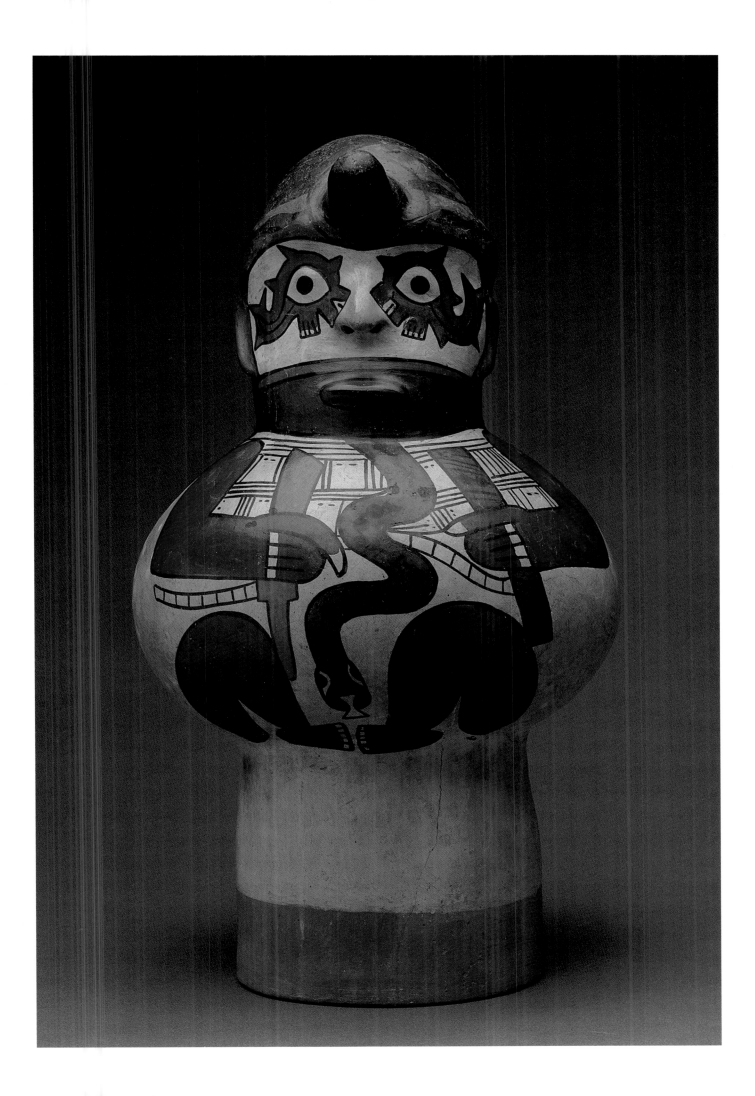

WARI-TIWANAKU CUP

The shape of this wooden cup, or *kero*, was one that had special meaning during the centuries that the cities of Wari and Tiwanaku dominated southern Peru from high in the Andes mountains. The two cities shared much religious symbolism and a number of cultural traditions. Sacred vessels of this shape were important to both. Deities were represented carrying them. The *keros* were produced in a variety of materials; known today are those made of wood, ceramic, and gold. The ceramic ones could reach very large sizes, standing over two feet in height, or they could be smaller than the wood example illustrated here.

Anthropomorphic winged figures, thought of as attendant figures (they are sometimes referred to as angels), are found in the religious imagery of each city. Four such winged and running figures, carved in low but sharply cut relief, encircle this tumbler. Two have bird heads and two feline heads. The feline-head figures gaze skyward, while those with bird heads face forward. All four figures carry tall staffs—an ancient Peruvian symbol of high status—and the tips of their wing feathers end in small, profile bird or animal heads, a convention much used during Wari-Tiwanaku times.

113 Kero
Peru (Wari-Tiwanaku); 7th–8th c.
Wood; H. 4¼ in. (10.7 cm.)
The Michael C. Rockefeller Memorial Collection,
Purchase, Nelson A. Rockefeller Gift, 1968
(1978.412.214)

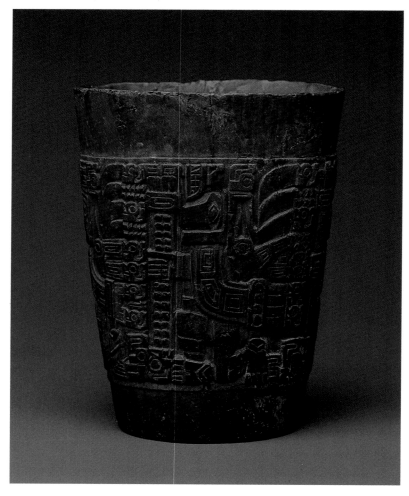

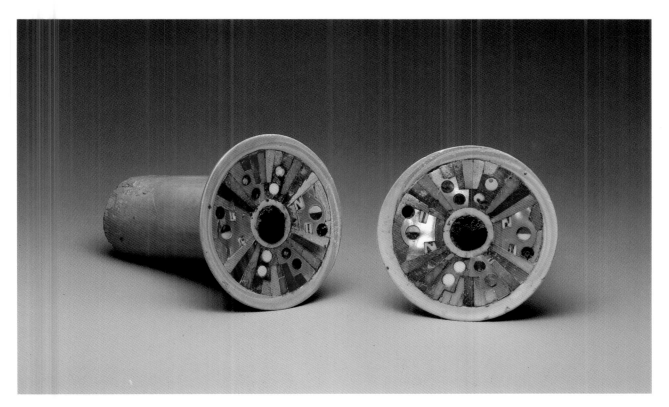

114 Pair of Ear Ornaments
Peru (Coastal Wari-Tiwanaku); 7th–8th c.
Bone, stone, shell; D. 1⅞ in. (4.8 cm.)
The Michael C. Rockefeller Memorial Collection,
Purchase, Nelson A. Rockefeller Gift, 1968
(1978.412.215,216)

WARI-TIWANAKU EAR ORNAMENTS

During the seventh and eighth centuries the peoples of the Pacific coastal valleys of southern and central Peru were under the dominion of the two highland Andean cities, Wari and Tiwanaku. Both cities strongly influenced the art of the coastal valleys. One result was an amalgam of highland and coastal artistic traditions that led to the production of many distinctive and pleasing objects. This pair of ear ornaments, constructed of bone and shell and inlaid with finely worked mosaics made of a variety of colorful materials, illustrates this amalgam of traditions. The geometric mosaic pattern with a profile feline head as its most significant component is highland in source, while the mosaic decoration, and the very sophisticated, multipart color patterning, are coastal. Another coastal contribution, albeit a circumstantial one, is the dry climate where objects made of such materials survived burial; in the wetter highlands they did not.

The ornaments were worn by men through distended holes in the ear lobes, where the weight and length of the shaft counterbalanced the frontal disk. At the time of the Spanish conquest, the Europeans were much struck with these ornaments and referred to those who wore them as "long ears."

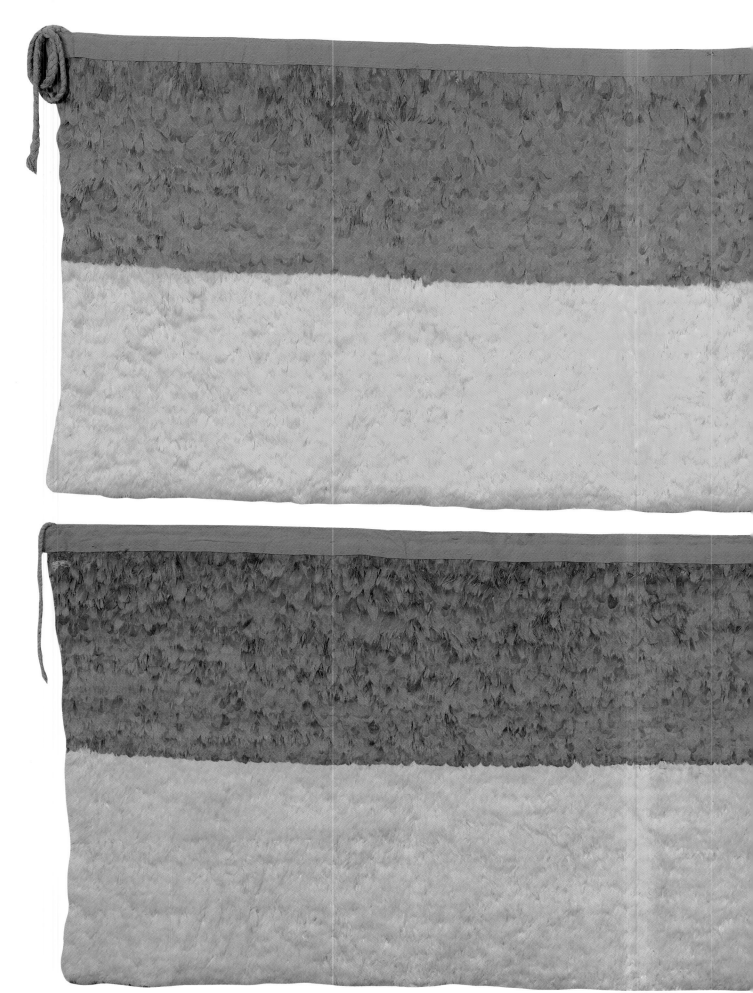

115 Feathered Hangings
Peru (Coastal Wari-Tiwanaku); 7th–8th c.
Feathers on cotton fabric; H. of both 26¾ in. (65.4 cm.)
The Michael C. Rockefeller Memorial Collection, Bequest
of Nelson A. Rockefeller, 1979 (1979.206.467,470)

Page 156: text

154

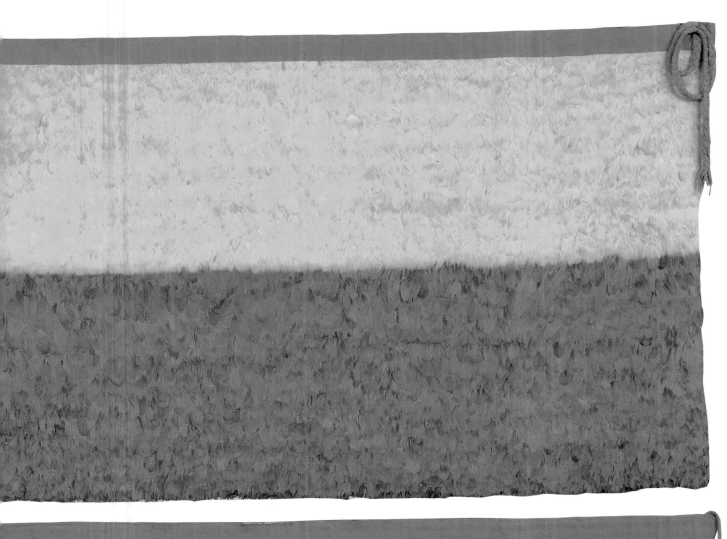

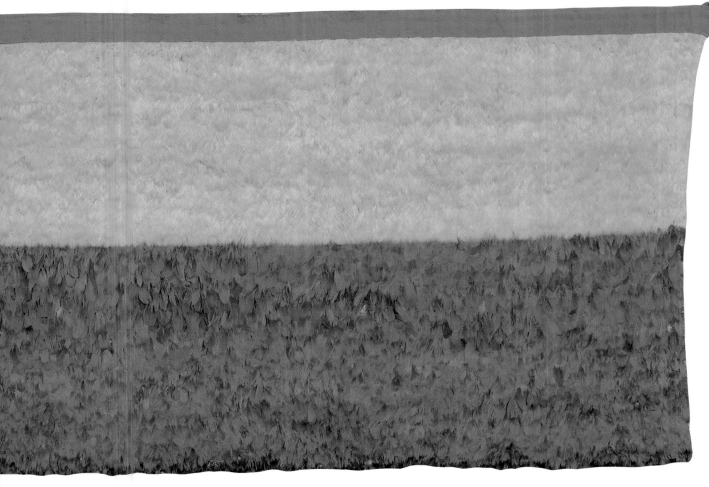

The feathered textiles of Peru are among the most luxurious textile products of the ancient world. Each feather is individually sewn to a cotton base-fabric, and the surfaces are thus built up to a soft, downy skin of radiant color. The feathers of tropical birds, from the Amazon jungles in eastern Peru, made the most brilliantly colored textiles, and the intense blues, greens, reds, and yellows were highly prized. The showy feathers were used in the fabrication of luxury items of all sorts, from objects as small as ear ornaments to those as large as these hangings, which have an average size of two by seven feet. The blue- and yellow-feathered textiles were made of parrot feathers, and it is presumed that they were used to decorate the walls of large compounds or courts on special occasions.

The feathered hangings were accidentally discovered in the early 1940s, when a large cache of ninety-six of them was reported in a find near the Ocoña River in southern Peru. The textiles had been rolled and placed in large, decorated ceramic jars that were more than three feet high, which were then left between the walls of what was said to be "concentric circles." Offerings on this scale, often involving large amounts of decorated pottery, are known from other sites on the southern coast. The offerings were not made to accompany the dead, but rather functioned in some other dedicatory or supplicatory manner.

TIWANAKU FIGURE

The great stone city of Tiwanaku with its sunken courts and intricately carved sculpture has impressed viewers since the sixteenth century, and its visible remains have given rise to highly individual interpretations. Archaeological investigation now places the city's beginnings in the third century B.C., and its era of greatest accomplishment in the sixth through the tenth centuries A.D. The stone sculpture for which it is noted presumably dates to this later period.

The sculpted image here is a small example of a type of columnar figure that existed in large sizes at Tiwanaku. The figure, tightly bound by the roughly rectangular confines of the stone, has a large head topped by a plain cap with a chin strap. Below each square eye, like a tear, is an incised profile animal head. To its unclad chest are held, in carefully symmetrical hands, objects that are probably snuffing tablets. Similar Precolumbian tablets are known in wood. They are thought to have been used for the taking of hallucinogenic snuff. The figure is clad only in a "kilt" that is decorated with an incised design of rectangles and stylized faces. The pattern runs diagonally, a device consistent with known textiles of the period. A wide belt encircles the waist and keeps the kilt in place; it is embellished with rayed central medallion units.

Tiwanaku Vessel

The ceramic vessels of highland Tiwanaku are sturdy and clean lined, with a no-nonsense approach to shape that sets them apart from the sculptural ceramic traditions of the coastal regions. Surface color too is restrained, with a predominance of earth tones in a limited range of hue. This flaring-side vessel is a typical, but distinctive, Tiwanaku type. It has a large feline head on one side and a stumpy, erect tail on the other. The head is surrounded by a large flange on which remnants of a design remain. Winged profile felines are on each side of the vessel. These big-footed cats abundantly fill the space allotted to them. Their eyes are round and divided in half with one half white and the other black, a stylization that was widely used on feline images.

Vessels such as these were made to represent either large cats or llamas. A number of them are modeled in the shape of the animal itself, with the animal's body forming the vessel container. The insides of both modeled and abstract vessels are often found blackened and sooty. This has lead to the supposition that they were used as censers in Precolumbian times. When in use, smoke would have come from the open mouth of the large feline head of this example, which does have a soot-blackened interior.

116 Figure with Ceremonial Objects
Bolivia (Tiwanaku); 6th–10th c.
Stone; H. 18⅜ in. (47.7 cm.)
The Michael C. Rockefeller Memorial Collection,
Bequest of Nelson A. Rockefeller, 1979 (1979.206.833)

117 Feline Vessel
Bolivia (Tiwanaku); 6th–10th c.
Ceramic; H. 10⅛ in. (25.7 cm.)
The Michael C. Rockefeller Memorial Collection,
Gift of Nelson A. Rockefeller, 1969 (1978.412.100)

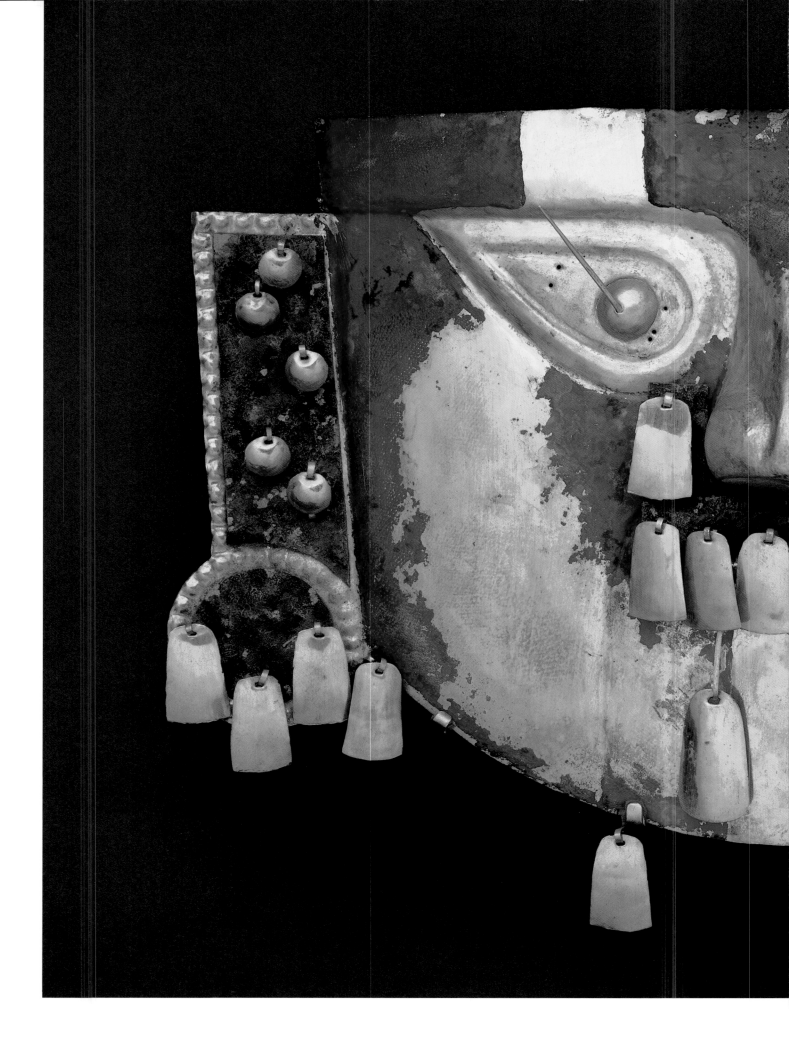

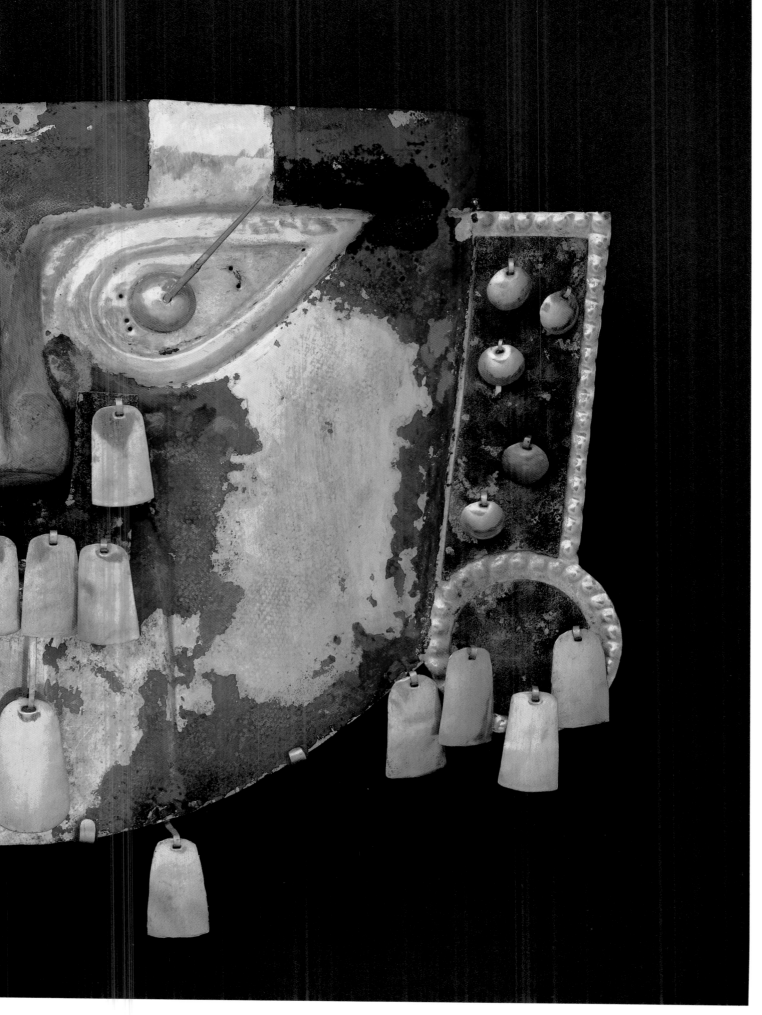

118 Funerary Mask
Peru (Sicán); 9th–11th c.
Gold, paint; H. 11½ in. (29.2 cm.)
Gift and Bequest of Alice K. Bache,
1974, 1977 (1974.271.35)

Page 160: text

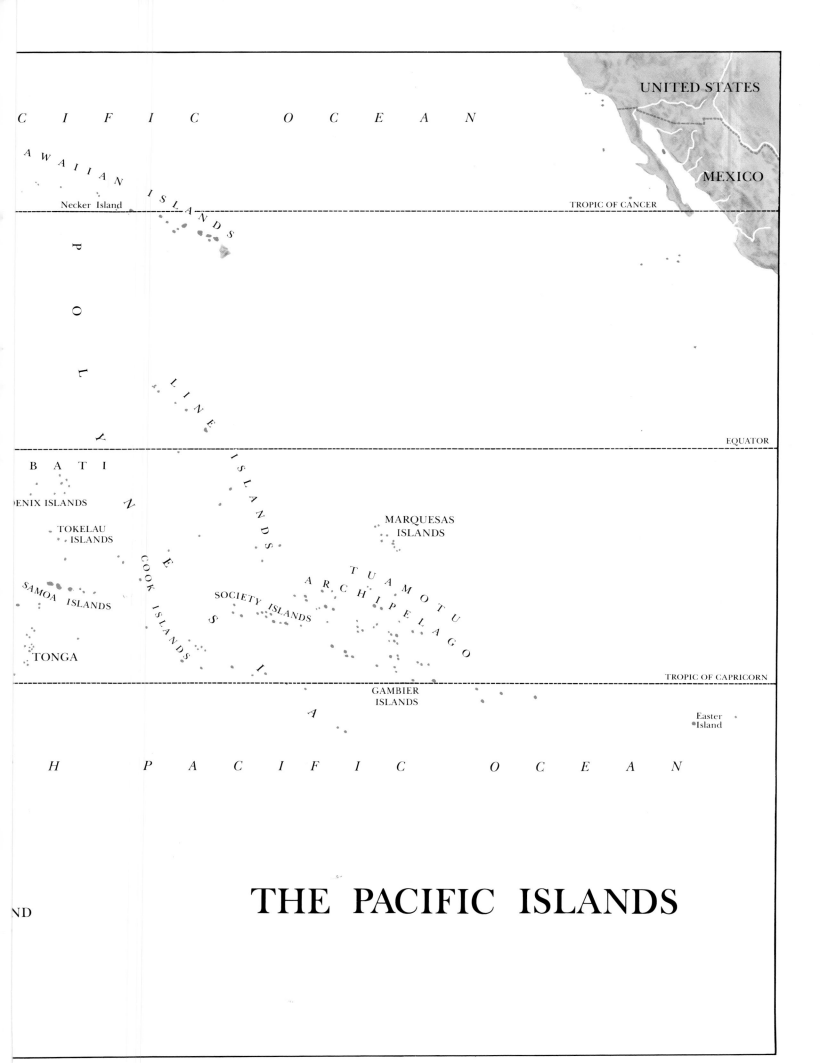

C I F I C O C E A N

UNITED STATES

MEXICO

A W A I I A N I S L A N D S

Necker Island

TROPIC OF CANCER

P O L Y N E S I A

L I N E I S L A N D S

EQUATOR

B A T I

ENIX ISLANDS

TOKELAU
ISLANDS

SAMOA
ISLANDS

COOK
ISLANDS

SOCIETY ISLANDS

MARQUESAS
ISLANDS

T U A M O T U O
A R C H I P E L A G O

TONGA

GAMBIER
ISLANDS

TROPIC OF CAPRICORN

Easter
Island

H P A C I F I C O C E A N

ND

THE PACIFIC ISLANDS